Defining Neomedievalism(s) II

Studies in Medievalism XX

2011

Studies in Medievalism

Founded by Leslie J. Workman

Previously published volumes are listed at the back of this book

Defining Neomedievalism(s) II

Edited by
Karl Fugelso

Studies in Medievalism XX 2011

Cambridge
D. S. Brewer

First published 2011
D. S. Brewer, Cambridge

ISBN 978–1–84384–267–5

ISSN 0738–7164

D. S. Brewer is an imprint of Boydell & Brewer Ltd
PO Box 9, Woodbridge, Suffolk, IP12 3DF, UK
and of Boydell & Brewer Inc.
668 Mount Hope Ave, Rochester, NY 14620, USA
website: www.boydellandbrewer.com

A CIP catalogue record for this book is available
from the British Library

The publisher has no responsibility for the continued existence or
accuracy of URLs for external or third-party internet websites referred to
in this book, and does not guarantee that any content on such websites is,
or will remain, accurate or appropriate.

Papers used by Boydell & Brewer Ltd are natural, recyclable products
made from wood grown in sustainable forests

Printed and bound in Great Britain by
The MPG Books Group, Bodmin and King's Lynn

Studies in Medievalism

Founding Editor	†Leslie J. Workman
Editor	Karl Fugelso

Advisory Board

Martin Arnold (Hull)
Geraldine Barnes (Sydney)
Rolf H. Bremmer, Jr. (Leiden)
William Calin (Florida)
A. E. Christa Canitz (New Brunswick, Canada)
Philip Cardew (South Bank University, London)
Elizabeth Emery (Montclair State)
David Matthews (Manchester)
Gwendolyn Morgan (Montana State)
Ulrich Müller (Salzburg)
Nils Holger Petersen (Copenhagen)
Tom Shippey (Saint Louis)
Clare A. Simmons (Ohio State)
John Simons (Lincoln)
Paul Szarmach (Western Michigan)
Toshiyuki Takamiya (Keio)
Jane Toswell (Western Ontario)
Richard Utz (Western Michigan)
Kathleen Verduin (Hope College, Michigan)
Andrew Wawn (Leeds)

Studies in Medievalism provides an interdisciplinary medium of exchange for scholars in all fields, including the visual and other arts, concerned with any aspect of the post-medieval idea and study of the Middle Ages and the influence, both scholarly and popular, of this study on Western society after 1500.

Studies in Medievalism is published by Boydell & Brewer, Ltd., P.O. Box 9, Woodbridge, Suffolk IP12 3DF, UK; Boydell & Brewer, Inc., 668 Mt. Hope Avenue, Rochester, NY 14620, USA. Orders and inquiries about back issues should be addressed to Boydell & Brewer at the appropriate office.

For a copy of the style sheet and for inquiries about **Studies in Medievalism**, please contact the editor, Karl Fugelso, at the Dept. of Art and Art History, Towson University, 8000 York Rd, Towson, MD 21252–0001, USA, tel. 410–704–2805, fax 410–704–2810 ATTN: Fugelso, e-mail <kfugelso@towson.edu>. All submissions should be sent to him as e-mail attachments in Word.

Acknowledgments

The device on the title page comes from the title page of *Des Knaben Wunderhorn: Alte deutsche Lieder*, edited by L. Achim von Arnim and Clemens Brentano (Heidelberg and Frankfurt, 1806).

The epigraph is from an unpublished paper by Lord Acton, written about 1859 and printed in Herbert Butterfield, *Man on His Past* (Cambridge University Press, 1955), 212.

Studies in Medievalism

Two great principles divide the world, and contend for the mastery, antiquity and the middle ages. These are the two civilizations that have preceded us, the two elements of which ours is composed. All political as well as religious questions reduce themselves practically to this. This is the great dualism that runs through our society.

Lord Acton

Editorial Note

As I mentioned in the Editorial Note for *Studies in Medievalism* 19, the practice of neomedievalism has become a growth industry. Numerous sessions at the International Congress on Medieval Studies, the International Medieval Congress, and almost every other conference related to the Middle Ages have been devoted to it. Many an article has at least touched on its subjects, concepts, or methods. And more than one book has been completely dedicated to it, including the forthcoming collection of papers edited by Carol L. Robinson and Pamela Clements, *The Medieval in Motion: Neomedievalism in Film, Television, and Digital Games.*

Yet the practice of neomedievalism has hardly outpaced the defining of this nascent area. Even as the superstructure of neomedievalism has risen to unprecedented heights, many scholars have concentrated on staking out and shoring up its foundations. Indeed, few authors who characterize their subject as neomedieval seem to assume that their audience knows what is meant by the term. Whether addressing, say, Monty Python or Japanese video games, they often take the time to articulate precisely how their work falls outside of traditional medievalist practice. Moreover, many self-professed neomedievalists have devoted entire papers to defining the subjects, methods, and values that they see as integral to their field. Rather than temporarily foreground their approach in the course of drawing conclusions about particular references to the Middle Ages, they temporarily foreground those references in the course of drawing conclusions about the nature of neomedievalism.

Of course, many of these scholars have run into resistance from not only within their own ranks, albeit often with regard to comparatively minor points, but also (other) medievalists. For the latter, an interest in new media, such as video games, does not fall outside of the broad definitions for medievalism established by its founders, particularly Leslie J. Workman. Nor does a layering of references to the Middle Ages, even when it hides the medieval origin of an allusion. Moreover, these critics often maintain that neomedievalists overemphasize differences in attitude (particularly degrees of irony) that may, in any case, be unknowable. For these medievalists, neomedievalists are defending artificial borders that diminish medievalism without establishing valid alternatives.

And as many neomedievalists and their critics have noted, these are not purely ideological and philosophical differences fought from ivory towers.

There are practical consequences for the participants and the larger cultures with which they identify. Tenure-review boards may be somewhat skeptical of this new field, not to mention the nontraditional media in which they often prefer to work. University administrations may have even more difficulty pigeonholing neomedievalists than medievalists, who are sometimes still treated as if they present a formidable challenge to academic conventions. And anyone seeking to learn more about the postmedieval treatment of the Middle Ages may face one more taxonomic challenge amid material that is frequently far more subdivided than intuition might require.

All of which has led to an extraordinarily passionate debate. The unprecedented number and stridency of responses to *SiM* 17 and 18, both of which featured sections devoted to definitions of medievalism, have already been overtaken by the reactions to our previous volume, which featured seven essays that responded to Robinson and Clements' defense of neomedievalism in *SiM* 18. In person and in e-mails, various scholars have not hesitated to let me know that they have an opinion about the validity of neomedievalism.

Unfortunately, many of them were unable to transform their thoughts into essays for the present volume of *SiM*. But we were able to commission four outstanding papers from authors with highly diverse and original insights on the nature of neomedievalism, particularly as defined by their predecessors. Harry Brown employs postmedieval references to the Templars as a crucible in which to test the precepts and conclusions of those predecessors, in which to find common denominators for material and approaches that seem to fall outside the conventions of traditional medievalism. KellyAnn Fitzpatrick argues that the value of neomedievalism lies precisely in its perpetual invitation to be defined, that it "must always be more about the denying than the unbroken integrity of the denial." David W. Marshall argues that neomedievalism is "a self-conscious, ahistorical, non-nostalgic imagining or reuse of the historical Middles Ages that selectively appropriates iconic images, often from other medievalisms, to construct a presentist space that disrupts traditional depictions of the medieval." And Nils Holger Petersen explores an interesting musical response to the Middle Ages that suggests at least some traits associated with neomedievalism may either be folded back into medievalism or invite further distinctions from it.

Of course, not all of these papers directly address the practice of medievalism as it has long appeared in the pages of *SiM*. But we hope that, even as the essayists define what they believe medievalism is not, they will open new windows onto all postmedieval interpretations of the Middle Ages, particularly the seven articles that follow these essays. In "*Quentin Durward* and Louis XI: Sir Walter Scott as Historian," Mark B. Spencer explores Scott's ability to wrap a celebrated narrative around historical information

that centered on a notoriously paradoxical and slippery subject, namely Louis XI. In "Chivalric Terrors: The Gendered Perils of Medievalism in M. E. Braddon's *Lady Audley's Secret*," Megan L. Morris observes that historical references, particularly to the Middle Ages, help construct and reinforce gender identities that very much pervade an influential Victorian novel. In "'Lessons Fairer than Flowers': Mary Elizabeth Haweis's *Chaucer for Children* and Models of Friendship," Karla Knutson reveals many of the ways in which another nineteenth-century author tailored medieval sources to reinforce Victorian values, particularly as they pertain to male friendship and other aspects of masculine identity. In "The Self and the *óðr*: Borges and the North," Vladimir Brljak surveys Norse references in the life and work of perhaps the most well-known Latin-American author. In "O Rare Ellis Peters: Two Rules for Medieval Murder," Alan T. Gaylord examines how Peters' novels about the monastic sleuth Cadfael reconcile conventions of detective fiction with her extraordinarily extensive knowledge of medieval culture. In "Performing Medieval Literature and/as History: The Museum of Woframs-Eschenbach," Alexandra Sterling-Hellenbrand takes us on a tour of a provincial German museum that has a particularly creative approach to a native son little known apart from his medieval writings. And in "Celtic Tattoos: Ancient, Medieval, and Postmodern," Maggie M. Williams investigates the modern practice of an art form whose styles as well as means are often closely linked by its practitioners with the Middle Ages.

Although not all scholars may accept neomedievalism as a new field, and though others may think it has little relevance to traditional medievalism, there can be little doubt that discussing its identity is beneficial to us all. As we formulate and entertain definitions of it, we are invited to reconsider the nature of not only it but also the field(s) to which it has been compared and from which it has been differentiated, particularly medievalism. That is to say, we are encouraged to rethink and recommit to our mission, values, and practices as (neo)medievalists.

List of Illustrations

"Lessons Fairer than Flowers": Mary Elizabeth Haweis's *Chaucer for Children* and Models of Friendship

Performing Medieval Literature and/as History: The Museum of Wolframs-Eschenbach

Celtic Tattoos: Ancient, Medieval, and Postmodern

Baphomet Incorporated:
A Case Study in Neomedievalism

Harry Brown

Recently *Studies in Medievalism* (*SiM*) has dedicated itself not only to reassessing the meaning of medievalism but also to defining the emergent field of neomedievalism. In their effort to distinguish neomedievalism as a new mode of expression qualitatively distinct from previous medievalisms, Carol Robinson and Pamela Clements, along with several of the contributors to *SiM* 19, have identified what they find to be the most salient features of neomedievalism. Most significantly, they argue, neomedievalism severs itself from history, often with conscious irony and anachronism, producing works refracted through the lenses of previous medievalisms rather than rooted in a real sense of the Middle Ages. These works foster the commodification and mass consumption of the past rather than the earnest attempt to recover and understand it. Moreover, while neomedievalism gestures to multicultural awareness, it sometimes presents a narrow and culturally homogeneous interpretation of the medieval. Finally, while digital technology does not by itself define neomedievalism, it provides an ideal environment to nurture works that are frequently intertextual, fluid, and collaborative.[1]

On one level, the attempt to distinguish neomedievalism from its "parent," as Robinson and Clements say, is a semantic exercise that betrays an anxiety of influence.[2] We misconstrue nothing by admitting simply that neomedievalism is medievalism adapted to the postmodern moment. As Amy S. Kaufman sensibly concludes, "while medievalism can exist perfectly independently at any point in time, neomedievalism despite its seeming ahistoricity, is historically contingent upon both medievalism itself and the postmodern condition. [...] Despite its desire to erase time, neomedievalism is situated in time: it just happens to be our time."[3] We do not need to disown medievalism in order to legitimate neomedievalism.

Nevertheless, the vigor of discussion in the pages of *SiM* and on the

panels of professional conferences suggests that we do need a new theoretical model, and perhaps a new term, to account for the new ways that contemporary culture has appropriated the medieval without quite comprehending (or wanting to comprehend) the Middle Ages, particularly in films and games. The appropriation of the medieval by Antoine Fuqua's film *King Arthur* (2004) or by the online video game *World of Warcraft*, with its nearly twelve-million subscribers, signals a cultural phenomenon more complex than pure "anarchy" or the mere "dumbing down" of the high medievalism practiced by J. R. R. Tolkien and T. H. White.[4] Rather than reiterate the definitions of neomedievalism that have been proposed so far, which usefully describe this cultural phenomenon, I will assess the value of these definitions in helping us to understand the synthesis of the medieval and the postmodern in one of its most prolific manifestations: the Templar conspiracy narrative.

The twelfth-century historian William of Tyre records that, following the capture of Jerusalem by the First Crusade, nine French knights formed an order of warrior monks to protect pilgrimage routes and to defend newly formed Christian kingdoms. They established their headquarters in the al-Aqsa mosque on the Temple Mount and called themselves the Order of the Poor Knights of Christ and the Temple of Solomon. Its reputation for military and spiritual discipline won the order numerous initiates and influential patrons. Even as the Muslims regained control of the Holy Land, the Templars consolidated their wealth and power in Europe, inviting the resentment of rivals.[5] In his account of the capture of Ascalon by the Second Crusade, for example, William alleges that the Templars undermined the military and diplomatic efforts of other Christian rulers in order to maintain their own privilege and dominance.[6] In the early fourteenth century, Philip IV of France and Pope Clement V conspired to seize Templar possessions, accusing the knights of homosexuality, defiling the cross, and paying homage to the pagan idol Baphomet. Many Templars fled France to regroup while others were imprisoned, tortured, and burned. In 1312 Clement formally dissolved the order.

More relevant to the discussion of neomedievalism, however, is the Templars' strange cultural afterlife, which has far outlasted the two centuries of the order's historical existence. In the mid eighteenth century, Scottish Freemasons adopted the Templars as forebears. Andrew Michael Ramsay identified the crusader knights as bearers of "ancient signs and symbolic words" and guardians of "the most sublime truths."[7] At the same time, Friedrich Schlegel and other scholars searched medieval romances for connections between the Templars and the Holy Grail, initiating the tradition linking the Templars to occult knowledge and Gnostic enlightenment.[8] In the revolutionary climate of the early nineteenth century, these

speculations assumed political significance, as conservatives revived the charges of heresy against the Templars in order to implicate the Freemasons in revenge plots against Roman Catholic governments.[9] In medievalist fiction of the nineteenth century, the Templars emerge in Walter Scott's *Ivanhoe* (1819) as a gang of thugs and schemers, a once noble brotherhood corrupted by wealth and power.

In our own time, the Templars' most compelling role in the popular imagination remains as guardians of "the most sublime truths." Bolstered by speculative and often specious scholarship, this erstwhile Masonic claim has gone viral. In *Holy Blood, Holy Grail* (1982), Michael Baigent, Richard Leigh, and Henry Lincoln identify the Templars as key players in an epochal conspiracy to obscure the true origin of Christianity, encoded in medieval Grail romances.[10] With equal enthusiasm, Graham Hancock, in *The Sign and the Seal* (1992), proposes that the Templars discovered the secret location of the Ark of the Covenant, in fact a radioactive alien weapon, during their occupation of the Temple Mount, likewise encoding their discovery in Grail romances.[11] In bestselling novels such as Umberto Eco's *Foucault's Pendulum* (1988), Dan Brown's *The Da Vinci Code* (2003), and Raymond Khoury's *The Last Templar* (2005), and in popular films such as Steven Spielberg's *Indiana Jones and the Last Crusade* (1989) and Jon Turteltaub's *National Treasure* (2004), the Templar conspiracy originating with Ramsay, Schlegel, and Scott has become not only one of the most commercially successful conceits of our generation but, for many people, an established truth.

We find evidence for the power of this narrative in the reaction of the Vatican to *The Da Vinci Code*, a romantic fictionalization of the theory proposed by Baigent, Leigh, and Lincoln. Alarmed that Vatican tourists were using the novel as a guide to religious history, the Church had to remind the world's Catholics that *The Da Vinci Code* is indeed a work of fiction. They appointed the publicist and debunker Cardinal Tarcisio Bertone, who told an Italian newspaper in 2005, "[t]here is a very real risk that many people who read [*The Da Vinci Code*] will believe that the fables it contains are true. [Dan Brown] even perverts the story of the holy grail, which most certainly does not refer to the descendants of Mary Magdalene. It astonishes and worries me that so many people believe these lies."[12] The following year, the Vatican called for Catholics to boycott Ron Howard's film adaptation of the novel.

Like Bertone, academic debunkers note the conflation of history and fiction in Templar conspiracy narratives. Surveying the tradition linking the Templars to the Holy Grail, Richard Barber calls such theories "nonsense." Templar spirituality, he explains, "seems to have been that of the knightly class from which most of their members were drawn, highly organized and very disciplined but with absolutely no interest in mysticism or the higher

levels of theology." Barber concludes, "[t]here is no trace in any medieval source of an association between the Templars and the literature on the Grail."[13]

What concerns neomedievalism, with its interest in the "blatantly inauthentic," is not the reality of the Templar conspiracy but rather the reactions it has produced, which signal that the Templars of romance and suspense fiction have somehow supplanted the Templars of the historical record, at least in the popular mind.[14] According to the backwards logic of the people who propagate and subscribe to these theories, Bertone's denial of the story only confirms its truth. The fact that scolding churchmen and stuffy academics rise in defense of orthodoxy merely bolsters the indictment of orthodoxy. While Baigent, Leigh, and Lincoln, for example, dismiss many of the esoteric claims about the Templars as "ridiculous" and "extravagant," they tempt the reader with suggestive rhetoric and the promise of their own true revelation:

> [W]as there some genuine mystery connected with [the Templars]? Could there have been some foundation for the later embellishments of myth? We first considered the accepted accounts of the Templars – the accounts offered by respected and responsible historians. On virtually every point these accounts raised more questions than they answered. They not only collapsed under scrutiny, but suggested some sort of "cover-up." We could not escape the suspicion that something had been deliberately concealed and a "cover story" manufactured, which later historians had merely accepted.[15]

Baigent, Leigh, and Lincoln momentarily nod to "respected and responsible" accounts like Barber's only to undermine them as incomplete, flimsy, or even indirectly complicit in their gullible acceptance of the "cover story," making them, in fact, seem untrustworthy and irresponsible.

By providing a foundation of pseudo-scholarship for numerous works of fiction, *Holy Blood, Holy Grail* marks a significant neomedievalist moment, as the Templars are uprooted from "respected and responsible" history and transplanted in the radioactive soil of imaginary history, where they are free to mutate into fantastic new forms. This notion of the conscious detachment from history and the consequent distortion of medieval material into something we no longer recognize as historical preoccupies the recent attempts to define neomedievalism. Robinson and Clements call neomedievalism an "alternate universe of medievalisms, a fantasy of medievalisms," created by manipulating the "illusion" rather than the reality of the Middle Ages.[16] Neomedievalism, they continue, demonstrates that "all

medievalisms are constructs, made from prefabricated materials."[17] Kaufman writes more succinctly that "[n]eomedievalism is thus not a dream of the Middle Ages, but a dream of someone else's medievalism. It is medievalism doubled upon itself."[18] Using Jean Baudrillard's *Simulacra and Simulation*, M. J. Toswell likewise describes neomedievalism as a simulacrum of the Middle Ages, drawing a distinction between medievalism, which "attempts to ground itself not just in generalized myth or history, but in specific representations [...] a sense of the real," and neomedievalism, which instead offers "a copy of an absent original, a sign that no longer speaks to a semiotic."[19] In *Holy Blood, Holy Grail* and *The Da Vinci Code*, medievalism "doubles upon itself" to construct an illusion of the Middle Ages from the residue of previous illusions. Here Ramsay, Schlegel, and Scott return like vaguely remembered dreams, becoming the "prefabricated materials" or "absent original" of our more familiar Templar myths, flawed copies of copies.

As Toswell shows, this characteristic disjunction from history proves particularly useful in distinguishing neomedievalism from medievalism and, more generally, describing the transformation of the medieval by the postmodern. In his effort to define postmodernism in relation to modernism, Fredric Jameson contrasts two paintings: Van Gogh's *A Pair of Boots* and Warhol's *Diamond Dust Shoes*. Jameson argues that Van Gogh's oil painting of a peasant's worn work shoes evokes "the whole object world of agricultural misery, of stark rural poverty, and the whole rudimentary human world of backbreaking peasant toil." The boots are "a clue or a symptom, for some vaster reality which replaces it as its ultimate truth." Jameson concludes that Van Gogh's modernist image has "depth," in that it signifies a social and historical condition suggested but not visibly represented in the image.[20] In contrast, Warhol's silver-and-black image of sleek pumps appears severed from "that whole larger lived context of the dance hall or the ball, the world of jetset fashion or glamour magazines." In this way Warhol's painting typifies "a new kind of flatness or depthlessness, a new kind of superficiality in the most literal sense." Jameson describes this lack of depth, this severance of a text or an image from history or a "larger lived context," as "the supreme formal feature of all [...] postmodernisms."[21]

As medievalism transformed by postmodernism, neomedievalism likewise exhibits superficiality and depthlessness as a significant, if not supreme, formal feature. Ubisoft's *Assassin's Creed*, one of the most recent and most footloose Templar fantasies, literally represents the medieval knights as dreams, or "genetic memories," buried in the unconscious mind of the game's protagonist, twenty-something bartender Desmond Miles. In the frame narrative, set in the present, the unsuspecting Desmond is abducted by operatives of mysterious Abstergo Industries and wired to Animus, a

prototype machine designed to unlock deeply embedded memories, including those encoded in DNA. In the embedded narrative, set within Desmond's mind in the year 1191, the player enacts these memories as Desmond's distant ancestor Altaïr ibn-La'Ahad, a Saracen assassin who battled the Templars to possess the Piece of Eden, a mystical (perhaps alien) artifact that the Templars unearthed beneath the Temple Mount. By accessing Desmond's genetic unconscious, Abstergo seeks to discover the hiding place of the artifact, now lost to the ages. Throughout the game, the Templars act as foils to the noble *hashshashin*, bullying and deceiving both Muslims and fellow Christians as part of their secret plan to dominate the Holy Land through the mind-control power contained in the artifact. They propose to bring peace by effectively lobotomizing the population and ruling as enlightened despots. Acting as Altaïr, the player inevitably foils the conspiracy. In a flourish of alternative medieval history, Altaïr kills Templar Grand Master Robert de Sablé in single combat refereed by Richard the Lionheart. Upon emerging from the Animus, however, Desmond learns that Abstergo is a front for the Templars, who have survived as a powerful covert organization and are now using him as a pawn in their continuing plans for world domination. Desmond realizes that he must use the latent powers of his assassin forebears to continue the fight against the Templars.

As an order of medieval knights now incarnate as a diabolical transnational corporation, the Templars of *Assassin's Creed* appear not only "depthless" and detached from the "larger lived context" of twelfth-century Jerusalem but, more strikingly, as a wild composite of previous Templar illusions. Like Ramsay's and Schlegel's adepts, they guard secret knowledge. Like Scott's thugs, they terrorize the weak and the innocent. Like Hancock's treasure hunters, they unearth an alien artifact beneath the Temple. Like Baigent, Leigh, and Lincoln's supreme conspirators, they operate covertly throughout the centuries, growing more powerful as they adapt their schemes to new historical conditions. This pastiche of "prefabricated materials," this matrix of meanings ascribed to the Templars by everyone from eighteenth-century Freemasons to twenty-first-century game developers, represents a particularly vivid manifestation of the "fantasy of medievalisms" generated by the play of meanings unmoored from history.

As Brent and Kevin Moberly argue, however, something more than anarchy motivates the culture-generating machinery that has produced *The Da Vinci Code* and *Assassin's Creed*. Rather, neomedievalist works produce "a version of the medieval that can be seen and touched, bought and sold, and therefore owned."[22] Kaufman similarly argues that the proverbial bored stockbroker who inhabits *World of Warcraft* indulges in a "refracted version of the Middle Ages" that reflects the self rather than the past:

In her created world, the Middle Ages as she imagines it both
belong to her and include her. However she acquired it, this is the
only medieval that matters. Neomedievalism is not as interested in
creating or recreating the Middle Ages as it is in assimilating and
consuming it. The danger of assimilation, of course, is that the
essence and the beauty of difference can be lost.[23]

Emptied of any contingent historical meaning, the medieval becomes more
easily traded, more receptive to a projection of the user's own identity. In
Assassin's Creed, Abstergo Industries, the Templars reincarnated in the
present, embodies popular fears of transnational corporations, with their
unimaginable wealth, arcane technology, and inscrutable, amoral machina-
tions. While he may be genetically equipped for superhuman cunning,
Desmond seems more prone to loafing in bars and playing video games, a
mirror of the typical *Assassin's Creed* player. The game envisions a harmonic
convergence between, on the one hand, the age of Microsoft, Halliburton,
and British Petroleum and, on the other hand, the age of the Templars and
hashshashin by projecting an avatar of Generation Facebook into a simula-
tion of the Third Crusade. In the context of discussions of medievalism and
neomedievalism, this personal appropriation of the Middle Ages represents a
significant difference in the way the user construes his or her relation to the
past as mediated by the text. The past becomes consumable, and the text
itself becomes more interactive, not simply because digital technology
enables it, but rather because neomedievalism proposes to create a commer-
cial and personal interface with the past in a way that classic works of medi-
evalism do not.

While such an interface fosters the creative mediation of the past appro-
priated for the consumer's personal use, as it does in *Assassin's Creed*, it can also
give way to what Kaufman calls "insufferable presentism," posing a threat to
the awareness of "true diversity" gained by acknowledging history.[24] Rather
than asking what distinguishes *World of Warcraft* and *Assassin's Creed* from *The
Lord of the Rings* and *The Once and Future King*, we might ask what distin-
guishes these games from E. L. Risden's hypothetical epic of European barbar-
ians and Asian samurai battling as pawns in a cosmic struggle between two
bloodthirsty and sexually excitable demigods enthroned at the center of the
earth.[25] Of course, we know neomedievalism, like pornography, when we see
it. The recognizable difference between neomedievalism and surreal fantasy
suggests that the denial history by neomedievalism is incomplete, that some
residue of the past remains. As Kaufman argues, "what initially appears to be
neomedievalism's denial of history may, instead, be a desire for history along-
side the uncomfortable suspicion that there is no such thing."[26]

What, then, remains of the Templars in Abstergo Industries? What does

the Templar conspiracy narrative, with all of its bifurcations, reveal about our "desire for history," the bridge between ourselves and the medieval? According to William of Tyre's chronicle, what made the Templars "exceedingly troublesome" to their contemporaries was not their wealth and power but rather a "neglect of humility" that caused them to "deny obedience" to the Patriarch of Jerusalem and other rightful superiors.[27] According to the rule of their order, the Templars answered to no one but the Pope. When a Christian knight donned their white cowl, he absolved himself of all temporal debts and obligations. The Templars existed independently of the hierarchy of vassalage, free to pursue an independent agenda with secrecy and impunity. William's apprehension about the Templars' influence in the twelfth century anticipates Cullen Murphy's provocative comparison between the privatization of security and social services in the global market and the resurgence of feudalism. Murphy writes:

> In the West the path away from the Middle Ages was marked by the evolution of governments and nation-states with a sense of responsibility for the public interest rather than merely private interests. Power was no longer a form of property. Social services and protections became a consequence of citizenship, not a private deal between a lord and his vassals, or between a private entity and its clients.[28]

The refiguring of the Templars as an ultramodern, ultrapowerful corporation in *Assassin's Creed* suggests that they continue to embody the popular suspicion of covert and unaccountable power, just as they had for William. In this sense, the medieval is not completely unmoored, and in the heart of the kaleidoscopic Templar myth we find a somewhat stable tether. The bridge between William and *Assassin's Creed* is a populist desire to expose power, to reveal and thus foil its conspiracies, whatever they are.

 In the popular imagination, the Templars have become an invisible hand, a sphere of influence whose center is everywhere and circumference nowhere. While Philip and Clement merely accused them of homosexuality and heresy, our own culture has heaped charges of assorted and more heinous crimes, conspiracies, and cover-ups. The Poor Knights of Christ have been portrayed as bullies, extortionists, murderers, misogynists, cultists, violent religious fanatics, ruthless oligarchs, enemies of peace and intercultural understanding, and technocrats bent on lobotomizing the planet in the interest of greater enlightenment. With the Church's condemnation of *The Da Vinci Code* as a modern heresy, we find the Templars in the middle of yet another controversy, a neomedieval reprise of the Vatican's original condemnation of the actual Templars seven centuries ago. The

novel, and more especially the broader Templar conspiracy, now stands in as Baphomet, the false idol, the sinister icon, the graven image of the neomedieval, which has effaced and replaced the real, and become an industry all its own.

NOTES

1. See Carol L. Robinson and Pamela Clements, "Living with Neomedievalism," *Studies in Medievalism* 18 (2009): 55–75; Amy S. Kaufman, "Medieval Unmoored," *Studies in Medievalism* 19 (2010): 1–11; Brent Moberly and Kevin Moberly, "Neomedievalism, Hyperrealism, and Simulation," *Studies in Medievalism* 19 (2010): 12–24; M. J. Toswell, "The Simulacrum of Neomedievalism," *Studies in Medievalism* 19 (2010): 44–57; E. L. Risden, "Sandworms, Bodices, and Undergrounds: The Transformative Mélange of Neomedievalism," *Studies in Medievalism* 19 (2010): 58–67.

2. Robinson and Clements, "Living with Neomedievalism," 56.

3. Kaufman, "Medieval Unmoored," 2, 5–6.

4. See Robinson and Clements, "Living with Neomedievalism," 55; Lesley Coote, "A Short Essay about Neomedievalism," *Studies in Medievalism* 19 (2010): 25–33 (28–9).

5. William of Tyre, *Historia rerum in partibus transmarinis gestarum*, XII, 7, *Patrologia Latina* 201, 526–7, trans. James Brundage, *The Crusades: A Documentary History* (Milwaukee, WI: Marquette University Press, 1962), 70–73.

6. William of Tyre, *Historia rerum in partibus transmarinis gestarum*, XVII, 22–5, 27–30, *Patrologia Latina* 201, 696–708, trans. James Brundage, *The Crusades: A Documentary History* (Milwaukee, WI: Marquette University Press, 1962), 126–36.

7. Richard Barber, *The Holy Grail: Imagination and Belief* (Cambridge, MA: Harvard University Press, 2004), 307.

8. Barber, *The Holy Grail*, 306–7.

9. Barber, *The Holy Grail*, 308–9.

10. Michael Baigent, Richard Leigh, and Henry Lincoln, *Holy Blood, Holy Grail* (London: Jonathan Cape Ltd., 1982; repr. New York: Bantam Dell, 2004), 64–95.

11. Graham Hancock, *The Sign and the Seal* (New York: Touchstone, 1992), 89–120.

12. Michelle Pauli, "Vatican Appoints Official Da Vinci Code Debunker," *The Guardian*, 15 March 2005, <http://www.guardian.co.uk/books/2005/mar/15/catholicism.religion> (accessed 30 July 2010).

13. Barber, *The Holy Grail*, 306–7, 309.

14. Robinson and Clements, "Living with Neomedievalism," 66.

15. Baigent, Leigh, and Lincoln, *Holy Blood, Holy Grail*, 65, 81.

16. Robinson and Clements, "Living with Neomedievalism," 56, 61.

17. Robinson and Clements, "Living with Neomedievalism," 66, 69.

18. Kaufman, "Medieval Unmoored," 4.

19. Toswell, "The Simulacrum of Medievalism," 46.

20. Fredric Jameson, *Postmodernism, or, The Cultural Logic of Late Capitalism* (Durham, NC: Duke University Press, 1991), 7–8.

21. Jameson, *Postmodernism*, 8–9.

22. Moberly and Moberly, "Neomedievalism, Hyperrealism, and Simulation," 15.

23. Kaufman, "Medieval Unmoored," 5.

24. Kaufman, "Medieval Unmoored," 5, 9.

25. Risden, "Sandworms, Bodices, and Undergrounds," 63–4.

26. Kaufman, "Medieval Unmoored," 3.

27. William of Tyre, *Historia rerum in partibus transmarinis gestarum*, XII, 7, *Patrologia Latina* 201, 526–7, trans. Brundage, *The Crusades*, 70–73.

28. Murphy, "Feudal Gestures," *Atlantic Monthly* 292 (October 2003): 135–7 (136).

(Re)producing (Neo)medievalism

KellyAnn Fitzpatrick

If medievalism remains, as Gwendolyn A. Morgan says, "somewhat slippery," then neomedievalism is outright ephemeral.[1] If a survey of recent scholarship on the topic is any indication, neomedievalism manages all at once to create a "hyperreality" more real than reality itself and to carve out its living in the furtive and ravenous consumption of mass-produced commodities, yet also floats disembodied above a sea of already constituted academic disciplines waiting to be formed into something solid and publishable/ten(ur)able.[2]

This ephemerality is perhaps most evident in the contradicting conclusions that recent scholarship has forwarded in regards to the relationship of neomedievalism to medievalism proper. In "Living with Neomedievalism" Carol L. Robinson and Pamela Clements locate their concept of neomedievalism among contrasting tropes such as postmodernism and fantasy, and inevitably produce part of their definition in relation to medievalism. They write:

> Unlike in postmodernism, however, neomedievalism does not look to the Middle Ages to use, to study, to copy, or even to learn; the perception of the Middle Ages is more filtered, perceptions of perceptions (and of distortions), done without a concern for facts of reality, such as the fact that The Knights Who Say "Ni" never existed. This lack of concern for historical accuracy, however, is not the same as that held in more traditional fantasy works: the difference is a degree of self-awareness and self-reflexivity. Nor is it the same as what we conceive to be medievalism.[3]

Cory Lowell Grewell, in responding to Robinson and Clements, credits them with hitting upon some useful approaches in defining neomedievalism but disagrees with them "when they assert that neomedievalism is something

other than medievalism."[4] While M. J. Toswell differentiates the two by means of their object of study,[5] Amy S. Kaufman calls neomedievalism a "functional subset" of medievalism and sees medievalism as a necessary precondition of neomedievalism. She writes, "Neomedievalism is one way of doing medievalism, one that requires certain philosophical and technological shifts in order to exist at all. Yet while medievalism can exist perfectly independently at any point in time, neomedievalism despite its seeming ahistoricity, is historically contingent upon both medievalism itself and the postmodern condition."[6] In the very same collection of essays where Kaufman firmly anchors neomedievalism to medievalism, Lesley Coote makes the ontological claim that "*neo*-medievalism, by its nature, cannot be fully contained within 'medievalism,' or any other, similar, terminology."[7]

Within the parameters of delineating a relationship between neomedievalism and medievalism, neomedievalism cannot logically hold all of these positions and yet, somehow, it does. Robinson and Clements argue that neomedievalism "lacks nostalgia" and "denies history."[8] This is done, however, with "a degree of self-awareness and self-reflexivity," which positions both consumer and producer of the neomedieval in the necessary position of knowing enough history and/or historiography to knowingly deny it. To do otherwise would defeat the point, but we are then faced with a concept of neomedievalism that relies one moment on that very thing it negates in the next. Indeed, in addition to working, as Coote asserts, "always to escape from the parameters that 'isms' impose,"[9] neomedievalism invokes a constant state of producing, alternating, and reproducing; it is less a thing than an action. It can position and reposition itself toward and away from medievalism proper as the occasion requires. As Lauryn S. Mayer points out, such a perspective on neomedievalism tasks us with reevaluating our entire battle plan when it comes to conceptual development:

> If there is one aspect of neomedievalism that critics can agree upon, it is that it resists any easy definition, and the problem may lie in the questions we are asking. To ask "what is neomedievalism?" or even "what are neomedievalisms?" is to treat a continuously unfolding and changing phenomenon as if it were a finished and static entity; any answer given will by default be "a slight fabrication."[10]

To borrow from the title of an aptly named Medieval Electronic Media Organization anthology, the neomedieval is always "in motion";[11] by the time we look at where and what it is, it has already moved on to something and somewhere new. To my mind, the wisest course of action in responding to this tangential nature of neomedievalism is to take Mayer's advice and

"worry less about what, precisely, it is and to spend more time thinking about what it does and why it does it."[12] The remainder of this essay demonstrates some of the ways neomedievalism is contingent on and participatory in a constant production and reproducing, assembly and reassembling; it then takes Mayer's advice as a starting point for an articulation of neomedieval praxis.[13]

As a number of scholars have noted, recent media forms taken by neomedieval texts have contributed to the "dissolution" of individual authorship in favor of the creation of narratives and narrative experiences through collaborative participation.[14] This results in a multiplicity of authors as well as narrative forms that are far more fragile and fleeting than the hard-copy objects of the pre-digital age.[15] At the same time the texts that take these forms necessitate that their participants shift into positions of production even while they are active consumers, which potentially entails a false sense of empowerment. As Robinson and Clements note:

> It suggests a movement from identity of narrative creator(s) through characterization (such as one seeks through the *Gawain*, *Pearl*, and *Cleanliness* poems) to identities of creators imposed upon the reader/player. The illusion of control seems to be on the end of the player as she develops her character and moves through the narrative structure of the game; however, just as is the case with most Hollywood studio films, the actual control is that of the corporation (the programmers, designers, marketers, …) that produces the film.[16]

Part of what a digital game sells is the illusion of control over the game itself, even as one becomes acutely aware of the narrative limitations that even virtual words must constitute by virtue of the component of their makeup that is hardline nuts-and-bolts code. Massively multiplayer online role-playing games (MMORPGs) such as *World of Warcraft* expand these possibilities in two important ways: first, by means of the component of social networking, which, in addition to positioning the player (however deceptively) as author of her own fate, necessitates variations on the gaming experience according to the other players with which she comes into contact; and second, through the commodification of a plethora of virtual objects and potential virtual objects that for some players drive the momentum of the game in more exciting ways than narrative creation or social networking. The intersections of social networking and virtual goods result in the establishment of entire economic systems designed to accommodate these phenomena, which in turn necessitates the creation of virtual currencies, markets, and on-the-job training.

World of Warcraft, like many other virtual worlds such as *SecondLife* or the social networking game *Farmville*, maintains its own virtual currency; in the case of *World of Warcraft* this is gold. While the accumulation of gold is in itself an attraction for some players, for the most part gold is useful in terms of what it can buy. In *World of Warcraft* this can range from traditional fantasy-action-game fare such as armor and weapons to virtual items that have no foreseeable use or other value in the game but that nevertheless become desirable commodities. The latter may include fashionable clothing, flashy jewelry, or exotic pets, and while Non-Player Character (NPC) vendors sell some trendy items, players also have the choice of visiting an auction house where they can either bid for items they want or sell items they have acquired through questing, production, or other means.

Players have the option of producing some of these virtual commodities, as each player may learn up to two "professions" such as Mining, Tailoring, Blacksmithing, or Jewelcrafting. Just as a traditional action game allows one to "level up" one's combat abilities, a player can level up her character's professional ability by extensive and often repetitive practice. As a player becomes more skilled in a profession, she can then craft higher-level goods that in turn can be traded or sold in order to buy other goods, including the raw materials required for further professional crafting. The services of the highest-level craftspeople are often sought out by other players who have not built up such abilities; while such services are often exchanged for gold, many will offer their services for free if a client provides the necessary materials, as this allows the craftsperson to build up their professional skill level without having to shell out the gold for raw materials.

The system of professions, then, serves as yet another way that a text such as *World of Warcraft* allows its players to participate in the process of production. Although these processes result in virtual goods that become the object of interest for some players,[17] the participatory nature of these types of production suggests that the virtual act of producing is somehow just as valuable as the resultant products. Indeed, players often have the option of migrating outside of a game in order to purchase auxiliary funds for use within the game. This is made possible by a practice known as "gold- farming" in which the currency within the virtual world of a Massively Multiplayer Online Game is accumulated and then exchanged for "real" currency.[18] This practice also extends to the buying and selling of high-level virtual goods, and players can even hire someone in the "real" world to "power-level" their characters, which allows them to outsource and thus skip the often tedious processes by which the game intends them to build up their characters' abilities. Gold-farming, trading virtual objects, and power-leveling are, however, greatly discouraged by most MMORPG companies. For example, part of *World of Warcraft*'s Terms of Use agreement expressly forbids these practices:

Blizzard owns, has licensed, or otherwise has rights to all of the
content that appears in the Game. You agree that you have no
right or title in or to any such content, including without limita-
tion the virtual goods or currency appearing or originating in the
Game, or any other attributes associated with the Account or
stored on the Service. Blizzard does not recognize any purported
transfers of virtual property executed outside of the Game, or the
purported sale, gift or trade in the "real world" of anything that
appears or originates in the Game. Accordingly, you may not sell
in-game items or currency for "real" money, or exchange those
items or currency for value outside of the Game.[19]

Despite these warnings, many players do engage in these activities, and some
make a living from them; however, the majority of players are interested not
only in the goods themselves but in the process that goes into producing
them. Indeed, one could argue that although this is a virtual process in
which virtual commodities are produced, it is the virtual production itself
that is commodified and then consumed by those who engage with these
types of neomedieval texts. The neomedieval, then, may at times produce
commodities but is equally capable of commodifying production as well.

This intertwined process of producing and consuming, commodifying
and creating, results in a certain romanticizing of the labor process itself.
Neomedievalist scholarship may endeavor to be cognizant of the processes of
commodification and consumption in which it participates, but at times
even we participate in processes of mystification. For example, in speaking of
digital-game designers and programmers, Kaufman proposes a link between
"programmers, whose own encoded language seems mysterious and inacces-
sible, and who act as the invisible yet omnipotent force behind a game" and
the magic-wielding characters in the games they create.[20] Robinson and
Clements have, in response to Kaufman, argued that "it is clear that a strong
bond exists between the culture of computers and the culture of medieval
fantasy and that culture is conducive to juxtapositions of tropes between
both worlds."[21]

Because the production of MMORPGs relies on skill sets and labor
practice that we ourselves are not equipped to perform, it is not surprising
that academics in the Humanities would be fascinated by them. With
Tolkien as a model of the novelist-scholar, there was always the suspicion
that one could, if one wanted, turn one's expertise into a self-aware product
that "gets it right" either in its adherence to or laughing departure from some
sort of cultural medieval accuracy. Very few of us, however, are comfortable
with programming code in any systematic way, and I have come across no
indication that the creation of digital worlds will become part of our job

description on a widespread basis anytime soon. It may be useful, however, to add to our understanding of the collaborative nature of neomedieval texts a more specialized understanding of the process that gives us the initial itera- tion of text, the raw materials that allow so many authors to simultaneously create and consume neomedieval narrative.[22]

As is, our fascination with programmers and our willing conflation of programming code with the magical and mystical reveal our own suscepti- bility to the neomedievalist texts that we study, as well as a willingness to overlook the bottom-line circumstances in which neomedievalism is contin- ually produced. Rather than feel ashamed of this, I suggest that we take this as a sign that we should investigate not only what neomedievalism *does*, but what we could do with it. For example, in addition to examining the history of our inherited disciplinary practices, neomedievalism as a set of scholarly practices could benefit from more careful self-examination of the width and breadth of practices that constitute not only our field, but those of a wider intellectual community. Indeed, the productive practices that determine the majority of our own labor conditions have been for some time in various states of crisis. For example, the expectation of monograph production has been deemed untenable by those who engage with it strictly as a commodity.[23] At the same time, our tenure-and-promotion committees rely on the acceptance of intellectual work as a commodity to make their deci- sions, and so our livelihoods become based not on the quality of our scholar- ship but on our ability to successfully engage in commodity production. Perhaps we could, as we boldly barge into virtual worlds and discover new ways of producing texts, consider alternate ways of making them accessible and assessable. As the book itself, and not just the academic monograph, is in crisis, we may wish to reconsider the digital technologies, such as e-book readers, that are displacing it.[24] If we can consider the importance of producing virtual loot in virtual worlds, we may also want to consider the effects that virtual books may have on our "real"-life production practices. This includes deciding whether it is the scholarly value of the monograph we value or the commodity, the intellectual labor or the paper and cloth that constitute it.

The constant processes that make up medievalism, then, not only invite us to produce meanings and commodities and narratives but also to critically re-examine our own assumptions about where we belong in this process. When we read a novel, play a digital game, or compose an essay, we produce our texts through ever more complicated patterns of consumption, play, authorship, and scholarship. Some participants catalogue their experience through relatively traditional approaches, such as Bonnie A. Nardi in her anthropological account of her time as a Night Elf Hunter in *World of Warcraft*.[25] Others have used the technologies of neomedieval texts to forge

new scholarly communities that operate cooperatively and collaboratively within the virtual worlds they study.[26] Still others choose to subvert the authority of the texts they study/produce/consume in an attempt to wrest control back from the corporations that produce them.[27] And then there are those who attempt to be as self-reflexive and self-aware as possible when endeavoring to produce scholarship on neomedievalism.

To that end, I must confess that I am fully aware of the irony of producing a definition that claims its own definition is impossible, that pushes to articulate the uses of less-permanent media through the means of a traditional one, and that urges a self-reflexive stance on intellectual production even as it serves as a potential part of the academic hire–tenure–promotion process. I have high hopes, however, that the ephemerality of neomedievalism will somehow let this work. Just as neomedievalism must acknowledge history as a precondition to denying history, I suspect that we can reverse the process: perhaps deny history, and then acknowledge it once more as yet another process of which we can make use. Indeed, the history of medievalism lends insight into issues of disciplinarity and historicity, and provides us with the exempla of "menacing medievalisms" and tropes misused to displace the production of something new/neo with nostalgia for the processes of production that, while they have armed us with the insight in the first place, are long outdated. This becomes possible if we realize that neomedievalism must always be more about the denying than the unbroken integrity of the denial, just as its value lies less in the definition than in the act of defining.

NOTES

1. Gwendolyn A. Morgan, "Medievalism, Authority, and the Academy," *Studies in Medievalism* 17 (2009): 55.

2. In reading through the volume of *Studies in Medievalism* that immediately precedes the present volume, one notices patterns emerging among the many definitions of neomedievalism. Baudrillard plays a role in the definitions forwarded in Brent Moberly and Kevin Moberly, "Neomedievalism, Hyperrealism, and Simulation," *Studies in Medievalism* 19 (2010): 15; Lesley Coote, "A Short Essay about Neo-Medievalism," *Studies in Medievalism* 19 (2010): 26; and M. J. Toswell, "The Simulacrum of Neomedievalism," *Studies in Medievalism* 19 (2010): 45–46. Commodities and consumption are linked to neomedievalism in Amy S. Kaufman, "Medieval Unmoored," *Studies in Medievalism* 19 (2010): 7–8; Moberly and Moberly, "Neomedievalism, Hyperrealism, and Simulation," 15; and E. L. Risden, "Sandworms, Bodices, and Undergrounds: The Transformative Mélange of Neomedievalism," *Studies in Medievalism* 19 (2010): 64–65. For approaches that link

the techniques of legitimization employed in establishing Medieval Studies and medievalism as acceptable fields of academic inquiry with the ongoing process of defining and establishing neomedievalism, see Richard Utz, "*Medievalitas Fugit*: Medievalism and Temporality," *Studies in Medievalism* 18 (2009): 33–35, and Cory Lowell Grewell, "Neomedievalism: An Eleventh Little Middle Ages?" *Studies in Medievalism* 19 (2010): 34.

3. Carol L. Robinson and Pamela Clements, "Living with Neomedievalism," *Studies in Medievalism* 18 (2009): 62.

4. Grewell, "Neomedievalism: An Eleventh Little Middle Ages?" 40–41.

5. Toswell, "The Simulacrum of Neomedievalism," 44. Toswell argues there that "The difference between the two terms as they are used in the English-speaking world is that medievalism implies a genuine link – sometimes direct, sometimes somewhat indirect – to the Middle Ages, whereas neomedievalism invokes a simulacrum of the medieval."

6. Kaufman, "Medieval Unmoored," 2.

7. Coote, "A Short Essay about Neo-Medievalism," 25.

8. <http://medievalelectronicmultimedia.org/definitions.html>, quoted in Robinson and Clements, "Living with Neomedievalism," 58.

9. Coote, "A Short Essay about Neo-Medievalism," 25.

10. Lauryn S. Mayer, "Dark Matters and Slippery Words: Grappling with Neomedievalism(s)," *Studies in Medievalism* 19 (2010): 68.

11. Carol L. Robinson, ed., *The Medieval in Motion: Neomedievalism in the Digital Age (Film, Television and Electronic Games)*, assoc. ed. Pamela Clements (Lewiston, NY: Edwin Mellen Press, forthcoming).

12. Mayer, "Dark Matters," 75.

13. As Lesley Coote notes in "A Short Essay about Neo-Medievalism," "Deconstructing the text is postmodern, but cutting and pasting it to make something new is neo-medieval – and it brings the cut-and-paster surprisingly, dangerously, close to medieval reading practices" (30).

14. Robinson and Clements, "Living with Neomedievalism," 68; Coote, "A Short Essay about Neo-Medievalism," 27–28; and Mayer, "Dark Matters," 73–74.

15. Richard N. Katz and Paul B. Gandel, "The Tower, the Cloud, and Posterity," in *The Tower and the Cloud: Higher Education in the Age of Cloud Computing*, ed. Richard N. Katz (Boulder: Educause, 2008), 180.

16. Robinson and Clements, "Living with Neomedievalism," 68–69.

17. Mike Molesworth and Janice Denegri-Knott, "Desire for Commodities and Fantastic Consumption in Digital Games," in *The Players' Realm: Studies on the Culture of Video Games and Gaming*, ed. K. Patrick Williams and Jonas Heide Smith (Jefferson, NC: McFarland & Company, 2007), 255–275.

18. For a solid introduction to the relationship between "real" and virtual economies, see Edward Castronova, *Synthetic Worlds: The Business and Culture of Online Gaming* (Chicago: University of Chicago Press, 2005).

19. "World of Warcraft Terms of Use Agreement," Blizzard Entertainment, last modified 9 July 2008, <http://www.worldofwarcraft.com/legal/termsofuse.html>.

20. Amy S. Kaufman, "Romancing the Game: Magic, Writing, and the Feminine in Neverwinter Nights," *Studies in Medievalism* 16 (2008): 147.

21. Robinson and Clements, "Living with Neomedievalism," 68.

22. For a solid introduction to the gaming industry and the process by which digital games are made, see Aphra Kerr, *The Business and Culture of Digital Games: Gamework/Gameplay* (London: Sage, 2006), 43–101.

23. Lindsay Water, "Rescue Tenure from the Tyrrany of the Monograph," *Chronicle of Higher Education*, 20 April 2001.

24. In July 2010, Amazon.com reported that it was now selling more virtual texts for its Kindle reader than hard-cover books. For details please see "Kindle Device Unit Sales Accelerate Each Month in Second Quarter; New $189 Price Results in Tipping Point for Growth," news release, 19 July 2010, <http://phx.corporate-ir.net/phoenix.zhtml?c=176060&p=irol-newsArticle&ID=1449176&highlight=>.

25. Bonnie A. Nardi, *My Life as a Night Elf Priest: An Anthropological Account of World of Warcraft* (Ann Arbor: University of Michigan Press, 2010).

26. Scott Rettberg, "Corporate Ideology in World of Warcraft," in *Digital Culture, Play and Identity: A World of Warcraft Reader*, ed. Hilde G. Corneliussen and Jill Walker Rettburg (Cambridge, MA: MIT Press, 2008), 19–20.

27. Daniel Gilbert and James Whitehead II, *Hacking World of Warcraft* (Indianapolis: Wiley Publishing, 2007).

Neomedievalism, Identification, and the Haze of Medievalisms

David W. Marshall

The opening of Tom Shippey's article "Medievalisms and Why They Matter" highlights the persistent confusion of meanings that surrounds the definition of this field of study.[1] Because of that haze, the last two years have been a significant moment for medievalism as an area of academic investigation. In the decades following Leslie Workman's inception of the journal, we have come to see just how profoundly varied different forms of medievalism are, necessitating some reevaluation of how we approach our subject. With two issues of *Studies in Medievalism* dedicated to "defining medievalism(s)" (volumes 17 and 18) and another issue exploring the various definitions of neomedievalism (volume 19), the subject has been given space for some much-needed theorizing. Workman's monumental accomplishment notwithstanding, medievalism – or medievalistics, as Nickolas Haydock has termed the study of such texts[2] – has been a field with only a vaguely defined sense of itself. Thus, and as E. L. Risden highlights, the Kalamazoo Congress on the Middle Ages has begun to feature sessions devoted to subjects perhaps with the barest links to the medieval.[3] So the efforts of this journal, its editor, and advisory board have enabled a pause to assess and reassess both what we understand medievalism to be and how we approach it as scholars.

The result of these efforts is a collective definition that has the potential to help structure the continued investigation of the subject. Haydock provides a general definition describing the basic pattern of medievalism in terms flexible enough to accommodate a wide variety of manifestations. He suggests we understand medievalism as "characterize[d] [...] as a discourse of contingent representations derived from the historical Middle Ages, composed of marked alterities to and continuities with the present."[4] His definition highlights the often intricate composition of medievalia, the warps and weft of past images interwoven with present concerns. Elizabeth

Emery further clarifies the texture of medievalism's weave by noting the dependence of medievalia on the medievalist discourses that came before, making medievalism "a constantly evolving and self-referential process of defining an always fictional Middle Ages."[5] Emery's sense of medievalism as dependent on not just the historical Middle Ages and present concerns, but also on preceding manifestations of medievalism, deepens understanding of the contingencies Haydock emphasizes. Emery also underscores the importance of Clare Simmons' discussion of the etymology of this field's name, medievalism. Simmons demonstrates the degree to which the basic contingencies of "medieval" were originally located in a complex of nineteenth-century concerns,[6] thus shaping the various responses of subsequent manifestations. The different possible contingencies, the myriad imaginable responses, lead us to Shippey's suggestion that medievalism might be better thought of in the plural, as an array of types.[7] Umberto Eco made a similar suggestion twenty years ago, offering up his "Ten Little Middle Ages" as a framework for delineating the differences.[8]

Neomedievalism, the topic of this essay, falls within this pluralistic sense of medievalism(s). M. J. Toswell has proposed that neomedievalism is distinct from medievalism,[9] but I think that suggestion accepts a monolithic sense of medievalism over a sense of medievalism as a spectrum of overlapping versions.

If we maintain a sense of multiplicity, then neomedievalism is not separate from medievalism, but distinct from other, perhaps more traditional, types of it.[10] In the pages that follow, I will offer a synthesis of the recent discussions of neomedievalism and outline the tendencies that simultaneously relate it to and distinguish it from other types of medievalism, in particular postmodern medievalism. In short, neomedievalism is a self-conscious, ahistorical, non-nostalgic imagining or reuse of the historical Middle Ages that selectively appropriates iconic images, often from other medievalisms, to construct a presentist space that disrupts traditional depictions of the medieval. To further define the distinction between neomedievalism and other, more traditional forms, I would like to suggest that medievalisms are constructs by which individuals (sometimes collectively) articulate their own discursive selves. Therefore, a key difference between neomedievalism and romantic medievalism (for example) can be located in *how* such identification with the medieval is made.

The Tendencies of Neomedievalism

Several of the recent essays discussing neomedievalism comment that a definition is difficult to determine.[11] That difficulty lies in the fact that to look at the broad spectrum of texts identified as neomedievalia is to encounter a

wide variety of manifestations. It is a task akin to attempting to describe the Platonic Form of, say, "table-ness" by looking at all the tables in a furniture store – an impossible task, since the truest form is the abstract and ideal one. In other words, there can be no truly pure neomedieval text that evinces all the (strictly) neomedieval traits. If medievalism and its various types are contingent constructions and often draw on the categories of medievalism that came before, then any given example will likely be laced with the features of those other particular types or sources. It is for that reason that I prefer to think of each discretely labeled type of medievalism in relation to its tendencies: features that often appear together but that are separable. We might think in terms of various dialects of medievalism. Much like the identification of different dialects depends on seeing a cluster of recurring though variable features, so too might we think of types of medievalia as identified by the cluster of common traits.

Because of this fluid classification, the boundaries of neomedievalism blur with, in particular, postmodern medievalism (a model of which we might deduce from, among other places, *Studies in Medievalism* 13). Carol L. Robinson and Pamela Clements argue that neomedievalism is a "post-postmodern ideology of medievalism."[12] The double "post" suggests a relationship of tension in which neomedievalism follows but does not supersede the postmodern and its own approach to the medieval. The initial "post" suggests a sequence but does not absent the latter term. Neomedievalism, thus, employs the aesthetic strategies of its cousins, namely anachronism, pastiche, and bricolage.[13] Neomedievalia, however, employs these not in a spirit of deconstruction, but to constructive ends. As Lesley Coote notes, "*Neo* is not content with reduction and deconstruction only; although decentered and localized, it seeks positively to build up from what it happily accepts as having been broken down."[14] If, as Linda Hutcheon has observed, postmodernism features "on the one hand […] a sense that we can never get out from under the weight of a long tradition of visual and narrative representations, and on the other hand, [a loss of faith] in both the inexhaustibility and the power of those existing representations,"[15] then neomedievalism offers an alternative: a playful reimagining of the medieval that has no concern for a veracious relationship to the past. Coote emphasizes the way in which neomedievalism reconstructs the medieval world out of the bits and pieces resulting from the deconstructed past. Importantly for Coote and most of the other essayists on the topic, neomedieval reconstructions are made with a self-awareness of their constructedness and with no concern for accuracy or a real historical pastness. Here we encounter one of the blurry spots in which neomedievalism's distinctiveness from postmodern forms is uncertain. Hutcheon suggests that parody uses and abuses conventional representational strategies to "de-naturalize them."[16] Neomedieval

depictions at times verge towards parody but at other times, such as in the game *World of Warcraft*, seem to function as superficial, flat, historical images.[17]

Given the lack of concern over representing the "real" Middle Ages, the distinguishing facet of neomedievalia may be that it often features an image of a past that is divorced from any chronology, the image of an alternative past detached from history. To manufacture this "past," neomedievalism appropriates iconic images and/or ideas of the medieval as signifiers largely emptied of associations. The result is a simulacrum, such as described by Brent and Kevin Moberly and M. J. Toswell, marked by medieval features and reminiscent of the Middle Ages, but not aspiring to be medieval.[18] Rather, the neomedieval simulacrum self-consciously interests itself in present concerns, what Amy Kaufman notes is "its exceptional, sometimes insufferable presentism."[19] Brian Helgeland's *A Knight's Tale* exemplifies this relationship to the past. The opening shots of face-painted peasant fans clapping to music by Queen announces the generic associations to light-hearted sports films like *The Replacements* (which bears an uncanny resemblance to the tale of William Thatcher) and *The Bad News Bears*. As the commoner William Thatcher's rivalry with aristocratic Adhemar grows, Adhemar is sidelined by the real work of knights; he fights on the battle front, reading of William's tournament success from illuminated manuscripts that resemble the NCAA basketball tournament brackets found in newspaper sports pages. The film develops its concerns with class-consciousness further, with William buying the right kind of armor and using it to enhance his performance. The sort of market economics that color this story of social hierarchies remove its focus from an idealized medieval past and onto our own contemporary concerns.[20] While medievalism (and any type of adaptation) causes medieval texts or history to speak to modern concerns, it is the self-aware nature of *A Knight's Tale*, its soundtrack, sports iconography, and commercial nods (the invocation of Nike's swoosh on William's armor), that characterizes the neomedieval. The use of the past in neomedievalism thus spurns nostalgia in preference for a "new and improved alternate universe."[21]

That these simulacra are separated from "real" history and invested in present concerns facilitates the use of neomedievalia to support myriad possible interests. Most charged are the political and economic uses of Hedley Bull and (in the example given by Kaufman) Stephen J. Kobrin, who both "assimilate a particular set of 'medieval' tropes, refracted through medievalism, into the present, and thus read everything [...] as neomedieval."[22] Bruce Holsinger describes this form in *Neomedievalism, Neoconservatism, and the War on Terror*. Bull, Kobrin, and Holsinger's Bush administration share an understanding of the neomedieval as an irruption of (imagined) past forms into the present.[23] Neomedievalism's detachment of medieval images

from a sense of the "real," its emptying of those images, on the one hand permits neomedievalia to serve the interests of repressive or exploitative purposes such as described by Holsinger or the capitalistic use of the medieval described by the Moberly brothers; and on the other hand, that emptying enables neomedievalism to become the "anarchic" site in which the margins that Coote and E. L. Risden describe can speak back.[24] More innocuous in their imagining are the secondary worlds, such as that of *World of Warcraft*, that are constructed out of the iconic, condensed images of the "medieval." These examples from socio-economic theory, political discourse, and mass-market entertainment are distinguished by the degree to which their producers are aware of the constructedness of their particular sense of a neomedieval period. Each, however, is facilitated by the malleability inherent in neomedievalism's made-to-order essentializing. Neomedievalism is not prone to one or the other, but open to any.

To some extent, that malleability derives from the resources from which neomedievalizing derives the iconic images and ideals of the medieval. While the various signifiers of the original refer back to the Middle Ages, they do so through a long tradition of preceding representations of that past. As Risden notes, "Neo-medievalism does not so much contribute new matter to the growing body of creative and scholarly endeavor of medievalism as it borrows creatively from the old matter [...]."[25] Herein we find another blurred boundary with earlier medievalisms, given Emery's statement that medievalism is self-referential. We find this sort of self-referential movement with the "What's in your wallet?" Vikings from the widespread Capital One credit-card advertisements, who began their careers as the bloodthirsty, vicious caricatures all too common in depictions of Vikings. In their most recent manifestations, however, they have begun to holiday on tropical islands and go skiing with their goats. The result is the tendency of neomedievalism: a sort of parodic commentary on the very barbaric image with which the commercials began.[26] Neomedievalism becomes a sort of medievalism-ism in which earlier forms are unsettled or reshaped by these later uses.[27] Lauryn S. Mayer suggests that we understand neomedievalism as working with the "'matter' of the Middle Ages," with *matter* referring not just to artifacts of the medieval but all subsequent representations of it. The implications are that neomedievalism treats the historical artifacts on an equal footing with later representations of them so that its products become a bricolage. Neomedievalism, in this vein, re-creates medievalism as a self-conscious collage of earlier medievalisms.

Taking note of the collage-like nature of neomedievalism points us to one of the defining tendencies of the phenomenon: its similarity to the cut-and-paste mentality that shapes it. My word-processing-derived phrase – cut-and-paste – invokes a technological model for understanding the

compositional processes that structure neomedievalia. Most of the discussions of neomedievalism note the significant role played by technologies, such as films, computer-based games, and other digital forms. Digital technologies facilitate imaginings of the medieval that draw simultaneously on multiple moments in the thousand years or so from the "fall" of Rome to the Reformation. Several of the writers on the topic note that those same technologies make possible the collaborative nature of neomedieval constructions of a past, though Toswell observes that neomedievalism cannot be determined by the presence of technology.[28] And yet, Mayer's reference to "emergence" and artificial life suggests an integral link between neomedievalism and technology even when digital technologies are not directly involved. She notes that neomedievalism is a "complex text" formed from "the interaction of elements within the matter," just as artificial life can be seen as derived from an aggregation of small machines that "interact with one another nonlinearly in the support of life-like, global dynamics."[29] My interest here is not in her definition of neomedievalism but in the metaphor she uses to convey it, a metaphor akin to my own "cut-and-paste" above. Katherine Hayles has written extensively about the ways in which the posthuman is marked by, among other things, a reconceptualizing of human functions in terms of computer-based technologies. For example, Hayles refers to her own sense of having different functions with separate requirements that may be in competition or conflict with one another at a given moment, or she notes the cut-and-paste mode as it generalizes out from writing to other mental processes.[30] If the neomedieval produces a cut-and-paste version of the medieval, if it appears as an emergence aggregated from the matter of the medieval, then neomedievalism may be a posthuman treatment of the past. Digital technologies, then, may not define neomedievalia in terms of its media (as Toswell notes), but it may be an integral component to how it is conceptualized and produced.[31]

Neomedievalism and Identification with the Past

If neomedievalism is an ahistorical, cut-and-paste version of a past, then we are left to wonder: why look back to the Middle Ages at all? Other medievalisms (though not postmodern medievalism) incline towards nostalgia – a term coined in the seventeenth century to characterize a sort of homesickness and implying a sense of feeling alienated from some originary point and a yearning for return. Neomedievalism, indeed, often lacks that, instead tending towards the gross rewriting of the past to suit current predilections. The question of why we look back to the Middle Ages at all indicates the changing nature of historical desire that emerges in neomedievalism's tendencies towards presentism (as opposed to more

romantically formed medievalisms, which are marked by the alienated yearning). Kaufman has proposed that "what initially appears to be neomedievalism's denial of history may, instead, be a desire for history alongside an uncomfortable suspicion that there is no such thing." The iconic images and ideas of the Middle Ages, according to Kaufman, are part of a trauma response, "a way of ensuring against [the] loss"[32] that derives from the postmodern deconstruction of historical knowledge. Kaufman offers an explanation for the persistence of historical appropriation that is rooted in a changed relation to the past; no longer a romantic imagining of the return but an irremediable alienation from the past.

Kaufman's observations explain the continued draw of a time for which there *appears* to be no real historical attachment. If the producers and consumers of neomedievalia could care less for the historical Middle Ages, then why do they keep returning to them? Kaufman suggests a changed desire, a coping with the effects of postmodernism. Another possibility exists alongside this. Neomedievalism is the result of a shift in the way that producers and consumers of medievalia *identify* with the past of the historical Middle Ages. For Lacan, imaginary identification occurs when the individual gazes at the Other and forms an Ideal Ego to be emulated, whereas symbolic identification occurs when the individual views the self from the general view of the Ideal Ego or when the Other is internalized into a discursive self.[33] In what follows, I will use these terms loosely to describe the ways in which different types of medievalism identify with the historical Middle Ages. The implication is that the medieval functions as a component in subject formation through such identification, so that, nostalgic or not, medievalism remains an active part of (post)modern discursivity.

A 5 July 2010 *New York Times* article entitled "Is Jousting the Next Extreme Sport?"[34] provides a means of illustrating this idea with distinctive images of a romantic medievalism and neomedievalism. In the article Dashka Slater portrays rival schools of jousting, one a refined, European display of technique and skill, the other a rough-and-tumble American extreme sport. The extreme-sport types are perceived as a sort of renegade group of mounted thugs by the members of the International Jousting League, a Europe-based organization with a few active members in the States. Slater exemplifies the league with Jeffrey Hedgecock, who sees jousting as a part of history. "For Hedgecock," Slater writes, "it makes no sense to joust while ignoring the past. 'Without the history, you might as well do it on motorcycles,' he says. 'If we didn't have historical knights, we wouldn't have jousting.'"[35] This sentiment contrasts dramatically with that of the extreme jouster Charlie Andrews, who "doesn't joust because he's attracted to romantic notions of honor and chivalry or because he has an affinity for the medieval period. ('I don't know jack about history, nor do I

care,' he says.) He does it because he considers jousting one of the most extreme sports ever invented [...]."³⁶ Slater describes Andrews and a group of neo-knights who practice what they call "full contact jousting." Forgoing the European preference for eight-foot lances with three-foot balsa wood tips, these American practitioners use solid eleven-foot dowels. The result is greater force, more frequent falls, and increased injuries. The stars of the sport, Shane Adams and Andrews, hope for sponsorship and a full-fledged arena-series akin to the rise of Ultimate Fighting. They hope for sports stardom. As Slater records, "'If you've got money, I'm there to fight,' Adams told [a potential promoter]. 'I'm a prize jouster.'"³⁷

In more nostalgic medievalisms, identification occurs with the medieval in an imaginary form, an imitative relation to that past. Hedgecock's passion for history, for example, leads to his requiring participants in his annual Tournament of the Phoenix to be outfitted in accurate fifteenth-century attire – including the horses.³⁸ The clothes, armor, and cultural values of the medieval knight that are idealized in Hedgecock's adherence to The Past function as a sort of medieval Ideal Historical Ego to be re-created through imitation. Without that idealized past, for Hedgecock, jousting ceases to be anything at all – a detached, empty action, devoid of the romantic ethos of Chivalry apparent in the giving of favors by women and praise for nobility featured in a video on the tournament's website.³⁹ Here, Hedgecock and his brothers-in-arms demonstrate the imaginary type of identification. They look at the historic Middle Ages and translate the texts and images to produce the Other. Their participation in tournaments then attempts to re-create that Other, to bring it back into existence. Implicit in this process is that the present moment is somehow lacking, or why else would we need to joust? The mimesis and sense of deficiency account for the nostalgia that this form of medievalism features. Nostalgia is, after all, an idealizing of the past, and within this identification participants like Hedgecock project themselves into that ideal.

In a postmodern context, however, Hedgecock's jousts smack of a certain artificiality deriving from the constructedness of their activities. Andrews points to this notion in his response to accusations of pretend jousting: "'I'm not an actor,' Andrews says. 'I don't do this to play a knight.'"⁴⁰ The nostalgia is challenged on the basis of its tendency towards imagining what no longer exists. Where are, for example, the peasants on whose backs these pseudo-nobles enjoy their romantic endeavors, or where is Innocent II's condemnation of tournaments as opportunities, not for chivalric nobility, but of sin? In our postmodern world, the imitation inherent to the imaginative identification, ironically, emphasizes the incomplete picture. Hedgecock's jousting, a romantic form of medievalism, evinces something like what Lacan describes as "an alienated,

virtual unity."[41] complete in itself but necessarily aware of its being removed from the model.

Neomedievalism, on the other hand, relates to the medieval through something more like symbolic identification, finding a structuring principle that nevertheless stresses the irreparable gap between medieval and (post)modern. As discussed above, in neomedievalism the iconic images of the medieval are vacated of meaning, rendering them empty signifiers in which associations can be both displaced and condensed. As Ernesto Laclau observes, the empty signifier is symptomatic of a loss of distinction, of a rendering of difference into a chain of similarity;[42] thus, the medieval as empty signifier enables a removal of the distinction that separates the medieval from the modern, opening the medieval to the presentist tendency characteristic of neomedievalism. That loss of distinction yielding from the emptying of signifiers enables the Middle Ages to become a site of symbolic association – though limited by the discursive field in which that association occurs.[43] If the medieval begins to occupy that symbolic space, then the possible shift from an imaginary identification to a symbolic identification emerges. The distinction between this and imaginary identification is that the symbolic seeks to imitate the inimitable. As Slavoj Žižek observes, "we identify ourselves with the other precisely at a point at which he is inimitable, at the point which eludes resemblance,"[44] but that relationship structures behavior and beliefs.

Recognizing that we cannot "be" medieval and that any attempt to re-create the medieval amounts to play-acting a dream, producers and participants in this sort of medievalism assert an autonomous expression of the medieval that is contingent upon its own cultural context. In effect, within this identification producers and consumers introject the medieval as a symbolic signifier within their own cultural systems. The Lacanian sense of *introject* conveys the way in which the symbolic order is internalized by the individual in the process of subject formation, incorporated into the discursive self in a meaningful way. We see this in Adams and Andrews, who eschew the idealized images of Chivalry. Rather, in the symbolic mode (and to paraphrase Žižek), they identify themselves with the medieval "at the point at which it is inimitable."[45] Andrews "doesn't know jack about history" and refuses to "play knight." He and Adams do not try to be like knights; instead they do what knights did by jousting for "real," no balsa wood tips, no hokey rules about authentic clothes. To appropriate Žižek's words, Andrews does not need "an external point of identification because he has achieved identity within himself [...]"[46] In effect, then, neomedievalism does not reject historicity but recognizes the impossibility of reproducing it. Adams and Andrews do not attempt to re-create or reenact the historical Middle Ages, but instead to re-create their own modern selves by

introjecting part of the medieval into their own discursivity. Part of the result is the violated sense of historical accuracy we see in neomedievalism's ahistoricity.

The upshot and irony of this – and this is noted by Žižek in his discussion of the Woody Allen film *Play it Again Sam*[47] – is that the shift to the symbolic mode of identification results in its own sort of historical accuracy, where accuracy refers to a perceived correlation. Adams and Andrews live out what they know to be the fundamental similarity of their actions and those of medieval knights. Take, for example, Andrews' remark about being a "prize jouster." In medieval tournaments, prize-winning and ransom could enrich a winning knight and advance his social interests, as exemplified by William Marshal. Similar neomedieval examples can be found in *A Knight's Tale*, which makes the prize winnings a significant feature of tournaments. Moreover, the film abstracts the romance narratives about the proving of a knight, making the film truer to the medieval form than many other "romance" films, which feature essentialized clichés of love and nobility. This "accuracy" is structural, having to do with deeper motivations, not superficial images. *World of Warcraft* makes a similar abstracting of the quest-based narrative as a means of improving the questing figure, equating "leveling up" to that improvement; alternatively, the attachment of cash values to quests facilitates such improvement through purchasing power. I do not mean to suggest that neomedievalism somehow gets the Middle Ages "right," whatever that would mean; rather, neomedievalism, read in this loose relation to modes of identification, locates parallels to the medieval in our own practice, whereas more nostalgic medievalisms attempt to create those parallels. More importantly, in this light, neomedievalism demonstrates an attachment to the medieval distinct from nostalgia. It is not that neomedievalism does not find interest in historicity. It may just express its interest in historicity differently.

The Implications of Differential Medievalism

I would like to end where I began, with Tom Shippey's suggestion that we speak of medievalisms, in the plural. For me, the significance of his essay in *Studies in Medievalism* 17 rests not in that statement, since most scholars working – or even dabbling – in the field likely maintain a sense that there are different medievalisms. To my mind, what Shippey has opened is a course of research implied by the titles of *SiM* 17 and 18: defining medievalisms. If, as Shippey suggests and as Eco made us aware twenty years ago, there are many medievalisms, and if, as Shippey states, medievalism is "an enormous field, still largely unsurveyed."[48] then it seems our course is to follow Eco's lead and the example of those working in neomedievalism. Eco's

"Dreaming the Middle Ages" moved past observing that there are multiple medievalisms to attempt a taxonomy of them. Scholars like Robinson and Clements, as well as the rest who define neomedievalism, have undertaken a similar step: to identify one of the broad categories of medievalism by describing the tendencies that mark that particular version. Norman Cantor's monumental *Inventing the Middle Ages* and subsequent such studies, such as Gwendolyn Morgan's contribution to *SiM* 17, perhaps work towards another somewhat firmly defined type, what Morgan terms "Academic Medievalism."[49] That is, in fact, an area that has received substantial theorizing among historians in addition to Cantor, such as Gabrielle Spiegel in *The Past as Text*, Allen Frantzen in *Desire for Origins*, and a host of others.[50] Romantic medievalism, rooted in nineteenth-century reconstructions of the past that reach back to the romance traditions of medieval literature, seems a somewhat clearly defined category, too, with works like Elizabeth Fay's *Romantic Medievalism: History and the Romantic Literary Ideal.*[51]

The challenge for scholars working in medievalism, therefore, is to develop a series of categories that operate around some logical system. This, I think, is where Eco's little Middle Ages failed to find a foothold despite often being cited. His categories shift from particular types of imagining, such as "The Middle Ages as a *barbaric age*" to what we might term "modes" of addressing the medieval, such as "The Middle Ages as the site of an *ironical revisitation*," to more esoteric types, such as "The Middle Ages of the *philosophia perennis.*"[52] Each of these is accurate in its own idiosyncratic way, and each offers yet another facet of how the medieval persists, but Eco's particular list seems somewhat arbitrary and, perhaps more significantly, does not always give the impression that it is clear about the contingencies on which each of the little Middle Ages is based. In developing a system of categories, Haydock's key terms can provide a rough guide: on what does the type tend to be contingent and how does its use of the Middle Ages tend to define the alterities and continuities imagined between the medieval and the modern? We might add to that guide another potential component: the sort of identification with the medieval past to which the type tends. Speaking in terms of tendencies, however, becomes essential. Eco's ten types may be discretely defined but they also permit overlap, such as the way his "Middle Ages of *Decadentism*" includes mention of being "inserted into the project of nationalistic restoration" just following his sixth type: "The Middle Ages of *national identities.*"[53] To speak in terms of *tendencies* opens the possibility of deviation from a norm and admits the sort of overlap that occurs between types, such as the way postmodern medievalism and neomedievalism both utilize techniques of fragmentation while doing so to different ends, or the way in which a single figure or text might be situated within multiple

categories, such as with Isabel Divanna's recent work in *Reconstructing the Middle Ages: Gaston Paris and the Development of Nineteenth-Century Medievalism.*[54]

There are, no doubt, problems with such a proposal. For example, the categories of medievalism could likely proliferate to pointlessness with individual perceptions and preferences on the parts of both producers of medievalia and scholars of it. Such proliferation would negate the productivity of new terms, much like the peculiar moment of the Inkhorn Debate. To maintain an explicit awareness of how various examples of medievalism participate in some larger patterns and remain distinct from others is important. The last two years have introduced a concerted effort to theorize this field, to develop greater self-consciousness about what we mean by our key terms. The net result has been an awareness of the differential nature of medievalism, so, regardless of the problems, a next step becomes to define the distinctions.

NOTES

1. Tom Shippey, "Medievalisms and Why They Matter," *Studies in Medievalism* 17 (2009): 45–54 (45).
2. Nickolas Haydock, "Medievalism and Excluded Middles," *Studies in Medievalism* 18 (2009): 17–30 (19).
3. Risden notes in particular that the growing attention to J. K. Rowling's *Harry Potter* series seems to stretch the limits a little. E. L. Risden, "Medievalists, Medievalism, and Medievalismists: The Middle Ages, Protean Thinking, and the Opportunistic Teacher-Scholar," *Studies in Medievalism* 18 (2009): 44–54 (50).
4. Haydock, "Excluded Middles," 19.
5. Elizabeth Emery, "Medievalism and the Middle Ages," *Studies in Medievalism* 17 (2009): 77–85 (85).
6. Clare Simmons, "Medievalism: Its Linguistic History in Nineteenth-Century Britain," *Studies in Medievalism* 17 (2009): 28–35.
7. Shippey, "Medievalisms," 46.
8. Umberto Eco, "Dreaming the Middle Ages," in *Travels in Hyperreality*, trans. William Weaver (New York: Harcourt Brace Jovanovich, 1990), 61–72.
9. M. J. Toswell, "The Simulacrum of Neomedievalism," *Studies in Medievalism* 19 (2010): 44–57 (44).
10. Keeping a unified discipline of medievalism in which we recognize multiple categories is an important issue for a field that, as Kathleen Verduin's narrative of Leslie Workman's efforts reveals, has struggled to receive recognition (see Kathleen Verduin, "The Founding and the Founder: Medievalism and the Legacy of Leslie J. Workman," *Studies in Medievalism* 17 [2009]: 1–27).
11. See, for example, Carol L. Robinson and Pamela Clements, "Living with Neomedievalism," *Studies in Medievalism* 18 (2009): 55–75 (56); Cary Lowell

Grewell, "Neomedievalism: An Eleventh Little Middle Ages?" *Studies in Medievalism* 19 (2010): 34–43 (34–35); and Lauryn S. Mayer, "Dark Matters and Slippery Words: Grappling with Neomedievalism(s)," *Studies in Medievalism* 19 (2010): 68–76 (68).

12. Robinson and Clements, "Living with Neomedievalism," 61–62.

13. Robinson and Clements, "Living with Neomedievalism," 64.

14. Lesley Coote, "A Short Essay about Neomedievalism," *Studies in Medievalism* 19 (2010): 25–33 (26–27).

15. Linda Hutcheon, *The Politics of Postmodernism* (London: Routledge, 1989), 8.

16. Hutcheon, *Politics*, 8.

17. The blurriness is exacerbated if we consider films like *First Knight* (1995), which may refer to medieval sources but are only vaguely interested in what we might call "accuracy."

18. Brent Moberly and Kevin Moberly, "Neomedievalism, Hyperrealism, and Simulation," *Studies in Medievalism* 19 (2010): 12–24 (15–16); Toswell, "The Simulacrum," 45–46.

19. Amy S. Kaufman, "Medieval Unmoored," *Studies in Medievalism* 19 (2010): 1–11 (5).

20. Moberly and Moberly, "Neomedievalism, Hyperrealism, and Simulation," 18–19.

21. Robinson and Clements, "Living with Neomedievalism," 66.

22. Kaufman, "Medieval Unmoored," 7.

23. Bruce Holsinger, *Neomedievalism, Neoconservatism, and the War on Terror* (Chicago: Prickly Paradigm Press, 2007). See also Mayer, "Grappling with Neomedievalism(s)," 71–72; Hedley Bull, *The Anarchical Society: A Study of Order in World Politics* (New York: Columbia University Press, 1977), esp. 248–85; Stephen J. Kolbrin, "Back to the Future: Neomedievalism and the Postmodern Digital World Economy," *Journal of International Affairs*; 51.2 (1998): 361–86.

24. Coote, "A Short Essay," 29; E. L. Risden, "Sandworms, Bodices, and Undergrounds: The Transformative Mélange of Neomedievalism," *Studies in Medievalism* 19 (2010): 58–67 (64–65).

25. Risden, "The Transformative Mélange," 58–59.

26. See Kevin J. Harty's introduction to *The Vikings on Film* (Jefferson, N.C.: McFarland, 2011) for a more developed discussion of these commercials.

27. Mayer, "Grappling with Neomedievalism(s)," 69.

28. Toswell, "The Simulacrum of Neomedievalism," 44.

29. Mayer, "Grappling with Neomedievalism(s)," 72–73.

30. Katherine Hayles, *How We Became Posthuman* (Chicago: University of Chicago Press, 1999), 5–7.

31. Reading the neomedieval as a posthuman medievalism permits exploration of connections between studies of medievalism and the sort of work introduced by the BABEL working group in their initial issue of the journal *Postmedieval*, which examined the intersections between studies of posthumanism and medieval studies.

32. Kaufman, "Medieval Unmoored," 3.

33. Jacques Lacan, The Seminar: Book 1. *Freud's Papers on Technique, 1953–*

1954, ed. Jacques-Alain Miller, trans. J. Forrester (New York: W. W. Norton & Co., 1988), esp. 129–42.

34. Dashka Slater, "Is Jousting the Next Extreme Sport?" *The New York Times*, <http://www.nytimes.com/2010/07/11/magazine/11Jousting-t.html>, accessed 18 July 2010.

35. Slater, "Jousting," para. 36.

36. Slater, "Jousting," para. 10.

37. Slater, "Jousting," para. 47.

38. Slater, "Jousting," para. 35.

39. <http://worldjoust.com/>.

40. Slater, "Jousting," para. 26.

41. *The Ego in Freud's Theory and in the Technique of Psychoanalysis, 1954–1955*, ed. Jacques-Allain Miller, trans. Sylvanna Tomaselli (New York: Norton, 1991), 50.

42. Ernesto Laclau, "Why do Empty Signifiers Matter to Politics?" in *Jacques Lacan: Critical Evaluations in Cultural Theory*, ed. Slavoj Žižek (London: Routledge, 2003), 308.

43. Jeffrey Mehlmen discusses the way in which Levi-Strauss's theories posit that the "floating" or "empty" signifier is the means by which symbolic identification works. See Jeffrey Mehlmen, "The Floating Signifier: From Levi-Strauss to Lacan," *Yale French Studies* 48 (1972): 10–37 (23).

44. Slavoj Žižek, *The Sublime Object of Ideology* (New York: Verso, 1989), 109.

45. Žižek, *Sublime Object*, 109.

46. Žižek, *Sublime Object*, 110.

47. Žižek, *Sublime Object*, 109–110.

48. Shippey, "Medievalisms," 45–46.

49. Gwendolyn Morgan, "Medievalism, Authority and the Academy," *Studies in Medievalism* 17 (2009): 55–67 (64).

50. Gabrielle M. Spiegel, *The Past as Text: The Theory and Practice of Medieval Historiography* (Baltimore, MD: Johns Hopkins University Press, 1997), and Allen J. Frantzen, *Desire for Origins: New Language, Old English, and Teaching the Tradition* (Piseataway, NJ: Rutgers University Press, 1990).

51. Elizabeth Fay, *Romantic Medievalism: History and the Romantic Literary Ideal* (New York: Palgrave, 2002).

52. Eco, "Dreaming the Middle Ages," 69–70.

53. Eco, "Dreaming the Middle Ages," 70.

54. Isabel Divanna, *Reconstructing the Middle Ages: Gaston Paris and the Development of Nineteenth-Century Medievalism* (Cambridge, Eng.: Cambridge Scholars Publishing, 2008).

Medieval Resurfacings, Old and New

Nils Holger Petersen

The purpose of this essay is to respond to recent attempts to define the notion of neomedievalism as distinct from (more traditional) medievalism. In the following I shall try to raise questions concerning categories of medievalism and concerning the general historiography of the Middle Ages.

To begin with, I shall reconsider the well-known definition (or characterization) of medievalism given by Leslie Workman, focusing in particular on a specific formulation to which several authors in the discussions published in volumes of *Studies in Medievalism* during the last few years have referred. In its briefest form, Workman's definition states that "Medievalism is the continuing process of creating the Middle Ages."[1] A brief discussion of this idea is also found in Workman's essay "The Future of Medievalism":

> medieval historiography, the study of the successive recreation of the Middle Ages by different generations, *is* the Middle Ages. And this of course is medievalism.[2]

Since Workman considers scholarly studies and "uses" of the Middle Ages (the latter including artistry as well as social reform) to be "two sides of the same coin,"[3] his understanding clearly emphasizes the intimate connection between historical scholarship and "creative" (artistic) approaches to the Middle Ages. And, as cited by Carol L. Robinson and Pamela Clements and emphasized by Elizabeth Emery, the statement makes it clear that his notion of the Middle Ages refers to something that changes with the investigating (and interpretative) eye and that a certain circularity is therefore involved in the process.[4] Scholars as well as artists aiming to recreate the Middle Ages give rise to a process that in itself is deemed to constitute the Middle Ages and medievalism. This would seem to establish (or refer to) a hermeneutical circle of the traditional kind in which a pre-understanding and some intellectual (or artistic) process leads to a renewed understanding, a new version,

as it were, of (a part of) the Middle Ages. In Workman's account, there is seemingly no well-defined object for these intellectual or artistic attempts, for as he points out in this context, "The Middle Ages quite simply has no objective correlative."[5]

In Workman's construction, there seems to be a certain pre-understanding of the notion of the "Middle Ages" at work, one that the scholar as well as the artist may have before his or her imagination as a point of departure. This may be related to or associated with certain more specific phenomena, events, texts, images, and ideas that can then be studied and approached so as to thereby modify the previous notion of the Middle Ages. As just pointed out, Workman's statement makes it clear that what is individually – or collectively – added is not an approximation to any kind of "real," "objective" Middle Ages, but constitutes – in any of the realizations that are brought out, as well as in the process of bringing it out – what the Middle Ages can be said to be. The Middle Ages cannot be separated from our interpretations of it; "we make the past. It is in our hands."[6]

Thus, in Workman's interpretation, the Middle Ages as a notion is fundamentally a reception historical phenomenon, a notion that is as much a fantasy as it is a scholarly object of inquiry.

One might ask, is this different from any other attempt at subsuming large historical periods under a name or a summarizing understanding? In a sense it is not, of course. Every attempt to make sweeping generalizations or characterizations of large historical phenomena or periods is bound to be subjective and thus to contain strong elements of imagination. On the other hand, the general historiography of the notion of the Middle Ages shows this idea, however vague it has been and is, to have had a considerable impact during the last couple of hundred years, probably beyond any other historiographic notion, including its closest competitors, Antiquity and the Renaissance.

It is a commonplace that after medievalism's negative connotations during the Early Modern period, Romantic artists and intellectuals from around 1800 reconsidered the Middle Ages as a poetically intriguing repository for the human imagination and the depths of human emotions. The Middle Ages then stimulated vast amounts of creative work in the arts as well as intellectual scholarly investigations (which were not *always* less creative) that have contributed to contemporary notions of the Middle Ages. Therefore, although the basic conditions for scholarly and creative responses to other historical periods or "ages" in principle would be similar to those concerning the Middle Ages, the consequences are more far-reaching in the latter case, not least because of the huge amount of artistic and popular responses to that era.

How then to characterize and categorize different types of studies and

"uses" of the Middle Ages with regard to the notion of medievalism? Workman's cited understanding does not emphasize the differences between scholarly and creative (artistic) approaches to the Middle Ages. In this respect, his attitude is similar to Hayden White's focus on the importance of rhetorical means in historiography. It may therefore be relevant to take a look at the most "scientific" type of approach to the Middle Ages: philology in a broad sense, including the strict philological editing of medieval texts but also the fairly equivalent musicological work of transcribing, analyzing, and editing musical notation from medieval manuscripts and, in another change of discipline, the uncovering and purely descriptive analyses of medieval archeological materials.

In this context, treatises, letters, various kinds of manuscripts, images, or material remnants from the period traditionally identified as the Middle Ages (varying, of course, from one historian to another) are not primarily considered as "medieval" but simply as texts or sources from the past. The notion of the Middle Ages may here be a convenient designation for a particular chronological period, as in claiming that such a periodization fundamentally makes sense for concrete historical reasons that may revolve around, say, the stability of known societal structures during that particular period. This "philological" kind of medieval scholarship then seems to build on a minimum of subjective pre-understanding of what the Middle Ages "looked like" or "was like."

Such a scenario poses questions to claims concerning the necessity of subjective creativity in historical scholarship. But such scholarship does not contribute very much to a creative notion of what the Middle Ages "were like" before the building blocks that these branches of scholarship contribute – the individual texts or remnants – are used in interpretative approaches to characterize the broader notion of the Middle Ages or parts thereof. Once that happens, such scholarship will inform visions of the Middle Ages that strive to be authentic, based on "real" knowledge, that attempt to appear to be convincing representations of something that actually was. At this point, an element of creative fantasy has become an intrinsic part of the scholarly construction.

In other words, serious or responsible scholarly (historical) work, whether to a smaller or larger degree based on interpretative interactions with the materials in question, will lend itself to the "authentic" kind of medievalism that is often found in such famous attempts at characterizing the Middle Ages (or important parts thereof) as Richard W. Southern's *The Making of the Middle Ages* (1953), Norman F. Cantor's *The Civilization of the Middle Age* (1993), or Jacques Le Goff's *The Birth of Europe* (2005; original French: *L'Europe est-elle née au moyen âge?* 2003) and other works of the Annales School, none of which claim to tell us everything about the Middle

Ages but clearly want to convey important impressions of what basically constituted the Middle Ages.

Scholarly meticulousness may also underlie many creative (artistic) productions in the sense that they combine creative work with accepted knowledge, in that the artist(s) involved strive to arrive at a construction that may be fictitious but does not contradict known relevant historical circumstances. An example of this is Barry Unsworth's novel *Morality Play* (1995), which daringly constructs a narrative about the birth of the "artist" but is clearly based on thorough historical knowledge concerning players and their social contexts in fourteenth-century England.[7]

Although such works of art – novels, films, and other narrative genres – may risk becoming outdated or at least lose their conviction with the arrival of new knowledge, they clearly belong to the historically pretentious kind of medievalism that is seen by many as the main contrast to neomedievalism. The neomedievalism described by Robinson and Clements is blatantly and consciously inauthentic:

> While it may have only developed in recent times, neomedievalism plays "a part as an element in the construction or recreation of the Middle Ages" that is anti-historical; it does not define when the Middle Ages ended (or began); it simply moves it off the timeline entirely, a phenomenon of distortion that steps outside of historical consciousness but also changes the very nature of that consciousness, thereby restricting medievalism to historical consciousness by default.[8]

Brent and Kevin Moberly similarly argue that:

> Neomedieval works, in this sense, do not simply seek to describe, reproduce, or otherwise recover the medieval, but instead employ contemporary techniques and technologies to simulate the medieval – that is, to produce a version of the medieval that is more medieval than the medieval […].[9]

To what extent is it possible to establish a clear delimitation between the historical endeavors in medievalism, whether in scholarship or in creative practices, and other kinds of "uses" of medieval artifacts or narrative components? Contemporary so-called "classical" avant-garde music provides examples defying such a distinction. I shall briefly comment on George Crumb's *Black Angels: Thirteen Images from the Dark Land for Electric String Quartet* (1970). This is a piece of music that – like many of Crumb's works – employs quotations of music in different historical styles integrated into

Crumb's very own personal musical style. Crumb's music has been inter-preted as part of a trend of "neo-mythologism in music,"[10] and the piece clearly does not attempt to recreate a historical period, style, or atmosphere.

In a recent article about Crumb's *Black Angels*, I argue that Crumb, although not trying to be historical in the sense of striving toward some authentic representation of any historical music, composes his music in a historically (as well as geographically) conceived sound universe.[11] This is brought out partly by his use of musical quotations (in many styles) as well as by textual allusions in the score. In *Black Angels*, the medieval sequence *Dies irae* appears side by side with striking modernistic sounds and a Schubert quotation, played as if by a Renaissance consort of viols. At the same time, Crumb explores the possibilities of his instruments to the extreme, creating sharp contrasts and a musical universe where many things are recognizable but where the total impression of the music is novel to a very high extent. Also in terms of musical form, Crumb appropriates well-known elements and structures that establish an overall musical narra-tive of redemption and correspond well to the medieval element but are also interrupted and contextualized by elements from non-Christian religious contexts.

All in all, it would seem to make sense to understand Crumb's work as a neomedievalist piece of music because of the lack of interest in building up a historical authenticity. However, the form and mythological pretension of the work are of a kind that does not seem to match general claims made about neomedievalism in the recent debates. Nor are the Middle Ages the focal point of the piece; the "medieval" is part of the historical heritage just as many other past periods, but Crumb is in no way particularly focused on the Middle Ages.

Here follows a sample of recent typical statements about neo-medievalism as points of reference for the following comments on Crumb's piece, some of which may well suit it whereas others do not:

In particular, neomedievalism is further independent, further detached, and thus consciously, purposefully, and perhaps even laughingly reshaping itself into an alternate universe of medievalisms, a fantasy of medievalisms, a meta-medievalism.[12]

As stated above, it is the blatantly inauthentic in which we are currently most interested: the overtly, even celebrated, "new and improved" alternate universe that we call neomedievalism.[13]

The difference between the two terms as they are used in the English-speaking world is that medievalism implies a genuine link

– sometimes direct, sometimes somewhat indirect – to the Middle Ages, whereas neomedievalism invokes a simulacrum of the medieval.[14]

neomedievalism, as Robinson and Clements define it, is entirely fantastical in its creation of alternate universes from quasi-medieval contexts and tropes and utterly unmoored from "responsible philological examination" in its "anti-historical" nature.[15]

Neo is not content with reduction and deconstruction only; although decentered and localized, it seeks positively to build up from what it happily accepts as having been broken down.[16]

Neomedievalism is not as interested in creating or recreating the Middle Ages as it is in assimilating and consuming it.[17]

Whereas Crumb's music in its appropriation of the medieval (as well as other historical) components is not trying to recreate a particular historical atmosphere it would also be wrong to describe it as inauthentic. On the contrary, in a certain way Crumb's music is importantly authentic in its appropriation of historical elements. Like other late-twentieth-century composers (such as Alfred Schnittke and Peter Maxwell Davies[18]), Crumb seems to highlight certain parts of the classical musical heritage that appear as important to him in the particular context. This means that the musical quotations carry positive connotations and are used to contribute to a complex construction of meaning by way of composing a musical form in a universe based on historical as well as new sounds.

It seems that the notion of neomedievalism could well be supplemented with other kinds of neo- or just medievalisms[19] in the direction of the historical attitude in Crumb's work. Conversely, one might be inclined to refrain from the complexity of a variety of sharply defined notions and, rather, opt for Workman's inclusive understanding of medievalism as that which continues to construct the Middle Ages in some sense, including partial constructions such as Crumb's piece.

Black Angels does not recreate the Middle Ages as such, but it does "use" the Middle Ages, or a small part of it, with a particular musical purpose. The *Dies irae*, the sequence from the medieval Requiem mass, stands as one element, a musical building block in the overall construction of a form in which it evokes the fear of "condemnation." Condemnation should here undoubtedly be taken in a generalized, certainly not dogmatic sense. In the overall shape of the piece, this element is placed in a form that has the shape of comedy, as derived from a traditional Christian shape of history (cf.

Dante's *Commedia*) so that the ultimate musical conclusion of the piece is one of hope, of – musical – redemption, a musical construction of meaning in which the medieval *Dies irae* has a role to play. Thus a particular musico-religious part of the Middle Ages is being "recreated" with respect to an overall construction of meaning related to an overall understanding of the Middle Ages, but not with the purpose of recreating this medieval world in its own right.[20]

NOTES

1. For Workman's definition, see his Preface to *Studies in Medievalism* 8 (1996) and Kathleen Verduin, "The Founding and the Founder: Medievalism and the Legacy of Leslie J. Workman," *Studies in Medievalism* 17 (2009): 1–27 (20), and also Carol L. Robinson and Pamela Clements, "Living with Neomedievalism," *Studies in Medievalism* 18 (2010): 78–107 (85). See further the debate about the notion of medievalism and neomedievalism in *Studies in Medievalism* 17 (2009), *Studies in Medievalism* 18 (2009), and *Studies in Medievalism* 19 (2010).

2. Leslie J. Workman, "The Future of Medievalism," *Medievalism: The Year's Work for 1995* 10 (1999): 7–18 (12). See also Verduin, "The Founding and the Founder," 20, as well as the discussions of this statement in Elizabeth Emery, "Medievalism and the Middle Ages," *Studies in Medievalism* 17 (2009): 77–85 (see esp. 78–79, 81, and 85), and Nils Holger Petersen, "Medievalism and Medieval Reception: A Terminological Question," *Studies in Medievalism* 17 (2009): 36–44 (36–37).

3. Workman, "The Future of Medievalism," 12.

4. Elizabeth Emery, "Medievalism and the Middle Ages," 79, and see also Robinson and Clements, "Living with Neomedievalism," 65–66.

5. Workman, "The Future of Medievalism," 11.

6. Workman, "The Future of Medievalism," 12.

7. Barry Unsworth, *Morality Play* (London: Penguin Books, 1995); see also Nils Holger Petersen, "Introduction: Transformations of Christian Traditions and their Representation in the Arts, 1000–2000," in *Signs of Change: Transformations of Christian Traditions and their Representation in the Arts, 1000–2000*, ed. Nils Holger Petersen, Claus Clüver, and Nicolas Bel (Amsterdam: Rodopi, 2004), 1–23 (8–9).

8. Robinson and Clements, "Living with Neomedievalism," 65.

9. Brent Moberly and Kevin Moberly, "Neomedievalism, Hyperrealism, and Simulation," *Studies in Medievalism* 19 (2010): 12–24 (15).

10. Victoria Adamenko, *Neo-Mythologism in Music: From Scriabin and Schoenberg to Schnittke and Crumb* (Hillsdale, NY: Pendragon Press, 2007), esp. 194–200.

11. Nils Holger Petersen, "Quotation and Framing: Re-contextualization and Intertextuality as Newness in George Crumb's *Black Angels*," *Contemporary Music Review* 29 (2010): 309–21.

12. Robinson and Clements, "Living with Neomedievalism," 56.

13. Robinson and Clements, "Living with Neomedievalism," 66.

14. M. J. Toswell, "The Simulacrum of Neomedievalism," *Studies in Medievalism* 19 (2010): 44–57 (44).

15. Cory Lowell Grewell, "Neomedievalism: An Eleventh Little Middle Ages?" *Studies in Medievalism* 19 (2010): 34–43 (36).

16. Lesley Coote, "A Short Essay about Neo-Medievalism," *Studies in Medievalism* 19 (2010): 25–33 (26–27).

17. Amy S. Kaufman, "Medieval Unmoored," *Studies in Medievalism* 19 (2010): 1–11 (5).

18. And I also consider my own *A Vigil for Thomas Becket* to be similar in this respect. See Nils Holger Petersen, "'In Rama sonat gemitus …' The Becket Story in a Danish Medievalist Music Drama, *A Vigil for Thomas Becket*," in *Medievalism in the Modern World: Essays in Honour of Leslie Workman*, ed. Richard Utz and Tom Shippey (Turnhout: Brepols, 1998), 341–358.

19. Cf. Grewell, "Neomedievalism: An Eleventh Little Middle Ages?" 35–36.

20. For a detailed discussion of this, see my aforementioned article (see above, n. 11).

Quentin Durward and Louis XI: Sir Walter Scott as Historian

Mark B. Spencer

Discussion of Sir Walter Scott's work as a historian recreating the past in his novels has long been a staple of Scott scholarship, but it usually focuses on his treatment of large historical themes, such as the transition from agrarian feudalism to the modern industrial state, as argued by Georg Lukács in his seminal study of the historical novel.[1] Critics have also frequently claimed that the novels set in the relatively recent past of his native Scotland are generally stronger than the medieval tales, and Ian Duncan has recently focused on these to argue that they constitute a major moment in the transformation of historical and fictional consciousness in Scotland during the later Enlightenment and Romantic era.[2] But surely *Quentin Durward* (1823) can be counted among Scott's most popular and influential works, for along with *Ivanhoe* (1819) its characteristic blend of history and romance set the mold for historical novels of medieval and early modern Europe for a century. J. H. Alexander and Judith Wilt have attempted to situate both *Quentin Durward* and *Anne of Geierstein* in the context of major historical developments in fifteenth-century France and the spectacular dynastic complex of territories assembled by the dukes of Burgundy, especially the transition from feudalism to the modern state.[3] However, this paper will take a different approach, more along the lines of a later medieval historian than a Romantic literature scholar, to suggest that the enduring heart of Scott's historical achievement in *Quentin Durward* lies not in these broader literary and historical perspectives, but first and foremost in his brilliant character study of King Louis XI of France (1461–83).

The story of young Quentin's adventures on the Continent in search of knightly honor and fortune is tightly interwoven with the most dramatic moments of high politics in the life-and-death struggle between Louis XI and his great vassal Duke Charles the Bold of Burgundy, culminating in

their famous interview at Péronne in 1468. The depiction of these events is firmly grounded in both primary and secondary historical accounts, above all the celebrated *Mémoires* of Philippe de Commynes. Beginning his career as an intimate advisor of Charles the Bold, Commynes switched sides a few years after the Péronne interview to assume an even closer association with Louis XI, and thus his memoirs provide an unparalleled *entrée* into both sides of their epic quarrel. Scott took full advantage of this golden opportunity, especially in his recreation of the fascinating and enigmatic character of the French king, and it is on this ground that his abilities as a historian can be most appropriately assessed.

The romance plot in *Quentin Durward* has been thoroughly analyzed by recent critics and need not be addressed here.[4] As the novel progresses the "little love intrigue" of the hero gradually gives way to the dramatic confrontation of Louis XI and Charles the Bold, until the ratio of history to romance becomes completely reversed from their original proportions. Indeed, the king of France all but eclipses Quentin as the central figure for the last third of the novel, and Quentin disappears from view entirely for several chapters at a stretch. The treatment of Charles the Bold is much less interesting and convincing, but Louis XI is a masterpiece of imaginative historical reconstruction from the surviving narrative sources. Even more striking is the extent to which Scott's characterization of the king anticipates the current consensus among professional historians, represented above all in the reigning narrative biography by Paul Kendall,[5] which is easily the most widely read and influential book on Louis XI today, both in English and the very well received French translation.[6] Kendall dismisses Scott's portrait as "a sinister gargoyle lit by the lurid flames of the declining Middle Ages," but perhaps the biographer "protests too much."[7] Almost all the essential elements that Kendall brilliantly elaborates and fleshes out are first captured and reproduced by Scott in his novel.

Louis XI's reputation has fluctuated considerably over the last five centuries, and a brief discussion forms the best way of introducing Scott's portrayal of the king. Widely feared and hated at his death, much of his regime was overturned at the Estates General of 1484, which established the regency for his son Charles VIII (depicted as a young boy in *Quentin Durward*, but not born until 1470). Several of the dead king's henchmen, including Olivier Le Dain, were hanged; his excruciatingly burdensome taxes were rolled back; and the huge standing army drastically diminished. The image of Louis XI as a remorseless tyrant endured unchallenged for more than a century, generating a wealth of scandalous anecdotes about his cruelty and perversity in such authors as Claude Seyssel and Pierre de Bourdeilles, seigneur de Brantôme, which Scott freely incorporates in *Quentin Durward*.[8] During the heyday of French royal absolutism in the

seventeenth century, however, Louis came to be widely admired as a master politician comparable to Richelieu or the Roman emperor Tiberius. His philosophy of rule was supposedly summed up by the apocryphal motto "he who does not know how to dissemble, does not know how to reign" ("qui nescit dissimulare, nescit regnare").[9] Voltaire was largely responsible for setting the pendulum back in the opposite direction, discounting Commynes as an obsequious courtier whose testimony is thoroughly vitiated by his betrayal of Charles the Bold. By Scott's time the king's "black legend" was once again in full flower, and spurred by the portraits of both Scott and Victor Hugo in his *Notre Dame de Paris* (1831), it endured for many decades. Towards the end of the nineteenth century, the products of modern archival research, especially the publication of Louis XI's letters in ten volumes and the dispatches of northern Europe's first regular ambassadors stationed at the French court by Duke Francesco Sforza of Milan, began to reveal a much more complex and many-sided figure.[10] A second rehabilitation was soon underway, inspired in part by surging French nationalism, and Louis XI became celebrated as "the founder of modern France."[11]

Above all, it was the personal character of the king that received a new face, as one by one the constituent elements of the black legend were stripped away. Some were exposed as mere rumors or popular fictions, such as the alleged poisoning of Louis' younger brother Charles, while others, including Brantôme's anecdotes of the cruelty of the king's hangmen, were explained away as merely typical of the times. The apogee of this process was reached in Kendall's masterful narrative biography, brilliantly written in a popular style but steeped in exhaustive research, where Louis XI becomes an entirely sympathetic, almost lovable, and marvelously larger-than-life figure: "a man of extraordinary powers wrapped in a personality so agile and various as to encompass the range of a dozen ordinary temperaments." Kendall enthuses over "the sheer exuberance of the man, the ability to charm, the bottomless curiosity, the capacity for loyalty." Louis could often be devious, but the smoke screens of dissimulation concealed "an astonishing plainness" and a simple heart that was easily shaken and wounded. The king had more than a mere sense of humor: "he was a connoisseur of irony, an indomitable actor, a comedian on a grand scale." He was certainly not without faults, however, as

> he had to overcome serious disabilities of temperament. He some-
> times fell prey to suspicions that obscured his vision. He chose to
> work by persuasion; yet he was ugly, thick-tongued, and careless of
> dignity. He often talked too much, and indiscreetly. He spun a
> web of policy that covered all Europe, but insisted on "doing
> everything out of his own head." He could not conceal from the

feudal nobles he needed to conciliate his scorn of their archaic atti-
tudes; and he intensified their alarms by flouting in dress and
manner and thought the conventions of an age committed to
convention. Restless to the marrow, he picked away at his own
achievement; and when his sense of comedy got the better of him,
he indulged in rascally exploits that endangered the profound
labors of his life.[12]

According to Kendall, if Louis XI "sometimes betrayed himself, he never
betrayed the people of France," for he transformed the realm into a national
monarchy, and the solidly wrought state that he left to his successors would
endure "essentially unchanged" until the French Revolution.[13]

Among contemporary French historians the only slightly less enthusi-
astic view put forward by Pierre-Roger Gaussin in his thorough analytical
study of the reign is perhaps more typical. The king still has some lingering
character flaws of the black-legend variety, most notably his "brutal
impulses, his taste for vengeance, a certain cruelty, a superstitious piety"
("impulsions brutales, son goût de la vengeance, une certain cruauté, une
devotion superstitieuse"), but these are largely written off as medieval
vestiges while the predominantly modern side of this king "between two
worlds" ("entre deux mondes") can be found in the march towards a benefi-
cent absolutism. As Louis XI admitted in his last will and testament, his
regime may have been troubled by great disturbances, treasons, conspiracies,
wars, effusions of blood, destruction, and desolation, but nevertheless he left
his kingdom solidly "maintained, defended and governed, augmented and
enlarged" ("maintenu, défendu et gouverné, augmenté et accru") and above
all "restored to peace, tranquility and union" ("mis en paix, tranquillité et
union").[14] The most recent study by Jacques Heers takes issue with this
simplistic medieval/modern dichotomy, but his overall assessment of Louis
XI's achievement remains essentially the same as Gaussin's. Indeed, Heers
would add another new praiseworthy dimension to the king's reputation,
namely as a man of letters in his own modest way and something of a
Maecenas to other writers and scholars, along the lines of Lorenzo de
Medici, Alfonso V of Aragon, and Matthias Corvinus of Hungary.[15] It seems
safe to say that the reputation of Louis XI has never been higher.

The great virtue of Scott's portrayal of the king is that he captures both
the devilish Machiavellian of the black legend and something of this later,
more complex reappraisal. As Susan Manning noted, Scott considerably
blackened his picture of Louis XI for the second Magnum edition of 1831,
especially in the new introduction where blanket assertions on the king's
total moral depravity are piled on relentlessly. Manning believes this reflects
Scott's growing pessimism and darker political vision in his later years,[16] but

perhaps he was simply afraid that he had made Louis XI too attractive. Despite his faithless scheming and the insouciance with which he sends Isabelle and Quentin to their harsh fate, or plots the murder of his astrologer in his cell at Péronne, Louis XI remains a deeply engaging figure, and Scott anticipates much of the attraction that Kendall exhibits towards his subject. It is as if Scott was torn between his sources. On the one hand, his learned authorities were sharply critical, particularly Nathaniel Wraxall, whose *History of France under the Kings of the Race of Valois* (1807) undergirds much of the 1831 introduction.[17] On the other hand Commynes, despite enumerating Louis' many eccentricities and petty cruelties, still calls him "wiser, more liberal, and more virtuous in all things than the other princes who ruled with him and in his time."[18]

Until recently historians generally awarded Commynes the faith that Scott invests in him, but the fact that he wrote his memoirs some twenty years after the events described, along with his ultimate desertion of Charles the Bold to take service with the king, means that his testimony must be regarded with a degree of healthy suspicion, whether in regard to the importance of the role he played personally at Péronne or to the character and behavior of the Burgundian duke. Labeling Commynes a traitor, however, and dismissing his memoirs as a thoroughly mendacious effort to exculpate his treachery, as Jean Dufournet and other scholars have done, is going much too far and reflects a rather anachronistic view of fifteenth-century politics.[19] There was no way for Scott to know these doubts, so his reliance on Commynes can hardly be faulted. Scott even takes considerable pains to bolster Commynes' veracity in *Quentin Durward*, including the highly improbable claim that he refused the gold that Louis was so liberally spreading around among Charles' other counselors.

As suggested by Dufournet, Commynes' standards of integrity and wisdom were pretty flexible, if not quite traitorous. Older critics used to think of him as a secular figure anticipating the Renaissance in northern Europe,[20] but in fact there is a huge amount of religious moralizing in the *Mémoires*. Ultimately, it appears that Commynes worshipped primarily at the shrine of success. Whoever wins in the end must have had God on his side all along, while the losers correspondingly transgressed and forfeited divine favor. Much in Commynes' account of events is determined by an effort to reconcile this hidden will of God with the world of contradictory appearances. The biggest winner of all, of course, was Louis XI, and the same wily and underhanded political maneuvers condemned by other contemporary chroniclers as treachery and faithlessness constitute for Commynes a kind of practical and shrewd wisdom (*saigesse*), that is demonstrably more efficacious, and thus more virtuous, than the bankrupt ideals of an outmoded chivalry.[21] Obviously, here lies the kernel of the larger

historical lesson that Scott draws from the feudal confrontation between the king of France and the duke of Burgundy, but however much Commynes may have led Scott astray with his own one-dimensional depiction of Charles the Bold's character, on Louis XI he remains convincing.

Especially striking in *Quentin Durward* is the way Scott catches the "sheer exuberance" of the French king as celebrated by Kendall. Louis XI is easily the most exciting and alive figure in the novel, his restless mind always churning, and his brilliantly mercurial character makes Quentin, however admirable and sincere, look rather dull and wooden in comparison. Scott himself identified Louis as "the principal character of the romance" in the 1831 introduction, and from the king's first appearance in the story disguised as a silk merchant of Tours, he dominates the action, even when out of sight. This disguise serves as a perfect vehicle to introduce the king's notoriously unregal appearance and demeanor. Judging by his clothes, Quentin cannot decide whether the man before him is either "very rich or very poor," although he suspects the former. Louis had already shrewdly tested Quentin's mettle by letting him attempt a dangerous river ford without offering fair warning. He then assuages the young man's fury by treating him to a free meal at the local inn, which likewise provides the king a handy opportunity to sound the stranger's intentions, ever alert as Louis was to spies and other conspiratorial agents. The king's stealthy and adroit methods are also well illustrated by the audience with the Burgundian ambassador Crèvecœur, where he precisely calibrates just how far he can humiliate Burgundy while simultaneously goading the ambassador to greater effrontery, which eggs on the indignation of his own court and allows the king to exhibit a cool restraining hand.

The conference of Louis with Olivier le Dain on what they should do about the Countess Isabelle is a small masterpiece of cold-blooded duplicity, as the king schemes to have William De la Marck abduct Isabelle for himself while *en route* to her supposed refuge with the bishop of Liège. Neither the rough treatment the tender countess will doubtless receive from the Wild Boar of the Ardennes, nor the fact that Quentin will most likely be killed in the course of the action, bothers the king in the slightest, and Louis and his barber actually joke about it. The familiarity that Olivier assumes with his master, insinuating himself as a possible husband for Isabelle and gently mocking the king's superstitious reliance on St. Julian when he is rebuffed, underlines the peculiar cronyism of Louis XI with his mostly low-born favorites, so completely beneath contemporary expectations of royal dignity but abundantly attested by the chroniclers. The fact that Louis' plan is ultimately thwarted by Quentin does little or nothing to reduce the king's stature, and actually makes him a rather more endearing figure in a strange way. After all, the reader knows this is a romance and the ostensible hero will

come to no real harm, so the principal effect is to defang Louis XI a little and make him appear less sinister.

Although there are some exciting scenes on the way to Liège and during the uprising there, the climax of the novel is the interview at Péronne in October 1468, where the two lovers largely drop from sight. Up to this point most of the action has been fictional, centering on Quentin and his endeavors, although thoroughly plausible as the sort of activities the king might be routinely engaged in, such as going about in disguise, receiving ambassadors, hunting, scheming with his counselors, and so on. The characters and events at Liège are more of a mix, combining nearly equal measures of fictional, historical, and anachronistic material, such as the storming of the bishop's castle and his subsequent murder by De la Marck, which occurred a decade later in 1483, as Scott points out in his notes. Once the scene moves to the Burgundian court at Péronne, however, historical events form the principal basis of the action throughout the rest of the novel, albeit with considerable fictional embroidery, and most are lifted straight out of Commynes' memoirs. Even the false herald scene is actually Scott's imaginative elaboration of an anecdote Commynes tells about Louis sending a fake herald to Edward IV, since the French king never maintained such useless chivalric flummeries in his entourage.[22]

Before describing the interview, Commynes expresses at length with numerous examples his disapproval of two princes ever meeting in person, unless they are very young and bent only on pleasure, since the opportunity for misunderstandings to arise is so great, and "war between two princes is easily begun, but very hard to be composed."[23] The murder of Louis d'Orléans by agents of Duke John the Fearless of Burgundy in 1407 and the subsequent revenge killing of John by the followers of Charles VII on a bridge at Montereau in 1419 were still very much on the minds of political observers at the far end of the fifteenth century. But Louis XI, as Kendall noted above, prided himself on his powers of persuasion. He had already met Charles once before in a similar fashion with favorable results outside the walls of Paris during the feudal rebellion known as the War of the Public Weal in 1465, and he would subsequently employ the same charms on Edward IV to deflect an English invasion of France nine years later. The duke of Burgundy agreed to meet the king a second time at Péronne only most reluctantly. When news arrived of a fresh rebellion at Liège, in which the king was undoubtedly complicit although perhaps not as directly responsible as Commynes and Scott suggest, Charles was beside himself with fury at Louis' perfidy, and he kept the king a virtual prisoner until he could decide what to do. It was easily the most dramatic moment of Louis XI's reign, even though it ultimately had few long-term consequences, since the treaty produced was immediately renounced as imposed under duress once

the king regained his liberty. As several scholars have pointed out, Commynes considerably exaggerates the significance of the affair, possibly because of his own personal involvement, but the incident could hardly be bettered as a showcase for a historical novelist to highlight the peculiar mind and methods of Louis XI.[24]

Scott suggests that the king sought for and went to the meeting even though his agents were active with the Liège uprising because he did not expect the Liégeois to act so soon. Commynes claims that Louis simply "forgot," which seems highly unlikely. According to Kendall, "it may be that somewhere in the folds of his unconsciousness he had allowed himself to forget," for the king was never happier or quicker in his wits than when "the water was up to his neck."[25] More prosaic reasons are not far to seek. The French and Burgundian armies had been encamped opposite each other near the Somme for several weeks, and when floods from unusually heavy autumn rains dislodged the Burgundians in disarray, the king's generals counseled immediate attack. But ever since the near disaster at Montlhéry during the War of the Public Weal, Louis had always avoided the uncertainty of a pitched battle whenever possible. It may also be true that Commynes was simply mistaken about the depth of Louis' involvement in the Liège revolt, and thus the king saw nothing to fear. Several modern scholars have convincingly demonstrated that Commynes in a similar fashion exaggerates the extent to which Louis XI's later machinations were responsible for the alliance of the Swiss and German towns of the Upper Rhine that eventually defeated the grandiose ambitions and pretensions of Charles the Bold.[26]

Once in up to his neck again, it was Louis XI who had to talk his way out, as there was obviously no Quentin Durward to save the day, but a liberal allocation of 15,000 gold crowns among the duke's counselors no doubt proved helpful as well. The extended exchange between Commynes and the king in Scott's account on how best to mollify the rage of the duke represents an imaginative reconstruction of conversations that Commynes obliquely describes in a few lines. After three days of stewing in rage, the duke decided that he would release Louis, if the king would swear to the peace treaty they had nearly completed when word from Liège had arrived, and if Louis would accompany Charles the Bold in the subjection of the Liégeois: "The king had been notified of this by some friend, who assured him that he would be safe if he accepted these two points; but, if he refused, he would place himself in such a dangerous position that nothing worse could happen to him."[27] It has long been generally accepted that the "friend" was Commynes himself, although other Burgundian courtiers may well have confirmed this intelligence. Interestingly, Scott has Louis recognizing the probity and value of Commynes in their imagined conversations, but then once Commynes leaves the cell he promptly begins laughing derisively at his

prim foolishness in not accepting the royal coin in payment for such timely service. As Commynes reports, the king routinely "spoke slightingly of people in their presence as well as in their absence,"[28] and Scott nicely turns this on the memoirist himself.

The king of France was never actually placed in a prison cell, although armed guards stationed about the castle were certainly posted to prevent the departure of anyone from the French entourage, which included such notables as Louis de Luxembourg, count of St. Pol, Duke Jean II of Bourbon, and Jean's brother Charles, archbishop of Lyons. Still, it was a stroke of genius for Scott to have Charles order the king to a closer confinement with only six chosen followers as companions. The choices Louis makes are hilariously revealing: Olivier le Dain, Le Balafré of the Scottish Guard, his astrologer Martius Galeotti, and his hangmen Tristan l'Hermite, Trois-Eschelles, and Petit André. As Charles the Bold's jester remarks, "a rare election! – A pandarly barber – a Scotch hired cut-throat – a chief hangman and his two assistants, and a thieving charlatan."[29] As usual, it turns out there is method in the king's selection, for the astrologer is not present and Louis wants him fetched so he can have Galeotti murdered for failing to read the stars aright and give him due warning of these troubles. At first he asks Le Balafré to dispatch the astrologer from behind, but the honorable Scot refuses to perpetrate such a cold-blooded murder, although he agrees to guard the door while Tristan and his associates ply their trade. As the hangmen make their preparations, they gleefully crack jokes, obviously relishing the opportunity to sweeten their predicament with a little professional employment. When Galeotti arrives, however, he spies the waiting noose and assiduously deploys his considerable powers of persuasion to thwart his impending fate, partly by promising that Quentin will once again show his mettle and save the royal skin, and partly by prophesying that the king's death will follow shortly on his own, a classic astrological anecdote that Scott erroneously attributes in his notes to Tacitus on the emperor Tiberius.[30]

Even more outrageous is the prayer that Scott has Louis XI address to the Virgin Mary at his darkest hour. The king's rather bizarre religiosity is amply recorded in the chronicles, including his massive bequests to his favorite churches and oratories, the little leaden images of the saints that he kept tucked in his hat band and frequently took down to kiss, and his insistence on routinely swearing over the holiest relics to treaties he apparently had no intention whatsoever of actually honoring. In his prayer to the Virgin of Cléry, Louis attempts to explain away the murder of his brother Charles by poison, as he knew "no better method of quieting the discontents" of his kingdom. He then asks forgiveness in advance for the intended murder of his astrologer, which would be "no sin, but an act of justice privately administered – for the villain is the greatest impostor that ever poured falsehood

into a Prince's ear, and leans besides to the filthy heresy of the Greeks."[31]
The king arose from his prayer apparently satisfied that he had secured the
intercession of this particular saint, since:

> he craftily reflected, that most of the sins for which he had
> requested her mediation on former occasions had been of a
> different character, and that, therefore, the Lady of Clery was less
> likely to consider him as a hardened and habitual shedder of
> blood, than the other saints whom he had more frequently made
> confidents of his crimes in this respect.[32]

As Scott reveals in his notes, he found the gist of this incident in Brantôme,
whose many scandalous and gossipy stories are often clearly apocryphal or
heavily embellished, but it well exemplifies the seemingly incredible discon-
nect between the king's ardent religious devotions and his deeds. Commynes
says that the archbishop of Tours actually wrote a letter to Louis on his eccle-
siastical largess, informing him that he would do far better for the sake of his
soul if he despoiled his favorite churches and monasteries and distributed the
proceeds to the wretched laborers of the realm who had to pay his onerous
taxes.[33]

One last scene worthy of note in Scott's account is Louis XI's trial on
the Liège question, which is entirely invented. Louis exhibits no apprehen-
sion, despite the duke's dark looks, but rather "he was resolved, like a wary
and skilful pilot, neither to suffer himself to be disconcerted by his own
fears, nor to abandon the helm, while there was a chance of saving the
vessel."[34] As the principal argument in his defense, the king barefacedly
declares that to incite the Liégeois to rebellion at the very moment he
planned a meeting with the duke would be like setting a match to the fuse of
a mine and then sitting down upon it. The suspense builds as Isabelle, fore-
warned by Quentin, testifies about her flight to the French court, and then
all eyes turn to the young Scottish archer. He is first questioned over the
attempt of the duke of Orléans and the count of Dunois to relieve him of
Countess Isabelle and Lady Hameline outside Tours, and both manfully
compliment Quentin on his chivalric prowess in defeating their effort.
When the point is pushed about whether he heard any mention of the king's
complicity when he learned of De la Marck's plot and deviated from his
prescribed route to Liège, Quentin artfully replies, "If such infamous fellows
had said so [...] I would know not how I should have believed them, having
the word of the king himself to place in opposition to theirs." At these words
the king audibly draws a deep breath of relief, "in the manner of one from
whose bosom a heavy weight has been at once removed."[35] The duke will
not give up so easily and he presses the issue several more times, but Quentin

remains steadfast in his assertion that even if he *had* heard such words he would not have believed them.

Few readers would wish to see Quentin tell what he knows to be true, though he lacks hard evidence, and thus betray the king to the mercy of Charles the Bold. Both the young Scot and Louis XI gain the reader's sympathy in this scene, the former for his noble elevation of spirit (the king had conspired against his life), while Louis earns a certain pity for needing Quentin's rescue from the parlous consequences of his own treachery. Immediately after this tense moment, another comic interlude is provided by the arrival of Hayraddin in herald's costume with an insulting message from the Boar of Ardennes. When he is finished, Charles the Bold calls out for the man to be "scourged till the bones are laid bare," but the assembled courtiers insist on the sanctity of all true heralds properly schooled in their craft, until a close examination of chivalric lore reveals that this one is an impostor. It is Louis XI who then suggests that the war-dogs be loosed upon the man, and the duke and the king together dissolve in riotous laughter at the spectacle which ensues. As Charles the Bold remarks, "Ah, Louis, Louis! would to God that thou wert as faithful a monarch as thou art a merry companion!"[36] After their sport the duke calls for the man's release, but with his herald's costume ripped to pieces Hayraddin's identity has been revealed and the king claims him from the duke as meat for his hangmen in order to guarantee the Bohemian's silence. As Hayraddin is carried away, the king pulls out a golden reliquary with a piece of the true cross, kisses it, and offers to swear by a new treaty on it. The effect is enjoyably bewildering, as the reader is simultaneously amused and appalled.

In all these scenes the striking juxtaposition of hypocrisy, faithlessness, malice, cruelty, and criminality on the one hand, with humor, wit, mental agility, bravery, resourcefulness, and an all-too-human fallibility and vulnerability on the other, creates a picture of Louis XI that rivals that of any historian or biographer. The license traditionally granted to the novelist not only frees Scott from having to make any effort to reconcile or explain away these contradictions, it even allows him to exaggerate them for greater effect. If Kendall dismisses Scott's Louis XI as "a sinister gargoyle," one could equally claim that he overly whitewashes and domesticates the king for squeamish twentieth-century sensibilities. It is perhaps worth noting that Kendall's biography of Richard III similarly attempted to rehabilitate the reputation of that much maligned monarch, although rather less convincingly.[37]

According to Kendall, the only "really cruel deed" of Louis XI's career was the forced marriage of his unattractive and physically deformed daughter Jeanne to Duke Louis of Orléans (son of the poet Charles) on the expectation that the marriage would prove barren and the Orléans lands would

revert to the crown. This too, of course, appears in *Quentin Durward*, although the princess is depicted as old enough to interact with her fiancé socially, when in reality she was not born until 1464, just four years before the interview at Péronne, and the marriage did not take place until 1476. Kendall admits that Louis XI left nothing to chance and "brutally forced the young couple to consummate the marriage" in order to eliminate possible grounds for annulment.[38] Gaussin provides further details on how the king compelled his new son-in-law to visit the bride at hours fixed by himself, and he posted doctors to confirm that the couple had successfully performed their marital duties.[39]

But evidence abounds for the many other petty cruelties committed by Louis XI, and not only in Commynes.[40] His own published letters reveal him ordering the corpses of executed rioters in Bourges to be hung up on the front doors of their houses as an example to others,[41] and the pages of Jean de Roye's Parisian chronicle, cited several times by Scott, run red with the blood of the king's enemies, as men from all social ranks are hanged, beheaded, drowned in a river, or drawn and quartered.[42] Indeed, the Paris depicted in the latter chapters of this journal bears all the signs of a fifteenth-century police-state, complete with arbitrary arrests without trial, confiscated property, rampant abuses by government bureau-crats, censorship, paid informants, and a general atmosphere of repression and terror. After the king's humiliation at Péronne, not only was all public criticism of the treaty banned, whether by word of mouth, graffiti, signs, pictures, rondeaux, or ballads (with a reward of 300 *écus* for turning in violators), but even parrots and talking birds were rounded up lest they be taught to utter remarks deemed insulting to him.[43] Any notion that the private will of the king corresponded to the unexpressed will and consent of his subjects is flatly denied by the repudiation of his regime in the Estates General of 1484 shortly after his death. It remains an open ques-tion whether Louis XI operated in the interests of "France" or merely himself. His effort to enlarge and consolidate his patrimony may well have been little different from that of Charles the Bold or any other great feudal magnate, except from the thoroughly anachronistic standpoint of modern nationalistic sentiment.

Despite the generalizations made in his introduction, Scott actually does very little with the historical transformation from feudalism to the modern political system, which is just as well, for it is by no means clear that Louis XI was indeed "the founder of modern France." His father Charles VII had both created the standing army by which the English were finally driven from French soil and successfully imposed taxation without consent in order to pay for it, which gradually undermined the Estates General and other representative assemblies, paving the way for royal absolutism. In each case

Louis XI merely continued in his father's footsteps, pushing both the army and the taxes to their furthest possible extreme. Nor is his reputation as "la vainqueur de la grande féodalité" entirely deserved, for his victory over the old feudal aristocracy was as much a product of good fortune as of conscious effort. Charles the Bold eventually self-destructed in his single-minded drive for Burgundian sovereignty and territorial expansion in the Holy Roman Empire, dying on the field of battle with what was left of his once grand army at Nancy in 1477. After his death Louis promptly helped himself to half the Burgundian inheritance before he was stopped by Maximilian of Austria, who had married Charles' only child and heir, Mary. Two prominent noblemen, Jacques d'Armagnac, duke of Nemours, and Louis of Luxembourg, count of St. Pol (mentioned several times in *Quentin Durward*), were executed for treason and had their estates confiscated by the crown, but the once great houses of Anjou and Foix became extinct for lack of an heir, and when Charles VIII died young and childless in 1498, the duke of Orléans brought his patrimony to the royal domain by ascending the throne himself as Louis XII. Duke Francis II of Brittany likewise died childless in 1488, and his daughter Anne was married to both Charles VIII and Louis XII in turn as a means of bringing and keeping her lands permanently in the royal fold. As the distinguished French historian Auguste Longnon observed, it seems that Providence itself had wished to favor the unification of France by this strange physical enfeeblement of the leading feudal houses.[44]

In *Quentin Durward* Scott focuses on historical personalities, not historical forces, and Louis XI was as unusual a character as ever held the throne of France. He had come to power in 1461 at the age of 47, after chafing for years at what he considered the indolence and inactivity of his father. Once at the helm he was determined to impose his will on everything and everyone by whatever means necessary with little tolerance for opposition of any sort, and not surprisingly within four years he managed to stir up the most formidable feudal rebellion that France had seen for several centuries. He saved his throne but he was forced to make substantial concessions in lands and revenues, above all to Charles the Bold, and he spent the rest of his reign trying to win back everything he had lost and more, with all the ruthlessness and sordid political dealing that a very sordid century could offer. As Charles Petit-Dutaillis aptly put it, "Louis XI was a tyrant in the full sense of the word, a tyrant like the Italian tyrants of his day. There lay his affinities, and there in truth was his moral parentage."[45] There would be no French king quite like him again.

Compared to Louis XI, the picture of Charles the Bold in *Quentin Durward* is much too superficial and one dimensional to posit him as the representative of the old feudal order and the king as that of the new. As

Richard Vaughan has demonstrated, Charles was no less aggressive and forward-looking than Louis XI in attempting to consolidate his disparate territories into a more cohesive unity obedient to his will, even if he was considerably less successful and adept. In fact, although the death of Charles the Bold at Nancy in 1477 and the subsequent dissolution of the Burgundian inheritance certainly benefited the political unification of France, it proved in large measure a victory for the old feudal order in the lower and upper Rhineland that would help delay the emergence of a modern unified state there for several more centuries. The uprising of Liège against its Burgundian-imposed bishop likewise had little to do with the rise of the modern middle class, but rather constituted a determined effort on the part of the Liégeois to preserve their traditional medieval privileges.[46] The ultimate winner in that conflict was the Catholic Church, and the bishopric of Liège would remain an ecclesiastical principality until 1795.

It is Quentin Durward and a handful of the aristocratic courtiers who represent the medieval chivalric ideal, which, if truth were told, was usually more lip service than reality. Machiavelli had little to teach the princes of northern Europe when it came to perfidy and duplicity. The true dynamic in the novel is not feudal versus modern, but rather idealism versus cynicism, played out almost entirely on the plane of personal ethics in the mode of romance. Whatever the larger contexts of the other Waverley novels, especially those set closer to Scott's own day, the historical portion of the novelist's achievement in *Quentin Durward* lies first in his remarkably multifaceted portrait of Louis XI, deeply steeped in all the sources available at the time, and secondly in the masterful way he interweaves his invented tale with documented historical events. Most impressive is Scott's success in conveying the mercurial strangeness of the king, his baffling and inexplicable mixture of attractive and repellent qualities that was perhaps a complex product of both his highly eccentric individuality and the rather fevered and disturbed times in which he lived. With his depiction of Louis XI, Scott truly makes history come alive, and it was a shame that so few among his legion of imitators were able to make the history and romance formula work half as well.

NOTES

1. Georg Lukács, *The Historical Novel*, trans. Hannah and Stanley Mitchell (Lincoln: University of Nebraska Press, 1962).
2. Ian Duncan, *Scott's Shadow: The Novel in Romantic Edinburgh* (Princeton, NJ: Princeton University Press, 2007). See also his earlier *Modern Romance and the Transformations of the Novel: The Gothic, Scott, Dickens* (Cambridge: Cambridge University Press, 1992).

3. J. H. Alexander, "The 'Amanuensis of History' in the Franco-Burgundian Novels," *European Romantic Review* 13 (2002): 239–47; Judith Wilt, "Transmutations: From Alchemy to History in *Quentin Durward* and *Anne of Geierstein*," *European Romantic Review* 13 (2002): 249–60.

4. Lionel Lackey, "Plausibility and the Romantic Plot Construction of Quentin Durward," *Studies in Philology* 90 (1993): 101–14.

5. Paul Murray Kendall, *Louis XI, the Universal Spider* (New York: W. W. Norton, 1971).

6. F. Châtillon, "Louis XI tel qu'il est vu d'Amerique," *Revue du Moyen Age latin* 40 (1984): 234–8. The reviewer does grouse slightly over why such a book had to be written by an American.

7. Kendall, *Louis XI*, 28; Alexander, "Amanuensis," 244.

8. Claude de Seyssel wrote *Les Louenges du Roy Louis XIIe de ce nom* (1508), in which he compares at length the beneficent reign of the present Louis to the deplorable excesses of his namesake predecessor, while Brantôme's miscellaneous collection of gossipy *Mémoires* about the rich and famous in sixteenth-century France were first published posthumously in 1665–66.

9. Adrianna Bakos, "'*Qui nescit dissimulare, nescit regnare*': Louis XI and *Raison d'état* during the Reign of Louis XIII," *Journal of the History of Ideas* 52 (1991): 399–416. See also her *Images of Kingship in Early Modern France: Louis XI in Political Thought, 1560–1789* (London: Routledge, 1997).

10. J. Vaesen and E. Charavay, eds., *Lettres de Louis XI*, 11 vols. (Paris: Renouard, 1889–1909); Bernard Mandrot and Charles Samaran, eds., *Dépêches des ambassadeurs milanais sous Louis XI et François Sforza*, 4 vols. (Paris: Renouard, 1916–23). Kendall and Vincent Ilardi began a massive English and Italian *en face* edition of the combined letters from the ambassadors to both France and Burgundy, but only three volumes containing the letters up to 1466 ever appeared: *Dispatches with Related Documents of Milanese Ambassadors in France and Burgundy, 1450–1483* (Athens: Ohio University Press, 1970–81).

11. Pierre Champion, *Louis XI*, 2 vols. (Paris: Champion, 1927); Joseph Calmette, *Le Grand règne de Louis XI* (Paris: Hachette, 1938).

12. Kendall, *Louis XI*, 28–9. Notice how even the king's deficiencies are skillfully marshaled to render him more endearing.

13. Kendall, *Louis XI*, 29, 21–2.

14. Pierre-Roger Gaussin, *Louis XI, un roi entre deux mondes* (Paris: Nizet, 1976), 447–9.

15. Jacques Heers, *Louis XI* (Paris: Perrin, 1999), 353–64.

16. Susan Manning, "Introduction," *Quentin Durward* (Oxford: Oxford University Press, 1992), xix.

17. For a complete source criticism see Max Friedrich Mann, "Quentin Durward," *Anglia* 12 (1889): 41–102. Mann includes both primary and secondary sources explicitly cited by Scott and others unmentioned, which he has deduced from close correspondence in selected passages. Selections from the principal chronicle sources can be found in *Historical Illustrations of Quentin Durward Selected from the Memoirs of Philip de Comines and other Authors* (London: Charles Knight, 1833).

18. Philippe de Commynes, *The Memoirs of Philippe de Commynes*, ed. Samuel Kinser, trans. Isabelle Cazeaux, 2 vols. (Columbia: University of South Carolina Press, 1969–73), 2:416. See also 1:91–2, 130–32.

19. Jean Dufournet, *La Destruction des myths dans les Mémoires de Philippe de Commynes* (Geneva: Droz, 1966); Karl Bittmann, *Ludwig XI und Karl der Kühne: Die Memoiren des Philippe de Commynes als historische Quelle* (Göttingen: Vandenhoeck & Ruprecht, 1964). A strong reply to Dufournet and Bittmann can be found in Kendall, *Louis XI*, 378–81.

20. William J. Bouwsma, "The Politics of Commynes," *Journal of Modern History* 23 (1951): 315–28.

21. Paul Archambault, "Commynes' *Saigesse* and the Renaissance Idea of Wisdom," *Humanisme et Renaissance* 30 (1967): 613–32.

22. Commynes, *The Memoirs*, 1:268–71.

23. Commynes, *The Memoirs*, 1:169–70, 173–7.

24. Richard Vaughan, *Charles the Bold* (New York: Barnes and Noble, 1973), 53–8; Dufournet, *La Destruction*, 181–93. For a minute analysis see Bittmann, *Ludwig XI*, 1:193–367.

25. Kendall, *Louis XI*, 217.

26. Vaughan, *Charles the Bold*, 310–11; Bittmann, *Ludwig XI*, 2:592–609.

27. Commynes, *The Memoirs*, 1:178.

28. Commynes, *The Memoirs*, 1:131.

29. Sir Walter Scott, *Quentin Durward*, ed. J. M. Alexander and G. A. M. Wood (Edinburgh: Edinburgh University Press, 2001), 304. This is the edition used for all subsequent quotes from the novel.

30. Vernon Rendell, "*Quentin Durward*: The Astrologer's Expedient," *Notes and Queries* 169 (1935): 188; *Historical Illustrations*, 111–12.

31. Scott, *Quentin Durward*, 310.

32. Scott, *Quentin Durward*, 311.

33. Commynes, *The Memoirs*, 1:407.

34. Scott, *Quentin Durward*, 349.

35. Scott, *Quentin Durward*, 357.

36. Scott, *Quentin Durward*, 366.

37. Paul Murray Kendall, *Richard the Third* (London: Allen & Unwin, 1955). His *Warwick the Kingmaker* (London: Allen & Unwin, 1957) also portrays Richard Neville in a highly favorable light.

38. Kendall, *Louis XI*, 344.

39. Gaussin, *Louis XI*, 426.

40. See especially the concluding chapters of Book VI in *The Memoirs*, where Commynes weighs the king's sins against his accomplishments as he approaches death.

41. Vaesen and Charavay, *Lettres*, 5:256–7.

42. Jean de Roye, *Journal de Jean de Roye connu sous le nom de Chronique Scandaleuse*, ed. Bernard de Mandrot, 2 vols. (Paris: Renouard, 1894–96), 1:70, 74–5, 78, 149–50, 154–5, 206–7, 209, 288, 291, 295, 303–9, 348–9, 360–61; 2:30–31, 47–9, 56–7, 83–4. See also Gaussin, *Louis XI*, 292–302.

43. Jean de Roye, *Journal*, 2:219–20, 260–61.

44. Auguste Longnon, *La Formation de l'unité française* (Paris: A. Picard, 1931), 273.

45. Charles Petit-Dutaillis, *The Cambridge Medieval History*, 8 vols. (Cambridge: Cambridge University Press, 1911–36), 8:305.

46. Vaughan, *Charles the Bold*, 185–90, 11–40.

Chivalric Terrors:
The Gendered Perils of Medievalism in
M. E. Braddon's *Lady Audley's Secret*

Megan L. Morris

The Eastern potentate who declared that women were at the bottom of all mischief, should have gone a little further and seen why it is so. It is because women are *never lazy*. They don't know what it is to be quiet. They are Semiramides, and Cleopatras, and Joan of Arcs, Queen Elizabeths, and Catharine the Seconds, and they riot in battle, and murder, and clamour, and desperation. If they can't agitate the universe and play at ball with hemispheres, they'll make mountains of warfare and vexation out of domestic molehills; and social storms in household teacups.[1]

<div align="right">Robert Audley</div>

At the end of the cattle-lined avenue that led to Audley Court, according to the narrator of Mary Elizabeth Braddon's *Lady Audley's Secret*, stood "an old arch and a clock tower, with a stupid, bewildering clock, which had only one hand – and which jumped straight from one hour to the next – and was therefore always in extremes" (43). Standing as it did at the entrance to a house that had been continuously constructed from medieval times to the present, the clock serves as a physical symbol of the visitor's entrance into an alternate, if indeterminate, temporal zone. Both the tower and the clock are marked indiscriminately as "old," setting the stage for the imprecise temporality of the novel.[2] In effect, the references to the one-handed clock that permeate the novel call constant attention to the disjunction between the modern and medieval structures within the Victorian world.

Lady Audley's Secret is an early example of the "sensation novel," a genre

that flourished in the mid- to late nineteenth century. Defined by their attempts to produce a corporeal response of shock and horror in their readers, these novels grew out of the Gothic novel of the late eighteenth century. Competing discourses of gender traditionally play a central role in critics' interpretations of the sensation novel. As Elaine Showalter has observed, sensation novels derive a portion of their horror from the destabilization of gender expectations within the framework of the novel. Showalter argues that *Lady Audley's Secret* "presents us with a carefully controlled female fantasy" that is "not only a virtual manifesto of female sensationalism, but also a witty inversion of Victorian sentimental and domestic conventions."[3] In order to act effectively on the body of the reader, the sensation novel must render the bodies of the novel, male as well as female, visible: they must tremble, weep, and faint. Although subjecting the female body to the reader's gaze does nothing to undermine an already visible gender, the male heroes of the sensation novel must occupy a feminized position as objects of the gaze. Often, the sensation novel's plot centers on the restoration of traditional patriarchal structures. Like the typical sensation novel, *Lady Audley's Secret* employs a scandal-ridden plot, complete with a faked death, bigamy, attempted murder, deception, and a detective investigation. Ultimately, the novel's plot relegates Lady Audley's subversive model of femininity to an insane asylum, thus permitting, to some degree, the restoration of male authority within the novel.

Also like the typical sensation novel, Braddon's work takes place in the modern age, and references to trains, telegraphs, watches, and other techno-logical elements constantly reinforce this modernity. Nearly all of these modern elements hinge upon the ability to accurately harness and measure time. This importance of history and temporality to the Victorian sensation novel has attracted recent attention in critical discourse. In *Writing the Past, Writing the Future*, Richard Albright argues that the plots of Gothic and sensation novels are primarily driven by the construction of temporal narratives.[4] Both the reader and the fictional detective race to reassemble a narrative of past events, and only through the accurate recreation of the past can present identity be understood. Albright's argument continues with an assertion that this drive for temporal narrative is central to the nineteenth-century consciousness: "The period from the late eighteenth through the mid-nineteenth centuries reveals a tremendous interest in situating the con-temporary era in relation to the past, a collective desire for the kind of 'bridge,' in Ricoeur's terminology, between the historical past and memory."[5] This bridge, Albright contends, is forged through the reconstruction of the complex sequence of past actions and crimes that lead towards the revelation of the Gothic or sensation criminal's true identity.[6]

Other critics have identified similar patterns in the role of historical and

temporal narratives in nineteenth-century literature. In "Reading the Gothic Revival," Christina Crosby argues that this drive towards historicization informs the Victorian conceptualization of their present identities, contending that "Historical novels and narrative histories, Pre-Raphaelite art, antiquarian and archaeological research, the restoration and preservation of old buildings, a revival of Gothic architecture and Gothic design [...] are part of a move to make all knowledge historical, to make something called 'history' the origin and end of 'man.'"[7] Crosby's analysis thus suggests that Victorian medievalism, like the sensation novel, relies on the construction of historical narrative in order to explain and validate the present. The overlapping functions of these two discourses invite closer analysis of the medieval structures that pervade the nineteenth-century sensation novel.

Perhaps because of *Lady Audley's Secret*'s overt concern with modernity, the role of medievalism in the novel has been almost entirely overlooked by critics. Elizabeth Tilly's "Gender and Role Playing in *Lady Audley's Secret*" argues that the sensation novel's special brand of horror specifically requires the elision of medievalism: "The novels documented the usual crimes and scandals, but they now occurred at home in an easily understood English landscape rather than in a foreign setting essentially outside time and history."[8] In support of her argument that the domestication of horror is central to the transition from the Gothic novel to the sensation novel, Tilly further observes that "The only convents, monasteries, or dilapidated castles to appear were Cromwell's ruins – or the successor to the convent – the madhouse."[9] In effect, Tilly's assertions minimize the role of medievalism in the sensation novel, instead highlighting the role of the domestic, local, and contemporary in Lady Audley's highly gendered machinations.

Despite its use of contemporary, domestic horror to titillate the audience, however, *Lady Audley's Secret*'s preoccupation with the past and focus on the reconstruction of temporal narrative invest the novel with a medievalist drive.[10] In order to invoke medievalist codes, Braddon frames her narrative with a house built continuously from the Norman Conquest through Victorian modernity, then reinforces the medievalism of her text through chivalric gender relations and a Pre-Raphaelite portrait of Lady Audley. Consequently, the past and the present continuously clash within the novel, constructing temporal disjunction through the superimposition of medieval structures upon the modern world. The stakes in this temporal disjunction are high: the reestablishment of traditional masculinity depends upon the ability of Robert Audley, the novel's hero and the eponymous lady's nephew, to excise medievalism and the Pre-Raphaelite Lady Audley from the novel. Thus, in *Lady Audley's Secret*, Braddon employs medievalism as the primary vehicle of horror and "sensation": within the framework of the sensation novel, the reinstitution of chivalric codes, rather than reinforcing

traditional patriarchal structures, undermines male ability to participate in progressive modernity. The novel's disjunction between temporal modes proves to be a fertile ground for Victorian sensationalism; a sudden collision between the two strips away the landscaped layers of the past to reveal the potent body of the female criminal.

Framing Medievalism: Gender and Architectural Temporality

A strong medievalist strain dominates much of the architectural and artistic imagery in *Lady Audley's Secret*. In "Victorian Architectures of Masculine Desire," Vincent A. Lankewish links the discourses of history, architecture, and gender by suggesting that, for Ruskin and Pater, "Bringing to light a lost, an unknown, or perhaps most important, an unappreciated work of art or art form represented not simply an intervention into aesthetic history [...] but rather an occasion to reflect on and to shape the direction of English masculinity."[11] For the Victorians, then, ancient architecture plays a critical role in the construction of a gendered identity. Although Lankewish concentrates on masculinity, medieval architecture plays an equally pivotal role in the construction of femininity. Frequently, as suggested by Lankewish's reading, historical architecture provides a stabilizing structure for traditional Victorian gender relations. Alfred, Lord Tennyson's "The Lady of Shalott," published in 1833 and again in 1842, offers a compelling example of the use of architectural metaphors to define medieval female gender roles.[12] This poem features a woman enclosed in her tower, faced with an overshadowing, but unnamed, curse if she looks directly on the outside world that surrounds the tower. The second stanza of the poem presents the Lady of Shalott in an architectural frame, the limits of her world set by the physical space that she inhabits: "Four gray walls, and four gray towers, / Overlook a space of flowers, / And the silent isle imbowers / The Lady of Shalott."[13] The "four gray walls" of the tower literally contain the Lady of Shalott, physically imposing the chivalric medievalism that circumscribes her performance of gender. This construction posits both architecture and medievalism, particularly when they work in concert, as regulatory forces within Victorian literature: Tennyson's engagement with tower imagery establishes limitation and circumscription as the defining element of the medieval chivalric codes.

Lankewish's analysis of the gendering of ancient architecture and my brief discussion of "The Lady of Shalott" shed considerable light on the medievalist architectural framework of *Lady Audley's Secret*. Other critics, including Richard Albright, have commented upon the role of the estate in the regulation of temporal discourses, both within *Lady Audley's Secret* and in the Victorian era as a whole. Albright observes that "Audley Court's irregularities exist in both the spatial and temporal dimensions, which inform each

other"; the architectural construction of the house offers a physical frame for the novel's medievalism.[14] In the context of the Victorian understanding of architecture, the conflicting temporal signification of the house's ornamentation is important. As Christina Crosby has argued, architectural manuals such as Pugin's *Contrasts* and Owen Jones' *The Grammar of Ornament* indicate that:

> Ornament [...] is what makes a building intelligible and makes legible the history not only of the building itself but of its whole epoch. The design of a capital, of a door jamb, of ornamental sculpture, the vaulting of a roof and turn of a drip-spout are to be read, for each detail tells the truth of its historical moment.[15]

In effect, then, the role of medieval architecture and ornament is to reveal truth, but Audley Court, which embodies a hybrid, monstrous mix of eras and times, has no cohesive, unilateral truth to reveal. The historical disunity of the Court's court prevents the construction of a historically coherent narrative.

The clock that opened this article serves as a tangible architectural marker of the novel's regression into medieval, chivalric structures. At critical moments in the novel, the old clock symbolizes the temporal shift between the modern world and the retrogressive realm of Audley Court. As George Talboys, the first husband of the bigamous Lady Audley, and his friend Robert Audley pass into Audley Court for the first time, the narrator's commentary establishes the disjunction between temporal zones. He says, "That stupid clock, which knew no middle course, and always skipped from one hour to the other, pointed to seven as the young men passed under the archway; but, for all that, it was nearer eight" (102). In this quotation, Braddon delineates an absolute distinction between the time of the outside world and the time within Audley Court, which has not kept up with that of the modern world. This sense of anachronism extends to the nearby village, where "The slow progress of the hands of the old clock in the church steeple was the only token by which a traveller could perceive that the sluggish course of rural time had not come to a full stop in the village of Audley" (272). This passage describes the "sluggish course of rural time" from the perspective of an outsider whose position mimics the reader's. By involving her audience in Audley Court's historical regression, Braddon renders us directly subject to the disorienting discourses of time that emerge from the novel's medievalism; we, as well as Robert Audley, must be extracted from medievalism's bewildering ahistoricism.

The gender discourses of *Lady Audley's Secret* are fundamentally driven by temporal conflicts that are rooted in the castle's historical construction.

This house, continuously built since the time of the Norman Conquest, reconstructs time as a threatening, hybrid force that bewilders and entraps all who approach it. The narrator's initial description of this house links horror to medievalism through Time's destabilization of architectural structures. The narrator describes Audley Court as:

> A noble place; inside as well as out, a noble place – a house in which you incontinently lost yourself if ever you were so rash as to go about it alone; a house in which no one room had any sympathy with another [...] a house that could never have been planned by any mortal architect, but must have been the handiwork of that good old builder – Time. (44–5)

Braddon's description of the castle, which opens *Lady Audley's Secret*, lays the groundwork for the medievalist construct of the novel by repeatedly employing the word "noble," invoking both aristocratic and chivalric discourses. Immediately, however, the language of this passage connects the medievalist architecture of the house with sexual threat: invoking incontinence here implies a lack of control that, driven by the hybrid temporality of the house, erodes the body's ability to conform to social conventions. The "good old builder – Time" creates a bizarre and bewildering combination of eras, making Time itself rather than any particular era the focus of the scene that the narrator is creating.

Similarly, the narrator's description of the old well into which Lady Audley pushes George during her murder attempt evokes and combines multiple eras without ever specifying a precise time period. In this scene, the dangers of this temporal combination become more precisely defined. Describing the grounds of the house, the narrator relates that:

> At the end of this dark arcade there was the shrubbery, where, half-buried amongst the tangled branches and the neglected weeds stood the rusty wheel of that old well [...]. It had been of good service in its time, no doubt; and busy nuns have perhaps drawn the cool water with their own fair hands; but it had fallen into disuse now. (45)

Although Braddon does not state directly that the "busy nuns" were medieval, the constructs in the novel, including the constant references to Pre-Raphaelites, induce the reader to interpret them as figures from the Middle Ages. Notably, the passage associates this medievalism with decay and tangles, connecting the well's medievalism with Lady Audley's attempt to resolve her tangled marital situation by murdering her original husband,

George Talboys.[16] The juxtaposition of the well's present uses with its past function indicates that the estate's attempt to transition between the past and the present has resulted in a hybrid. The narrative of the novel evokes the medieval past through its embodiment in fair-handed nuns, creating a tangible history through the presence of the female body. The tangles and darkness of the modern surroundings, however, corrupt this medievalism into a threatening force. This passage clarifies the relationship between medievalism and the historical Middle Ages in the novel: the medieval itself is not a corrupt, horrific force, but modernity's manipulation of this medieval past transforms it into a sensational weapon.

"Medieval Monstrosities": Pre-Raphaelites and Hybrid Temporalities

Lady Audley, inseparable from her hybrid domestic space, likewise embodies both medieval and modern times, employing a mixture of temporal discourses in order to conceal truth rather than to reveal it.[17] Removing the temporal context of this novel makes the body the regulator of time. In *Narrative Bodies: Towards a Corporeal Narratology*, Daniel Punday argues that the body has traditionally been perceived as the antithesis to the production of a temporal narrative: "In broader philosophical treatments of the narrative organization of human experience, the body naturally appears as the 'other' to narrative" and the kind of historical time that narrative constructs.[18] Within *Lady Audley's Secret*, however, time becomes a bodily function rather than a historical event. This transfer allows Lady Audley, whose body dominates the novel, to dictate discourses of time within Audley Court.

The medievalism of *Lady Audley's Secret* is constructed externally rather than internally: it frames both Lady Audley's body and the mansion that surrounds her, yet in no way reflects her inward state. The Pre-Raphaelite portrait of the lady constructs her as a "medieval monstrosity," yet her angelic appearance associates her with the traditional Victorian domestic goddess. The combination of these two roles allows Lady Audley to destabilize the roles of both genders: through the physical construction of her body, she forces the men of the novel to conform to chivalric structures. Lady Audley herself, however, channels the weapons of modernity – the train and the telegram – to achieve the active agency of a New Woman. The resolution of the novel depends upon Robert Audley's ability to transcend these medieval structures and excise both the temporally hybrid lady and the house that she occupies from the novel. Lady Audley's body, particularly her hair, is constantly emphasized as the source of her power; initially, this power appears to dovetail completely with traditional Victorian femininity. "They were the most wonderful curls in the world – soft and feathery, always floating away from her face, and making a pale halo round her head when

the sunlight shone through them," the narrator tells the reader during the first encounter with Lady Audley (49). Here, Lady Audley clearly performs the role of the Angel in her house: the halo of her hair serves as an obvious physical reminder of that status.

Lady Audley's hair, however, functions as a marker of Pre-Raphaelite medievalist discourse as well as of Victorian domestic femininity. A Pre-Raphaelite portrait of Lady Audley in her private chamber at Audley Court reconstructs Lady Audley's body as a fascinating medieval trope that unhinges the temporal discourse of the novel. Through repeated references to this portrait throughout the novel, Braddon explicitly links Lady Audley's hair, and the rest of her body, to subversive medieval power. Robert Audley and George Talboys, her lawful husband, invade these chambers, desperate to see her famed beauty. As they gaze at the portrait, the narrator translates the experience for the readership of the novel through the lens of Pre-Raphaelite art: "No one but a pre-Raphaelite would have painted, hair by hair, those feathery masses of ringlets with every glimmer of gold, and every shadow of pale brown" (107). The lady's beauty, portrayed in great detail by the artist, becomes a medieval construct. The narrator then regret-fully informs us that "I suppose the painter had copied quaint mediaeval monstrosities until his brain had grown bewildered, for my lady, in his portrait of her, had something of the aspect of a beautiful fiend" (107). By revealing that the artist who painted Lady Audley interpreted her through the lens of "medieval monstrosities," the narrator implicitly invites the reader to adopt a similar stance. Medievalism thus both reveals and enables Lady Audley's malevolent power: Pre-Raphaelite portraiture functions as a form of speech act, simultaneously creative and descriptive. By casting Lady Audley as a beautiful fiend, the painter grants her the power to perform in that capacity.

The invocation of the Pre-Raphaelites here is particularly important; from the standpoint of traditional Victorian gender politics, some members of the Brotherhood gave dangerous, subversive women powerful voices. William Morris' "Defence of Guenevere," for instance, which preceded *Lady Audley's Secret*'s 1860 publication by only two years, invests the adulteress with a compelling, sympathetic voice and thus, to some degree, legitimizes bigamy. By invoking Pre-Raphaelite art, Braddon deliberately refers the reader to this broader context of Pre-Raphaelitism. As Sophia Andres argues in *The Pre-Raphaelite Art of the Victorian Novel*, descriptions of these paint-ings invoke memories of physical paintings; accordingly, "At the site of these reconfigurations, where the fictional merged with the actual, readers were drawn into not merely hypothetical issues but also into questions confronting them in their quotidian lives."[19] This construction suggests that the combination of Pre-Raphaelite art and the Victorian sensation novel is

particularly potent. While the sensation novel invites the reader to extract the horror from their domestic realities, Pre-Raphaelite portraiture evokes the everyday by portraying the fictional. Thus, Braddon's persistent use of Pre-Raphaelite portraiture as an interpretative lens for Lady Audley forces the reader to reconsider issues of gender, power, and medievalism on multiple levels. The image of a medieval woman constructed here is of a "beautiful fiend," made perilous by her beauty; the dangerous text of medieval femininity is simultaneously created and revealed on her face. "No one but a Pre-Raphaelite would have so exaggerated every attribute of that delicate face as to give a lurid lightness to the blonde complexion, and a strange, sinister light to the deep blue eyes," the narrator emphasizes. "No one but a pre-Raphaelite could have given to that pretty pouting mouth the hard and almost wicked look it had in the portrait" (107). In painting Lady Audley in the same mold as a "medieval monstrosity," the Pre-Raphaelite artist remodels her beauty into a chivalric construct, making her threatening within the medievalist framework of the house.

Monasticism, Chivalry, and the Debilitation of Masculinity

Medievalism proves severely disorienting to Robert himself, who struggles with a lethargy that the narrator associates with medieval monasticism. In order to successfully investigate his friend's disappearance, Robert must reassert an active, traditional masculinity. After George Talboys' disappearance and Robert's return to his own home, the narrator reports that "The usual lazy monotony of his life had been broken as it had never been broken before [...]. His mind was beginning to grow confused upon the point of time" (129). Robert is forced to bridge two separate worlds, simultaneously occupying both the medieval and the modern realms. The narrator associates the passive, ineffective masculinity with which Robert begins the novel with medievalism: "If Robert Audley had lived in the time of Thomas à Kempis," the narrator informs us, "he would very likely have built himself a narrow hermitage amid some forest loneliness" (235). This being impractical in the Victorian context, however, the narrator suggests that Robert's life as an idle barrister substitutes for this passive existence, qualifying this observation with the remark that "his sins were of so simply negative an order, that it would have been very easy for him to have abandoned them for negative virtues" (235). Certainly Robert is the direct object of the critique offered here, but the medieval monks come in for their share of the condemnation: their virtues are negative because they fail to encounter the world. This suggestion of monasticism is more than a passing whim of the narrator's: later in the novel, as Robert pursues his investigation at the port of Wildernsea, the young man reflects, "I should like to live here, and tell the

beads upon my rosary, and repent and rest" (265). In order to combat this passivity, Robert must find a replacement for his medieval models in the active, progressive measurement of time that is demanded by his investigation.

In many ways, medievalism and chivalric codes seem to oppose the typical agenda of the Victorian sensation novel, which traditionally destabilizes gender expectations, generating horror through the combination of strong women and terrifyingly weak men who fall under their sway. Victorian medievalism, in contrast, typically reinstates chivalric codes as stabilizing forces within the novel: Tennyson's King Arthur, for example, provides a reassuring new model for Victorian manhood, while his Enid embodies the peculiar virtues of nineteenth-century Victorian femininity. Initially, the use of chivalric structures in the relationship between Sir Michael and Lady Audley appears to reflect this traditional system. The linguistic framework of the novel forces the reader to locate Sir Michael and his wife within this chivalric, archetypical framework. This structure is particularly noticeable when the narrator refers to Lady Audley. Rather than calling her by any of the many names that are rightfully hers – Helen Maldon, Helen Talboys, Lucy Graham, Lucy Audley – this narrator instead refers to her as "my lady" until her crimes rob her of her social position. Correspondingly, Sir Michael is continually referred to by his title.

Although these titles serve as marks of aristocracy that distance these characters from middle-class morality, they simultaneously mark a chivalric relationship. The narrator later explicitly connects the relationship between Lady Audley and Sir Michael to chivalry; he asserts that "It is impossible for me ever to tell the purity of his generous love – it is impossible to describe that affection which was as tender as the love of a young mother for her first born, as brave and chivalrous as the heroic passion of a Bayard for his liege mistress" (295). As this passage reveals, however, the chivalric relationship between Sir Michael and Lady Audley destabilizes gender norms within the novel rather than reinforcing them. The above quotation offers a seemingly sincere and unambiguously adulatory description of Sir Michael's affection for his new wife, yet also carefully highlights the overlap of feminine and masculine attributes within the knightly character. While Sir Michael's love is categorized as "brave and chivalrous," it also, in a novel of absent mothers, rechristens him as the only actively maternal figure in *Lady Audley's* Secret. In the context of the Victorian sensation novel, womanliness is not a positive male characteristic: it implies that the chivalric structures of Sir Michael's love ultimately weaken him. This early presentiment of conflict is later confirmed by Sir Michael's final pronouncement upon Lady Audley's crimes: "I leave all in your hands, Robert […] I may not have heard the end, but I have heard enough. Heaven knows I have no need to hear more. I leave all to

you, but you will not be cruel – you will remember how much I loved" (374). Sir Michael's chivalrous love renders him incapable of effective action: he must abdicate his responsibilities and transfer them to Robert, who is not weakened by chivalric love. In effect, *Lady Audley's Secret* deconstructs the "medieval" knightly character to reveal its inherently unstable combination of gender traits.[20]

Temporal Collisions: The Exorcism of Medievalism

Braddon's construction of the initial confrontation between Robert Audley and Lady Audley employs the Pre-Raphaelite painting of Lady Audley to construct a hybrid mixture of modern and medieval imagery. In this episode, Lady Audley appears as the true product of medievalism: created by a modern artist, she is nonetheless cast in a medieval mold, and is able to manipulate the conventions of both modernity and the Middle Ages to her advantage. Robert Audley, summoned to visit his ailing uncle, first confronts the Pre-Raphaelite portrait of Lady Audley that has dominated much of the novel. Initially, Braddon contrasts the modernity of the portrait with the age of its surroundings: "The picture was finished now, and hung in the post of honour opposite the window, amidst Claudes, Poussins and Wouvermans, whose less brilliant hues were killed by the vivid colouring of the modern artist" (236).[21] Note, however, that this description differentiates between the paintings solely based on color, not topic or subject matter. The implications of this contrast become clearer in the next sentence, in which the narrator, again emphasizing the vividness of Lady Audley's presence, states that her "bright face looked out of that tangled glitter of golden hair, in which the Pre-Raphaelites delight, with a mocking smile, as Robert paused for a moment to glance at the well-remembered picture" (236). Invoking the Pre-Raphaelites here brings to mind their particular brand of medievalism, which superimposes the medieval on the modern, and offers a yet more threatening interpretation of the portrait's eclipse of the surrounding, older paintings. The "vivid coloring" of Pre-Raphaelite medievalism "kill[s]" history and replaces it with a more threatening force in the form of the Pre-Raphaelite reinterpretation of Lady Audley.

This medievalist construction of Lady Audley's beauty allows her to draw subversively upon the chivalric structures of the novel. After Robert Audley confronts Lady Audley with his accusations of murder, she inserts her husband as a physical barrier between herself and danger: "Those who strike me must strike through him," she informs Robert (238). The narrator connects this act of defiance, and assertion of a lady's right to be defended, with the portrait that both Robert and the reader have already seen. "She defied him with her quiet smile – a smile of fatal beauty, full of lurking

significance and mysterious meaning," the narrator tells us, "the smile which the artist had exaggerated in his portrait of Sir Michael's wife" (238). The peculiar construction of this quotation reemphasizes both the chivalric structures of the novel and their connection to the pseudo-medieval portrait of the lady.

Lady Audley merges the moral weight of a medieval saint with the scheming agency of the New Woman. This force can only be contained by the erasure of chivalric structures within the novel, as is made clear by Lady Audley's ability to redefine the men closest to her. As Lady Audley watches over her ailing husband's bed, this perfect beauty becomes the marker of medieval sainthood: "Lucy Audley, with her disordered hair in a pale haze of yellow gold about her thoughtful face [...] might have served as a model for a medieval saint," the narrator informs us (237). In this scene, however, the gender role that Lady Audley has adopted likewise defines her husband's role. "What saintly martyr of the Middle Ages," the narrator asks, "could have borne a holier aspect than the man whose grey beard lay upon the dark silken coverlet of the stately bed?" (237). Lady Audley's role as a medieval saint necessarily redefines her husband's role as well: he must be the martyr to her performative sainthood.

Lady Audley's self-defense combines her pseudo-medieval Pre-Raphaelite beauty with Victorian domesticity. As Robert Audley begins to assemble the case for accusing Lady Audley of the murder of George Talboys, Lady Audley both invokes Sir Michael's chivalric protection and employs her own domestic graces for self-protection. She repeatedly refers to herself as a "poor little woman" who does not understand legal evidence. The narrator constantly emphasizes the performativity of the "poor little woman" construct, however. When Lady Audley begins to suspect that Robert has a strong case against her, she promptly responds by making tea. The narrator's description of the process emphasizes the witchcraft that she is working: "She seems a social fairy, weaving potent spells [...]. At the tea-table she reigns omnipotent, unapproachable. What do men know of the mysterious beverage? [...] To do away with the tea-table is to rob woman of her legitimate empire" (243). This scene demonstrates the extension of domestic power beyond the domestic sphere: functioning as a New Woman, Lady Audley manipulates these rituals in order to protect herself from the judicial system.

The old clock that obscured and muddied the temporality of Audley Court has, however, been replaced by the regular, inescapable ticking of a modern watch. During Robert's initial accusation of Lady Audley, the narrative immediately contrasts the description of Lady Audley as a "model for a medieval saint" with the restitution of a regular temporal discourse within the novel: "He paused for a few minutes before he spoke again. The regular

breathing of the sleeper, the ticking of a gold hunting-watch at the head of the bed, and the crackling of the burning logs, were the only sounds that broke the stillness" (237). Notably, this confrontation occurs over the body of the sleeping Sir Michael, and the narrative flow of the sentence directly connects Sir Michael's "regular" breathing with the rhythm of the watch's tick. It is particularly important here that the watch hangs over Sir Michael's bed, the symbolic center of the marriage between Sir Michael and Lady Audley. This positioning indicates that regular temporality has reasserted itself within the marriage, ending the rule of medievalism and chivalric discourses that enabled Lady Audley's domination.

After this symbolic shift in the temporal discourse of the novel, Lady Audley's loss of power occurs through her redefinition by Robert Audley. He does not, however, seek her trial and conviction for murder – or, as it turns out, attempted murder; instead, he removes her from the gendered systems of the novel. Looking down at the crouching woman, Robert Audley declares, "Henceforth you must seem to me no longer a woman [...]. I look upon you henceforth as the demoniac incarnation of some evil principle" (354). Lady Audley's subversive combination of Victorian angelicism and Pre-Raphaelite malevolence is no longer defined as the ultimate performance of femininity. Instead, she is excluded from its borders, redefined as solely the beautiful fiend portrayed in the portrait: "my lady looked up: a glittering light shone through the tears in her eyes, and the lines about her pretty rosy mouth, those hard and cruel lines which Robert Audley had observed in the pre-Raphaelite portrait, were plainly visible in the firelight," the narrator tells us (299). In this passage, as her face becomes indistinguishable from her portrait's, Lady Audley's transformation into a medieval monstrosity is complete. And thus, as a medieval monstrosity rather than a woman, Lady Audley may safely be confined to a sanitarium in France. Both she and medievalism are excised from the novel.

Replacing Medievalism: Classicism and the Restitution of Masculinity

In place of medievalism, however, another temporal discourse arises within the novel: classicism. Medievalism and the chivalric construct concentrate primarily on male devotion to a female idol, as exemplified by Sir Michael's relationship with Lady Audley. Despite his early fascination with Lady Audley, however, Robert's relationship with George Talboys prevents his absorption by these chivalric discourses.[22] Alicia astutely observes the importance of this relationship as Robert first discovers and reports his friend's disappearance: "What a dreadful catastrophe [...]. Since Pythias, in the person of Mr. Robert Audley, cannot exist for half an hour without Damon, in the person of Mr. Robert Audley!" (119). Here, Alicia specifically

connects the homosocial bond between Robert and George with classicism, suggesting an alternative to the threatening chivalric discourses that circulate around Lady Audley.

Invoking the bond between Damon and Pythias is potentially problematical in the context of the Victorian novel, however, because it suggests the blurring of a fine line between the homosocial and the homosexual.[23] Accordingly, Braddon transfers the burden of classical signification within the novel to George's sister Clara, yet constantly reminds the reader that Clara is, in more ways than one, a gateway towards the restitution of Victorian masculinity in the form of the relationship between Robert and George. Robert's introduction of Clara's role into *Lady Audley's Secret* specifically engages with the novel's peculiar reengagement with history. He exclaims, "Is it *me* the flying female wants? [...] It is an age of eccentricity, an abnormal era of the world's history. She may want me" (218). On one level, of course, Robert's pronouncement refers to the speed of change in the Victorian era and the sense of temporal unease that accompanies this change. On another level, however, this comment transfers historical signification to the body of Clara Talboys, who replaces Lady Audley as the driving force of temporality in the novel.[24] As Clara pushes Robert to complete his investigation and exposure of Lady Audley's past, the narrator comments, "Now this girl, this apparently passionless girl, had found a voice, and was urging him on towards his fate" (221). Like Lady Audley, Clara Talboys employs her body to redefine the plot of the novel as a classical drama: "Her beauty was elevated into sublimity by the intensity of her suppressed passion ... [Robert's] cousin was pretty, his uncle's wife was lovely, but Clara Talboys was beautiful. Niobe's face, sublimated by sorrow, could scarcely have been more purely classical than hers" (222). Braddon's use of Niobe, a symbol of mourning, redefines the temporal discourses of the novel to center upon Clara's evocation of Greek tragedy.

Braddon's descriptions of Clara, however, never allow the reader to forget that she functions as a substitute for her brother during the expulsion of medievalism and restitution of traditional masculinity in the novel.[24] Nearly every reference to Clara within the novel is paired with a corresponding mention of her brother. Whereas *Lady Audley's Secret* associates medievalism with ambiguity, confusion, and lethargy in the male characters, Clara's classical body drives Robert forward into traditional masculinity and revenge. He asks rhetorically, "What am I in her hands? [...] What am I in the hands of this woman, who has my lost friend's face and the manner of Pallas Athenè? She reads my pitiful, vacillating soul, and plucks the thoughts out of my heart with the magic of her solemn brown eyes" (275). Through the face and form of Clara, this passage links active masculinity, classicism, and male homosociality. Replacing classicism with medievalism permits the

restitution of masculinity within *Lady Audley's Secret* because it essentially collapses Robert's desires for female companionship and male homosociality into one body. Whereas the hybridity of Lady Audley's medievalist body – both fragile Victorian domestic angel and Pre-Raphaelite monstrosity – demands the fragmentation of the male body into motherly tenderness and knightly valiance, classicism permits the reunification of Robert's masculinity.

The shifts among classical, medieval, and modern discourses within the novel shed new light upon the gender instability of this archetypical sensation novel. They suggest that history is critical to the formation of these gendered structures, and that medievalism's reintroduction of chivalric discourse threatens Victorian modernity. Classicism, however, encourages the formation of homosocial male bonds within the novel, and therefore offers a more stable framework for the restitution of Victorian masculinity. Like the novel's feminized medievalism, however, classicism fundamentally depends upon the female body, which serves as the vehicle for all temporal discourse. To recall a metaphor from Alicia's wry commentary on Robert and George's relationship, Damon can only stand as surety for his Pythias when the properly historicized female body creates a conduit between them.

NOTES

1. Mary Elizabeth Braddon, *Lady Audley's Secret* (Peterborough: Broadview Press, 2003), 229.

2. In *Writing the Past, Writing the Future: Time and Narrative in Gothic and Sensation Fiction* (Bethlehem, PA: Lehigh University Press, 2009), Richard Albright cites evidence from Stewart Sherman to suggest that clocks before 1656 typically had only one hand, then proceeds to argue that in *Lady Audley's Secret,* "The old clock is 'stupid' only because it is out of date, lacking the precision, the 'now-saying' that modern life demands of its timepieces. It jumps to 'keep up' just as the people of the 1860s found themselves 'hurried to death,' and just as Robert jumps to keep up, in the present, with his aunt's past movements" (188).

3. Elaine Showalter, *A Literature of Their Own: British Women Writers from Brontë to Lessing* (Princeton, NJ: Princeton University Press, 1999), 163, 164.

4. Albright, *Writing the Past.*

5. Albright, *Writing the Past*, 18.

6. Reintroducing gender into a temporal reading of *Lady Audley's Secret* differs significantly from Albright's approach; he specifically mentions a desire to shift away from other critics' focus on gender in the gothic and sensation novels in order to read these novels "dialogically rather than monologically." (*Writing the Past*, 17). I would argue, however, that the diologism of a temporal reading of *Lady Audley's Secret* can be fruitfully recombined with a gendered reading of the novel. It is, after

all, difficult to wholly separate the sensation novel from the construction of masculinity and femininity, and history's role in this construction destabilizes both Braddon's presentation of gender and the traditional interpretation of Victorian medievalism.

7. Christina Crosby, "Reading the Gothic Revival: 'History' and Hints on Household Taste," in Linda M. Shires, *Rewriting the Victorians: Theory, History and the Politics of Gender* (New York: Routledge, 1992), 101–15 (101).

8. Elizabeth Tilly, "Gender and Role-Playing in *Lady Audley's Secret*," in Valeria Tinkler-Villani, Peter Davidson, and Jane Stevenson, eds., *Exhibited by Candlelight: Sources and Developments in the Gothic Tradition* (Amsterdam: Rodopi, 1995), 197–204 (197).

9. Tilly, "Gender," 197.

10. In this article, I employ the term "medievalist" as an adjective to refer to Braddon's (and the Victorians') literary interpretation of the Middle Ages. I find this term useful because it indicates some degree of imprecision; within the structures of the novel, anything "old" becomes vaguely medieval. Furthermore, my use of this term indicates the gap between the historical reality of the Middle Ages and the nineteenth century's reinterpretation of this time period.

11. Vincent A. Lankewish, "Victorian Architectures of Masculine Desire," *Nineteenth Century Studies* 14 (2000): 93–119 (97). In this article, Lankewish's primary argument is that A. W. N. Pugin and John Ruskin "encoded within their most famous treatises on the [architecture] deep anxieties about gender, the body, sensuality, and sexuality" (93). It is important to note that the "aesthetic history" that Lankewish mentions in the above could be either medieval or classical, since the scholars whom he mentions pursue both.

12. The overwhelming popularity of this work makes it an excellent model for the engagement of medievalism, architecture, and gender issues in the Victorian consciousness. As Jennifer Gribble's *The Lady of Shalott in the Victorian Novel* (London: MacMillan, 1983) suggests, the motif of the confined lady within the tower persists throughout Victorian literature, whether as a conscious invocation of Tennyson or an independent representation belonging to the same cultural tradition.

13. Alfred, Lord Tennyson, "The Lady of Shalott." *The Camelot Project at the University of Rochester.* <http://www.lib.rochester.edu/camelot/cphome.stm>, accessed 15 February 2011.

14. Albright, *Writing the Past*, 188.

15. Crosby, "Reading the Gothic Revival," 104.

16. For further discussions of Audley Court's decay and its significance in the context of Victorian culture, see Aeron Haynie, "'An Idle Handle That Was Never Turned, and a Lazy Rope So Rotten': The Decay of the Country Estate in Lady Audley's Secret," in *Beyond Sensation: Mary Elizabeth Braddon in Context*, ed. Marlene Tromp (Albany: State University of New York Press, 2000), 63–74.

17. For more on the relationship between Lady Audley's body and the house that frames it, see Elizabeth Langland's discussion in "Enclosure Acts: Framing Women's Bodies in Braddon's *Lady Audley's Secret*," anthologized in *Beyond Sensation*. In this essay, Langland says, she "explore[s] the relationship between the

enclosure of lands and the enclosure of bodies reflected in descriptions of domestic sanctuaries that function as visible signs of the social order" (3). Although Langland concentrates chiefly on issues of confinement and limitation, the parallel that she draws between women's bodies and the estate could also be fruitful in the context of Lady Audley's similarities to the house that she inhabits.

18. Daniel Punday, *Narrative Bodies: Towards a Corporeal Narratology* (New York: Palgrave Macmillan, 2003), 88.

19. Sophia Andres, *The Pre-Raphaelite Art of the Victorian Novel: Narrative Challenges to Visual Gendered Boundaries* (Columbus: Ohio State University Press, 2005), xvii.

20. George Talboys also offers a fascinating example of the dangers of medi-evalism to the male characters. In the opening scenes of the novel, as George is returning from Australia, the narrator reports that "he freely owned that he had no talent for whist, and that he didn't know a knight from a castle upon the chess board" (55). Although the explicit reference here is clearly to the game of strategy, this quotation reveals George's inability to participate in the machinations of chivalric structures. Since Lady Audley – or, in this case, Helen Talboys – operates almost entirely within these structures, George's inability to function within the medievalist construct of the novel plays a key role in his downfall.

21. The choice of artists here is interesting; all three of the painters worked in the sixteenth and seventeenth centuries. Although they are too late to be strictly medieval, they worked at a sufficient historical remove from the Pre-Raphaelites to make them representatives of the same vague and distant past that much of the imagery surrounding Audley Court evokes.

22. Early in the novel, Robert exclaims, "George Talboys, I feel like the hero of a French novel; I am falling in love with my aunt" (94). Later, his extreme eager-ness to view Lady Audley's portrait indicates a continuing fascination with the lady. He cries, "Her portrait! ... I would give anything to see it, for I have only an imper-fect notion of her face" (103). However, he makes both of these pronouncements in the presence of George, and his fascination with his aunt serves, in a peculiar way, to solidify the relationship between the two men. They are, after all, entranced by the same woman.

23. Other critics have also suggested a link between classicism and homosexu-ality in Victorian culture. For a more detailed exploration of this relationship, see Linda Dowling, *Helenism and Homosexuality in Victorian Oxford* (Ithaca, NY: Cornell University Press, 1994), which investigates "the way Greek studies operated as a 'homosexual code'" and "swe[pt] aside the deep fears of 'corruption' and 'effemi-nacy' associated with male love [...] that [...] had exercised a powerful hold over the English cultural imagination for over two hundred years" (xiii, xv).

24. It is worth noting that Braddon twice uses a classical image to describe Lady Audley. "She's for all the world like one of those what's-its-names, who got poor old Ulysses into trouble," George Talboys says of his wife when describing her to Robert (75). The other classical reference to Lady Audley in the novel likewise constructs her as a siren: during the scene in which Lady Audley attempts to convince Sir Michael of Robert's madness, the narrator comments, "It would have seemed as foolish to expect dignified reserve or womanly gravity from this

amber-haired syren, as to wish for rich basses amid the clear treble of a sky-lark's song" (297). The majority of historical imagery connected with Lady Audley, however, is medievalist and Pre-Raphaelite. These shifts into classical imagery, which both pose Lady Audley as a threatening figure, suggest her ability to contaminate any historical and temporal discourse into which she enters, indicating that it is the body of the woman which is the true regulator of time within the novel.

25. For a more detailed exploration of the role of women in homosocial relationships between men in the Victorian novel, see Eve Kofosky Sedgewick's *Between Men: English Literature and Male Homosocial Desire* (New York: Columbia University Press, 1985). I draw on her work here to suggest that Clara becomes a socially acceptable substitute for her brother in Robert's mind, and also that one of the primary functions of Robert's relationship with Clara is to strengthen the relationship between George and Robert.

"Lessons Fairer than Flowers": Mary Eliza Haweis's *Chaucer for Children* and Models of Friendship

Karla Knutson

Victorian medievalism constructed the Middle Ages as a simpler time in contrast to the increasingly industrial society of nineteenth-century England, a period often characterized by social and economic disorder.[1] "Simpler," however, held ambivalent meanings, indicating not only an idealization of the Middle Ages as "a period of faith, order, joy, munificence, and creativity"[2] but also condemnation of its crude, unrefined culture. Literary discourses reflected this construction, as writers and critics spoke of the Middle Ages as the infancy of the English nation and their present as its maturity.[3] These discourses are evident in the lengthy history of Geoffrey Chaucer's reception and particularly in the adaptation of his work for children, the subject of this article. Much of the credit for Chaucer's association with this theoretical schema can be given to a tradition of scholarship popularized by John Dryden (1631–1700).[4] In the preface to *Fables Ancient and Modern, Translated into Verse, from Homer, Ovid, Boccace, & Chaucer* (1700), Dryden asserts that Chaucer lived during the English nation's childhood: "We can only say, that he liv'd in the Infancy of our Poetry, and that nothing is brought to Perfection at the first. We must be Children before we grow Men."[5] Yet within the same text, Dryden points to Chaucer's keen description of early English people as evidence for giving Chaucer the title of "the Father of English Poetry."[6]

Although these discourses of concurrent paternity and infancy may appear to be incompatible, they do not compete. In fact, they converge in adaptations of medieval literature for Victorian children. As this article will discuss further, the unpolished literature of the English Middle Ages was seen as ideal subject matter for children, the people in Victorian society

whose abilities were considered to most closely correspond to the supposedly infantile and linguistically deficient people of medieval England. Mary Eliza Joy Haweis's *Chaucer for Children: A Golden Key* (1876) reflects this attitude toward the Middle Ages in its discussion of Chaucer's language. However, Haweis also draws upon Chaucer's ethos as the "Father of English Poetry" to prove Chaucer's texts to be not only appropriate reading material but also edifying moral lessons for children.

Her instructional aims are evident immediately upon examination of the text. The front cover displays her own artwork,[7] consisting of five arches depicting scenes from *The Canterbury Tales* and daisies strewn across the remaining space. The fifth arch is covered by a lock and a key, the golden key of the book's title, to be unlocked by the explication on the inside of the cover. Here Haweis explains that the daisies' presence on the cover represents what she hopes her audience will learn: "The Daisy, symbol for all time both of Chaucer and of children, and thus curiously fitted to be the connecting link between them, may point the way to lessons fairer than flowers in stories as simple as daisies."[8]

The primary "lessons fairer than flowers" *Chaucer for Children* teaches are about social interaction with peers. Haweis provides models of male friendship and reinforces norms of Victorian English masculinity in her efforts to teach her audience of young boys the skills necessary to make and keep friends. Examples of sincere and insincere friends are evident in multiple parts of the text: through the creation of a close friendship between Chaucer and John of Gaunt in the introductory material, through the presentation of Chaucer as a pilgrim in an adaptation of the *General Prologue*, through the portraits of the only two Canterbury pilgrims identified as friends, the Pardoner and the Summoner, and through examples of unfaithful friends in *The Pardoner's Tale*. *Chaucer for Children* thus teaches the young male audience not only about Chaucer, the "Father of English Poetry," but also skills for their social development.

In addition to the didactic lessons Haweis draws from Chaucer's life and texts, there are several reasons Chaucer would be an attractive author to adapt for an audience of Victorian children. A primary reason is his "unrefined" language. In the introductory "Forewords" addressed to the mother who presumably will read the book to her child, Haweis explains the rationale for her project and how Chaucer's language inspired her to adapt Chaucer's texts for children: "A Chaucer for Children may seem to some an impossible story-book, but it is one which I have been encouraged to put together by noticing how quickly my own little boy learned and understood fragments of early English poetry. I believe that if they had the chance, many other children would do the same" (xi). Haweis compares Chaucer's language directly to the language of Victorian children, citing the

similarities: "I think that much of the construction and pronunciation of old English which seems stiff and obscure to grown up people, appears easy to children, whose crude language is in many ways its counterpart" (xi). Haweis also notes that Chaucer's poetry seems suitable for children because of its narrative structure: "The narrative in early English poetry is almost always very simply and clearly expressed, with the same kind of repetition of facts and names which, as every mother knows, is what children most require in story-telling" (xi). Haweis's comments reflect the previously mentioned commonplace of Victorian medievalism, a construction of the Middle Ages as unsophisticated and the present as fully mature.

Another reason Chaucer's texts were deemed suitable children's reading was the trend in the late nineteenth century to modify adult literature for children. Medieval texts were popular choices to adapt for children, especially stories about King Arthur and Robin Hood; these types of texts illustrated Victorian medievalism's fantasies of an English past as a traditional, orderly society.[9] These stories about England's early people and customs also narrated a patriotic "childhood of the race" for English children.[10]

Chaucer's reputation provides an additional explanation for why his works were adapted for children. As "the father of English poetry," Chaucer was an obvious figure to present to children learning about the history of their nation. Moreover, Frederick Furnivall (1825–1910) had already begun to position Chaucer as an ethical paragon through efforts such as the founding of the Chaucer Society in 1868. Furnivall suggested that Chaucer, the exemplary father, must be studied because of his important role in the history of England and his texts' ability to promote self-reflection and thus positively influence the lives of contemporary English people.[11]

In order to lend weight to its moral lessons, *Chaucer for Children* draws upon these movements by emphasizing Chaucer's authority as a figure of great significance to England.[12] In the introductory section called "Chaucer the Tale-teller," which is directly addressed to a young reader and provides background information about Chaucer's life and the culture and language of the Middle Ages, Haweis exhorts the child reader to remember Chaucer's name, "for he was so great a man that he has been called the 'Father of English Poetry' – that is, the beginner or inventor of all the poetry that belongs to our England" (1). In the earlier foreword directed at the mother, Haweis explains that all English children need to know about Chaucer's contribution to their nation: "It seems but natural that every English child should know something of one who left so deep an impression on his age, and on the English tongue, that he has been called by Occleve 'the finder of our fair language'" (xi). Haweis also stresses that this important figure who has done so much for England is an excellent teacher for children, reassuring

the mothers that his poetry has an edifying message: "Chaucer is, moreover, a thoroughly religious poet, all his merriest stories having a fair moral; even those which are too coarse for modern taste are rather *naïve* than injurious; and his pages breathe a genuine faith in God, and a passionate sense of the beauty and harmony of the divine work" (xii). To prove his merit as a moral guide, Haweis laces Chaucer's biographical information with remarks about his valuable qualities. In "Chaucer the Tale-teller," addressed to the child reader, Haweis immediately introduces him as "a very wise and good man" (1). Having established his beneficent moral nature, Haweis continues to list additional positive traits: "You may see how good and clever Chaucer was by his face; such a wise, thoughtful, pleasant face! He looks very kind, I think, as if he would never say anything harsh or bitter; but sometimes he made fun of people in a merry way" (3). She also highlights Chaucer's work ethic: "All day he worked hard, and his spare time was given to 'studying and reading alway,' till his head ached and his look became dazed" and how this virtue benefited his education: "but there is no doubt that his education was a good one, and that he worked very hard at his books and tasks, otherwise he could not have grown to be the learned and cultivated man he was" (3). Haweis's Chaucer is a good-natured, thoughtful man who cares about others, is not afraid of facing a difficult task, and is intellectually curious. These are habits most mothers would want to cultivate in their children. His texts also reflect these virtues: "The CANTERBURY TALES are full of cheerfulness and fun; full of love for the beautiful world, and full of sympathy for all who are in trouble or misery. The beauty of Chaucer's character, and his deep piety, come out very clearly in these tales, as I think you will see" (11–12). Haweis's efforts parallel those of Furnivall, suggesting that Chaucer can positively influence his readers.

Having established her rationale for adapting Chaucer for children, Haweis identifies the particular audience she envisions reading the text. Although the "Forewords" speaks "To the Mother," the rest of the text directly addresses an audience of children, primarily male children. Within "Chaucer the Tale-teller," Haweis invokes this audience: "Chaucer lived in England 500 years ago – a longer time than such a little boy as you can even think of" (1). The intended male audience is evident also in the dedication to her son Lionel: "Chiefly for the use and pleasure of my little Lionel, for whom I felt the need of some book of the kind, I have arranged and illustrated this Chaucer story-book" (v). While the dedication does not directly express a didactic intention, the passage's reference to feeling impelled to seek a book like this suggests a desire to share the lessons offered by Chaucer with her own son. Lionel and other boys also would need to know of Chaucer because "[…] when you are grown up, you will often hear of Chaucer and his works" (1). When mature, these boys

possibly could join Furnivall's Chaucer Society, a group founded to discuss and admire Chaucer.

Chaucer for Children instructs this young male audience in the ways in which they will be expected to interact when grown. The Victorian man that young boys were supposed to emulate was a good citizen, much like Haweis's Chaucer: "The manly man may be patriotic, generous, broad-minded, decent, chivalrous and free-spirited by turns."[13] Charles Kingsley (1819–75) and Thomas Hughes (1822–96), champions of "muscular Christianity" in the late nineteenth century, expounded upon this concept, including its association of masculinity with ideas of courage, physical strength, duty to others, and religious devotion in Hughes's literature for boys and young men.[14] As this ideal of manliness gradually moved farther from religious influence, it developed into "the cult of athleticism," whose focus on "fair play" and "being a good loser" influenced British imperialism and the public schools.[15] This typical Victorian man was expected to retain rigid control of himself, keeping "what was known as the Englishman's 'stiff upper lip.'"[16] A threat to this emphasis on reserve as an essential aspect of manliness was the "dandy" who flouted convention by calling attention to himself.[17] The Victorian ideal of masculinity was influenced in part by nineteenth-century medievalism and nostalgia for chivalry. Because it was considered by the Victorians to have been an integral part of the early English nation, chivalry provided a sense of order, a model of behavior for the nineteenth-century man to emulate in order to seem quintessentially English.[18] Artistic works of medievalism glorifying chivalry in turn instruct the Victorian boy how to behave like a gentleman, a primary reason for adapting medieval literature into versions for children.

Chaucer for Children teaches its audience of male children about not only Chaucer and his texts but also how to be faithful fellows in a community and good adult Englishmen living by the code of the gentleman. Haweis uses different types of textual examples to illustrate these lessons, the previously discussed foreword to the mother, "Chaucer the Tale-teller," and Chaucer's poetry. Haweis includes six selections from *The Canterbury Tales*: "Chaucer's Prologue," which is Haweis's version of Chaucer's *General Prologue*, "The Knight's Tale," "The Friar's Tale," "The Clerk's Tale," "The Franklin's Tale," and "The Pardoner's Tale." Next are four of Chaucer's shorter poems, the "Complaint of Chaucer to his Purse," "Two Rondeaux," "Virelai," and "Good Counsel of Chaucer." The poems are presented in both Chaucer's Middle English verse, with Haweis's facing translation, and occasional prose paragraphs used mainly to condense the tales and omit elements deemed inappropriate for children. After each poem, Haweis explicates its message and the rationale for its inclusion in a section called "Notes by the Way." Of the adaptations,

"Chaucer's Prologue" and "The Pardoner's Tale" offer the primary opportunities for sharing lessons about masculinity and social interaction.[19] These tales reinforce Haweis's previous presentation of Chaucer's model friendships in "Chaucer the Tale-teller."

Chaucer figures as the consummate example of a friend in two sections of *Chaucer for Children*, "Chaucer the Tale-teller" and "Chaucer's Prologue." In the former, Haweis demonstrates Chaucer's exemplary friendship through the fabrication of a close relationship between Chaucer and John of Gaunt. While discussing Chaucer's numerous positions in the court, Haweis creates a profound friendship from what was a professional relationship of patronage between the king's son and a man who served in a variety of court and government posts, including page and customs official: "he found a fast friend in John of Gaunt, one of the sons of King Edward III" (5). She provides further evidence of their friendship, the "many instances recorded of John's attachment to both Chaucer and Philippa all his life," including being the same age and the records of silver cups presented to Philippa, Chaucer's wife (7). In fact, Haweis suggests that Gaunt did so much for Chaucer that she can easily omit some of the examples because the reader "would get tired of hearing about it" (8). She does offer a few examples of how Gaunt rewarded Chaucer for being "shrewd and trustworthy" (8) and used his influence to help Chaucer receive the king's favor, attributing the king's gift to Chaucer of a daily pitcher of wine to Gaunt: "This seems like a mark of personal friendship more than formal royal bounty" (8). She cites Gaunt's "goodwill" for Chaucer's appointments in the customs offices (8), a grant of £10 per year, the custody of a rich ward, and a reward for discovering fraud in the customs office (9).

Chaucer is not the only one who benefits from this situation. Instead, their relationship demonstrates the mutually beneficial nature of a true friendship. Both men are generous and selfless, and their love for each other is evident in the deep, unwavering loyalty shown when each remembers the other during periods of both prosperity and distress:

> When John of Gaunt was in power he never forgot Chaucer. When he became unpopular it was Chaucer's turn to be faithful to him; and faithful he was, whatever he suffered, and he did suffer for it severely, and became quite poor at times, as you will see. Directly John came into power again up went Chaucer too, and his circumstances improved. There are few friendships so long and so faithful on both sides as this was. (7)

This passage refers to the time in which Gaunt was out of favor with the people because of his governance before the young King Richard was ready

to rule. Haweis describes Chaucer's fortunes as falling with those of his friend because the people were angry with Gaunt and with "everybody who remained his friend. So, of course, they did not like Chaucer" (9). Chaucer "took up the part of his friend warmly, and sat in the House of Commons as representative of Kent [...] on purpose to support the ministers who were on John of Gaunt's side" (10). Even after his public support for Gaunt caused him to lose his positions in the customs offices, "Chaucer never wavered or changed. And his faithfulness to his friend deserves better than the unjust suspicion that his disgrace was warranted by neglect of his duties. Chaucer was too good, and too pious, and too honourable a man to commit any such act" (10). In 1389, when Richard took control of the government and Gaunt returned from Portgual, "Immediately Chaucer was thought of" (11).

Haweis's version of the relationship between John of Gaunt and Chaucer becomes even closer when John of Gaunt marries Philippa's sister:

> It is touching to see how faithful these two friends were to each other, and how long their friendship lasted. The first we hear of it was about 1359, the year when John married Blanche, and for forty years it remained unbroken. Nay, it grew closer and closer, for in 1394, when John of Gaunt and Chaucer were both middle-aged men, John married Philippa's sister [...] so that Chaucer became John of Gaunt's brother. (7)

Their friendship has reached new levels of intimacy; transgressing social position, they become not only friends but also family and are joined by ties of blood through their wives and extended families. To prove this, Haweis depicts the men's families as intermingling socially: "Still it is pleasant to find that Henry of Lancaster shared his father's friendship for Chaucer. I dare say he had been rocked on Chaucer's knee when a little child, and had played with Chaucer's children" (12). Haweis's construction of a familial association deepens the affection that the audience is supposed to assume exists between the two men. Consequently, Chaucer experiences significant sorrow when Gaunt dies: "it must have been a real grief to Chaucer, then an old man of sixty, when this long and faithful friend was taken from him" (12).

This ideal friendship between Chaucer and John of Gaunt demonstrates every aspect of manly behavior Haweis is at pains to instill in her young male audience – loyalty, generosity, selflessness, affection, courage, duty, "being a good loser," and keeping the Victorian Englishman's "stiff upper-lip" in the face of adversity. Creating this close, mutually beneficial, and loving male friendship provides Haweis with excellent justification for using Chaucer's texts to instruct children in being good fellows. Who better

to give advice about friendship than a person who obviously was such an exemplary friend himself?

In "Chaucer's Prologue," Chaucer again appears as an ideal friend. He immediately familiarizes himself with each of the twenty-nine pilgrims staying at the Tabard Inn:

> there arrived towards night at the inn a large company of all sorts of people – nine-and-twenty of them: they had met by chance, all being pilgrims to Canterbury. [...] And shortly, after sunset, I had made friends with them all, and soon became one of their party. We all agreed to rise up early, to pursue our journey together. (19)

Haweis's Chaucer is extremely efficient at establishing friendships. He "made friends with them all" between their arrival "towards night" yet before the sun set. Also, he learns a great deal about each pilgrim in a brief amount of time; he is able to tell the reader "who these people were, their condition and rank, which was which, and what they looked like" (19). Chaucer must be exceptionally personable in order to acquire such detailed knowledge of the other pilgrims and to simultaneously endear himself to them so effectively that they embrace him as a traveling companion. However, Haweis's translation of this scene takes creative license with Chaucer's Middle English text, as do many of the passages she condenses into prose paragraphs. Chaucer involves two different uses of the term "felaweshipe" in his description of the pilgrims' meeting, first stressing, as Haweis also does, that they only recently were acquainted:

> At nyght was come into that hostelrye
> Wel nyne and twenty in a compaignye
> Of sondry folk, by aventure yfalle
> In felaweshipe, and pilgrims were they alle.[20]

This use of "felaweshipe" implies that the pilgrims meet and spend a brief amount of time together as acquaintances, participating in informal conversation common to guests at an inn. This behavior is what twenty-first-century readers would expect, based on common understandings of Western social mores. The first definition of "fēlauship" in the *Middle English Dictionary* suggests that medieval English people also would have expected this type of relationship; "fēlauship" could be defined as "The condition of being in company with another or others; casual or temporary companionship; social intercourse, company."[21] "Temporary companionship" signifies the coincidental or "by aventure" nature of the scenario Chaucer describes.

The second meaning of "felaweshipe" points to the actual group of pilgrims. Soon after the pilgrims' first casual encounter, they make traveling plans based on the realization of their shared destination:

> And shortly, whan the sonne was to reste,
> So hadde I spoken with hem everichon
> That I was of hir felaweshipe anon,
> And made forward erly for to ryse,
> To take oure wey ther as I yow devyse. (I.30–34)

After speaking with each pilgrim, Chaucer joins their group, according to another Middle English definition of "felaweshipe": "A band of associates or companions; a company of pilgrims."[22] Although in the Middle Ages the term could also refer to "close or intimate companionship; comradeship, friendship,"[23] the textual evidence indicates the pilgrims' continued status as acquaintances. Chaucer has not immediately "made friends with them all" in the way that Haweis implies. He has entered into a temporary and mutually beneficial social alliance with other travelers. It is certainly possible that Chaucer's character could sustain and deepen a relationship with another pilgrim, but the relevant evidence for a connection of this variety is lacking in *The Canterbury Tales*. Haweis's version instead presents an amiable and likeable Chaucer, a person able to befriend others swiftly. Substituting "made friends" as a synonym for joining a group emphasizes the importance of warm interactions in relationships and reinforces the habits of being agreeable and using good manners with others. Haweis's phrasing teaches children that friendliness is the first step toward initiating and maintaining a lasting, intimate association.

Chaucer's *General Prologue* provides Haweis with another example of friendship. Although many of the pilgrims are described as riding together, for example the Franklin rides with the Sergeant of the Law "in his compaignye" (I.331), Chaucer specifically identifies only the Pardoner and the Summoner as friends: "With hym [the Summoner] ther rood a gentil Pardoner / Of Rouncivale, his freend and his compeer" (I.669–70). But Haweis's continual references linking these two as friends occur even more frequently than Chaucer's lone reference, as she labels them as friends in both of their portraits and again in the notes to the illustrations: "the Summoner, and his friend the smart Pardoner" (107). The repeated identification of the two as friends implies that the pair will be important to Haweis's pedagogical project. However, these friends do not behave like Haweis's Chaucer and John of Gaunt. The Pardoner's unabashed delight in fraud and his ambiguous association with the Summoner, another known charlatan, mark him as significantly different from Haweis's version of

Chaucer, the ideal friend and ethical paragon. As does any children's book author, Haweis had to consider what would be deemed appropriate material for the children reading her adaptation. The inclusion of *The Pardoner's Tale* may seem remarkable to modern readers familiar with the Pardoner's deceitful behavior and the significant body of work published on his sexuality. Because Chaucer's bawdy tales could not be read by Victorian children if left unmodified, Haweis would need to choose tales or alter certain tales and the descriptions of several pilgrims according to these social parameters.[24] Haweis appears to have found *The Pardoner's Tale*'s didactic warning about vice too valuable to omit from her text.[25] Moreover, it explores the nature of friendship and provides an excellent example of friends behaving badly, a striking and instructive contrast to the benefits illustrated by the relationships Haweis constructs for Chaucer. In order to use this narrative in *Chaucer for Children*, Haweis needed to sanitize the Pardoner. She does this by eliminating any indications of sexual indeterminacy and desire and by downplaying his skillful deception of the pious.

Although Haweis avoids any allusion to it, the Pardoner's sexuality has been a heated topic of debate in twenty- and twenty-first-century Chaucer Studies. W. C. Curry began this discussion in 1919 by labeling the Pardoner a congenital eunuch.[26] This label continues to be examined[27] while alternative readings are posed. The Pardoner thus alternatively becomes a "feminoid" male,[28] a hermaphrodite,[29] a homosexual or gay man,[30] or also an effeminate "womanizer."[31] Glenn Burger and Robert S. Sturges avoid the issue of categorization by discussing the ways in which the Pardoner's sexuality plays a role in the text, including in his interactions with other pilgrims.[32]

Chaucer for Children does not indicate if Haweis would use any of the previously mentioned terms to label the Pardoner, but her adjustment of his portrait and his prologue indicates that she certainly finds him to be different from the Victorian ideal of masculinity. She neglects to include the lines that have caused such a lengthy debate in the academic community:

> A voys he hadde as small as hath a goot.
> No berd hadde he, ne nevere sholde have;
> As smothe it was as it were late shave.
> I trowe he were a gelding or a mare. (I.688–91)

Instead, in Haweis's verse and prose translations and her accompanying visual illustration, there is no reference to sexuality in the description of his physical features. The Pardoner's high-pitched voice and Chaucer's narrator's comment on the indeterminate classification of his sexuality are elided to remove any question of sexual desire or lack of conformity to Victorian

manliness. Haweis's depiction of the Pardoner suggests a man similar to the Victorian dandy, characterized by his vanity and his attempts to call attention to himself: "he had long thin hair, as yellow as wax, that hung in shreds on his shoulders. He wore no hood, but kept it in his wallet: he thought himself quite in the tip-top of fashion" (31). Chaucer's Pardoner, like a dandy, hopes to be recognized for his fashion sense, for his good looks, and, most importantly, for his skill in selling relics and pardons. By casting him as a dandy, Haweis labels him according to Victorian standards of undesirable behavior.

Haweis's physical description of the Pardoner is fairly similar to Chaucer's version:

> By ounces henge his lokkes that he hadde,
> And therwith he his shuldres overspradde;
> But thynne it lay, by colpons oon and oon.
> But hood, for jolitee, wered he noon,
> For it was trussed up in his wallet.
> Hym thought he rood al of the newe jet. (I.677–82)

Chaucer emphasizes the Pardoner's hair, describing it in detail as hanging in fine, greasy clumps and spread so thinly across his shoulders that the strands are visible individually, "oon and oon." In Haweis's translation, however, the only attribute that a reader might interpret as being unattractive would be the Pardoner's limp hair hanging by shreds. The rest of her description follows Chaucer's closely, as she provides four lines of Chaucer's Middle English text[33] facing her translation:

> Dishevell'd, save his cap, he rode barehead:
> Such glaring eyes, like to a hare, he had!
> A vernicle was sewed upon his cap;
> His wallet lay before him, in his lap. (32)

This description replicates Chaucer's original text, except for the notable exclamation mark at the end of the second line. Haweis's choice of punctuation calls attention to the Pardoner's glaring eyes but dismisses them as being innocuous, like a rabbit.

Haweis's written description of the Pardoner's physical attributes is generally faithful to Chaucer's text, but her own illustrations are not. Her woodcut (Fig. 1) accompanying the portrait depicts a character that cannot be recognized as the Pardoner of either writer. Instead of the bug-eyed and ungroomed man described by both Chaucer and Haweis, the Pardoner appears in Haweis's woodcut as a boy. He is a docile youth, with long, fair

The Pardoner.

Figure 1.
Mary Eliza Haweis, *The Pardoner*,
1895. Woodcut. 4cm x 3cm.

hair that appears thick, almost luxurious, as it spreads across his shoulders. The expression on his smooth, clear face is quiet, and his eyes are not "glarynge," as they are in both Chaucer's and Haweis's written versions (I.684). Haweis's Pardoner rests on a bench with a knapsack strapped across his body and his hands folded, perhaps in prayer, on top of another box-like case, which presumably carries relics or items necessary for traveling. The image is rather more attractive than that suggested by Chaucer's description of a man with greasy, limp, untethered hair and staring, googly eyes. The frontispiece (Fig. 2) of *Chaucer for Children*, the first colored picture entitled "Mine Host Assembling the Canterbury Pilgrims," depicts the same Pardoner. He kneels next to the Summoner, looking up at the other pilgrims with a calm expression upon his face. His hair again appears thick, though its cut does not appear even. There is nothing in his appearance to suggest malevolence or even mischievousness. Haweis's elisions of any verbal allusions to sexuality render the Pardoner unthreatening, and her artwork is more censorious. These illustrations do not even suggest the vain Victorian dandy alluded to in her text but instead depict a passive, well-behaved young man, a model to be emulated by the youthful readers.

Neither Haweis's written or visual presentation of the Pardoner points to Chaucer's portrait of the Pardoner as a gregarious swindler, proud of his ability to tell a sermon and sell fake relics: "with feyned flaterye and japes, / He made the person and the peple his apes" (I.705–6). However, while Haweis presents the Pardoner as desiring to be admired for his physical appearance, she omits Chaucer's rather lengthy fifteen-line description of the Pardoner's superb skill in trickery and his longing to be acknowledged for that form of prowess as well. Chaucer's Pardoner spends much of his

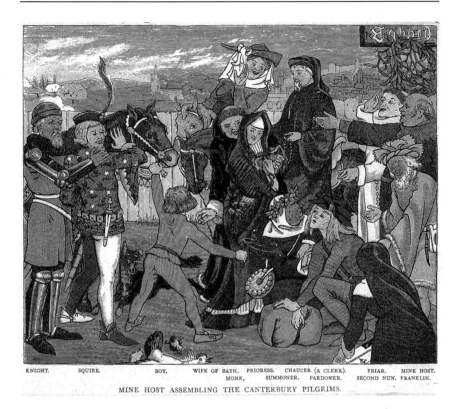

KNIGHT. SQUIRE. BOY. WIFE OF BATH. PRIORESS. CHAUCER (A CLERK). FRIAR. MINE HOST.
 MONK, SUMMONER. PARDONER. SECOND NUN. FRANKLIN.
MINE HOST ASSEMBLING THE CANTERBURY PILGRIMS.

Figure 2. Mary Eliza Haweis, Frontispiece, 1895.
Colored picture. 15¾cm x 19¾cm.

prologue confessing the elaborate ruses he employs to entice unsophisticated parishioners to purchase his wares. In contrast, Haweis's introductory statement that "The Pardoner was a great cheat too" (linking the Pardoner to his friend the Summoner) and the unflattering physical description could be forgotten as the reader gazes upon the picture of the humble youth and reads her praise: "He was in church a noble ecclesiast. / Well could he read a lesson or a story, / But ever best he sang the offertory" (32). Haweis leaves the reader with this impression, emphasizing his earnest and pious participation in the church service. By glossing over Chaucer's detailed explanation of the Pardoner's attempts to deceive parishioners, Haweis presents her readers with the picture of a devout young man.

Instead, the Summoner bears the brunt of the blame for their mutual goal of swindling. Haweis indicates that because the Pardoner also was a cheat, "the friends were well matched" (31). However, in contrast to the Pardoner's earnest devotion, the Summoner has been portrayed as a frightful

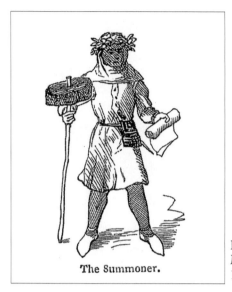

The Summoner.

Figure 3.
Mary Eliza Haweis, *The Summoner*,
1895. Woodcut. 5cm x 3cm.

creature: "Children were sore afraid of him when they saw him, he was so repulsive, and so cruel in extorting his gains. He was a very bad man: for though it was his duty to call up before the Archdeacon's court anybody whom he found doing wrong, yet he would let the wickedest people off, if they bribed him with money" (31). Haweis does not hesitate to label the Summoner as "a very bad man," an extortionist who bilks others for monetary gain. The woodcut of the Summoner (Fig. 3) does not present an attractive image either; the figure takes a wide stance, with arms and legs spread, commanding a great deal of space and suggesting aggression. His face is shaded in, alluding to Chaucer's description of his "fyr-reed cherubynnes face, / For saucefleem he was" (I.624–5). Haweis includes these two lines in her facing translation but omits Chaucer's next section: "As hoot he was and lecherous as a sparwe, / With scalled browes blake and pile berd" (I.626–7). These lines indicate that the cause of his reddish complexion and profuse pimples may be venereal disease, a detail Haweis omits because of her young and impressionable audience who must remain innocent of sexual knowledge. The frontispiece depicts a similar Summoner, but its colorful image provides a closer view of the Summoner's red, pock-marked visage. Unlike the calm Pardoner, next to whom he kneels, the Summoner scowls angrily at the Friar. He appears ready at any moment to jump up and issue a challenge or an insult. A reader gazing at this picture could construe his red face as a sign of his anger rather than a sign of the lechery Haweis mentions or the venereal disease she omits.

Haweis deals with a passage about the Pardoner's sexuality in a similar

way. She first mentions the Pardoner's friendship with the Summoner in the latter's portrait: "The Summoner was a terrible-looking person, and rode with the Pardoner, who was his friend: the Pardoner singing a lively song, and the Summoner growling out a bass to it, with a loud, harsh voice" (31). In this version, the friends sing a "lively" song. But "lively" is a vague term and indicates any number of relationships. Haweis explicitly ignores Chaucer's indication that they sing a love song: "Ful loude he soong 'Com hider, love, to me!'" (I.672). Whether or not this song indicates that the Pardoner is the Summoner's sexual "compeer," Haweis modifies Chaucer's verse to avoid an implication of same-sex desire (I.670). Victorian children instead read a text sanitized of sexual allusion. She replaces the song with "lively," an adjective that could inspire images of boyish camaraderie, such as that involved in sporting teams and between school chums. In Haweis's version of the *General Prologue*, the two are suited for each other only as friends, as cohorts in extortion and greed, and they provide an example of how English boys should not behave in their youth or when adults.

Despite the swindling associated with the Pardoner and the Summoner, for Haweis the moral tale that the Pardoner tells justifies recovering the Pardoner from fraudulent dealings and any indeterminate sexual desires. She indicates this purpose in a footnote to his portrait: "The Pardoner's eloquence and musical gifts account, perhaps, for the exquisite story he afterwards tells" (32). She further indicates her belief in the aesthetic value of his tale and its didactic message in "Notes by the Way": "The extreme beauty of this poem, even in a technical sense alone, is such that I lament the necessity of abridging it" (99). Haweis does not modify the tale too extensively, except to shorten the Pardoner's exhortations on sin, but she does disregard the Pardoner's prologue entirely, shifting directly from the Host's entreaty for a story and the Pardoner's refreshment to the beginning of his tale. This elision removes his confession of selling fake relics and his desire for money: "For myn entent is nat but for to wynne, / And nothing for correccioun of synne" (VI.403–4). This omission suits her choices in the prologue, in which the Pardoner is marked as a swindler only in a passing reference, one possibly even forgotten by the end of the portrait.

Haweis's version of *The Pardoner's Prologue* and *Tale* focuses on the tale's plot, directing her audience's attention again to the issue of friendship. Like the Summoner and the Pardoner, the rioters provide examples of the bad behavior in which only untrue friends engage: "There was in Flanders a company of young folk, who gave themselves up to folly and wrong-doing. They did nothing but gamble and riot, and drink wine, and dance, and sear; and their gluttony and idleness made them wicked, so that when they heard of other people committing sin they laughed and did as much wrong as ever

they could" (92). In Chaucer's version, the Pardoner follows this description with an admonition on the perils of these vices. Haweis also is at pains to emphasize this behavior as immoral and employs the Pardoner's exhortations to do so: "This kind of life degrades every one. Gluttony was the first cause of our confusion: Adam and Eve were driven from Paradise for that vice. And drunkenness leads to many other sins, as is shown in Holy Writ" (92).

The rioters also mock faithful friendship, both in taking an oath of fidelity and in failing to keep it: "So these three men, half drunk as they were, plighted faith to live and die for each other, as though they were brothers born" (93). As Haweis would expect from such ne're-do-wells, the first drunken rioter expresses his haste to dispose of the bonds of fellowship with the youngest man who went to town for provisions. In an ironic rhetorical move, the first rioter craftily employs the same oath to enlist the second friend in the attack on the youngest: "As soon as their companion was gone / The first one subtly spoke unto the other: 'Thou knowest well that thou art my sworn brother'" (96). Using an oath of friendship to betray another friend demonstrates the ultimate disloyalty. Chaucer's repetition of "felawes" and "freend" as the youngest rioter returns with the poisoned wine emphasizes the gravity of the deceit: "To his felawes again repaireth he" (VI.878). Haweis stresses the treachery further by adding common synonyms to her translations of Chaucer's "felawes" and "freend," reminding her readers that these three rioters had been "comrades" and "mates" (97; 98). They obviously do not behave like Chaucer and John of Gaunt, who have been celebrated in the introduction for the happiness found in their faithful friendship. Haweis's following explication indicates that the rioters serve as a striking example of what happens to those who show disloyalty to friends: "Their end is beyond measure frightful" (99).

The Pardoner's Tale is the last of Chaucer's tales included in *Chaucer for Children*, and Haweis's final explication is a strong condemnation of the rioters' behavior: "The three rioters were probably young men who had ruined themselves by folly and licence, and whose besetting sin, surviving all it throve on, urged them to any and every crime for the sake of renewed gratification" (99). These young men who indulge their impulses are the opposite of the Victorian gentleman, a man who retains control of his desires and emotions, helps others, and believes in fairness and generosity. *Chaucer for Children's* narrative portion thus ends with a model of friendship that demonstrates possible consequences of immoral living. It easily could send a frightened boy in search of a virtuous lifestyle, right back to the alternative offered at the beginning of the text, the exceptionally faithful friendship between Chaucer and John of Gaunt. Chaucer, Gaunt, and Chaucer's characters have been presented as opposing examples of fidelity and

masculinity but, as every adult reader of Chaucer knows, these entities are more complex than they appear in *Chaucer for Children*. Haweis creates "lessons fairer than flowers" from stories and biographical information that are not "as simple as daisies." Ultimately, the "Father of English Poetry" proves the most faithful friend to Haweis, lending his life and texts to assist in her project.

<center>NOTES</center>

1. Mark Girouard, *The Return to Camelot: Chivalry and the English Gentleman* (New Haven, CT: Yale University Press, 1981), 23. Victorian interest in the Middle Ages has been the subject of numerous studies. For example, see also Alice Chandler, *A Dream of Order: The Medieval Ideal in Nineteenth-Century English Literature* (Lincoln: University of Nebraska Press, 1970); Carolyn P. Collette, "Chaucer and Victorian Medievalism: Culture and Society," *Poetica* 29–30 (1989): 115–25 (116); Charles Delheim, *The Face of the Past: The Preservation of the Medieval Inheritance in Victorian England* (New York and London: Cambridge University Press, 1982); David Matthews, *The Making of Middle English, 1765–1910*, Medieval Cultures 18 (Minneapolis: University of Minnesota Press, 1999), 13–37; and Clare A. Simmons, *Reversing the Conquest: History and Myth in Nineteenth-Century British Literature* (New Brunswick, NJ, and London: Rutgers University Press, 1990).

2. Chandler, *Dream*, 1.

3. Matthews has written extensively on this topic, explaining that many scholars of this period considered themselves better informed than medieval people, even the well-known Chaucer: "Most critics of the eighteenth and early nineteenth centuries wrote in the knowledge that theirs was a superior time; to them, though he is a great poet, Chaucer, far from living in the linguistic golden age imagined by the fifteenth-century poets, was condemned to struggle with a poor language and to live in a time of religious superstition." "Infantilizing the Father: Chaucer Translations and Moral Regulation," *Studies in the Age of Chaucer* 22 (2000): 93–114 (100). See also *Making* ix–xxxv and 162–86 and "Speaking to Chaucer: The Poet and the Nineteenth-Century Academy," *Studies in Medievalism* 9 (1997): 5–25.

4. In her investigation of the discourses of modern Chaucer scholarship, Stephanie Trigg comments on the importance given to Dryden's preface by scholars: "Chaucerians have been very ready to recognize Dryden's essay as a founding moment in modern Chaucerianism. His recognitions of Chaucer's realism, humor, sense of character, and humanity have been cited again and again." *Congenial Souls: Reading Chaucer from Medieval to Postmodern*, Medieval Cultures 30 (Minneapolis: University of Minnesota Press, 2002), 152.

5. John Dryden, "Preface to Fables Ancient and Modern; Translated into Verse, from Homer, Ovid, Boccace, & Chaucer: with Original Poems," in *The Works of John Dryden*, ed. Vinton A. Dearing (Berkeley: University of California Press, 2000), 34.

6. Dryden, "Preface," 33.

7. Mary Flowers Braswell, "The Chaucer Scholarship of Mary Eliza Haweis (1852–1898)," *The Chaucer Review* 39.4 (2005): 402.

8. Mary Eliza Haweis, *Chaucer for Children: A Golden Key*, 3rd ed. (London: Chatto & Windus, 1895). Subsequent references will be cited parenthetically. This passage reflects the previously introduced attitude toward the Middle Ages. Chaucer offers moral lessons, but his stories are simple and reflect the innocence of childhood represented by the daisy.

9. Velma Bourgeois Richmond, *Chaucer as Children's Literature: Retellings from the Victorian and Edwardian Eras* (Jefferson, NC: McFarland, 2004), 12.

10. Richmond, *Chaucer*, 12.

11. Matthews, "Infantilizing," 99.

12. Emily Walker Heady cites Charles Dickens's presentation of King Alfred in *A Child's History of England* as an example of the trend to use important figures from English history to assist in didactic instruction. "A Steam-Whistle Modernist?: Representations of King Alfred in Dickens's *A Child's History of England* and *The Battle of Life*," *Studies in Medievalism* 17 (2009): 95.

13. Norman Vance, *The Sinews of the Spirit: The Ideal of Christian Manliness in Victorian Literature and Religious Thought* (Cambridge: Cambridge University Press, 1985), 8.

14. Jeffrey Richards, "'Passing the Love of Women': Manly Love and Victorian Society," in *Manliness and Morality: Middle-class Masculinity in Britain and America, 1800–1940*, ed. J. A. Mangan and James Walvin (Manchester: Manchester University Press, 1987), 103.

15. Richards, "Passing," 104.

16. Andrew Dowling, *Manliness and the Male Novelist in Victorian Literature*, The Nineteenth Century Series (Aldershot, Hampshire: Ashgate, 2001), 1.

17. James Eli Adams, *Dandies and Desert Saints: Styles of Victorian Masculinity* (Ithaca, NY: Cornell University Press, 1995), 22.

18. Girouard, *Return to Camelot*, 7.

19. *The Knight's Tale* also focuses on social interaction between men, but it focuses more on family dynamics than on friendships. In contrast to its frequency in the prologue and *The Pardoner's Tale*, "friends" only appears once in Haweis's translation.

20. Geoffrey Chaucer, "General Prologue," *The Riverside Chaucer*, ed. Larry Benson, 3rd ed. (Boston: Houghton Mifflin, 1987), 23–36, lines 23–6. Subsequent references will be cited parenthetically.

21. *Middle English Dictionary*, Online ed., s.v. "Fēlauship," def. 1.

22. *Middle English Dictionary*, Online ed., s.v. "Fēlauship," def. 5.a.

23. *Middle English Dictionary* , Online ed., s.v. "Fēlauship," def. 2.a.

24. Cultural attitudes of Victorian England precluded much discussion of sexuality with children. Philippe Ariès traced the development of this convention in *L'Enfant et la vie familiale sous l'Ancien Regime* in 1960, which was translated by Robert Baldick into English as *Centuries of Childhood: A Social History of Family Life* (London: J. Cape) in 1962. Ariès argues for a moral evolution from the Middle Ages to the twentieth century in the chapter "From Immodesty to Innocence," positing

that "One of the unwritten laws of contemporary morality, the strictest and best respected of all" restricts Western adults from discussing or joking about anything sexual with children (100).

25. Haweis was not the only writer to adapt *The Pardoner's Tale* for children. Richmond includes a table listing which of the Canterbury Tales were included in various children's versions from the nineteenth and early twentieth centuries. Twenty-two of the twenty-nine versions include *The Pardoner's Tale* (220–21).

26. Walter Clyde Curry, "The Secret of Chaucer's Pardoner," *Journal of English and Germanic Philology* 18 (1919): 593–606.

27. See Carolyn Dinshaw, *Chaucer's Sexual Poetics* (Madison: University of Wisconsin Press, 1989), 156–86; and Robert P. Miller, "Chaucer's Pardoner, the Scriptural Eunuch, and the Pardoner's Tale," *Speculum* 30 (1955): 180–99.

28. See Donald R. Howard, *The Idea of the* Canterbury Tales (Berkeley: University of California Press, 1976), 342–5.

29. See Beryl Rowland, "Animal Imagery and the Pardoner's Abnormality," *Neophilologus* 48 (1964): 56–60.

30. See Monica E. McAlpine, "The Pardoner's Homosexuality and How it Matters," *PMLA* 95 (1980): 8–22; and Steven Kruger, "Claiming the Pardoner: Toward a Gay Reading of Chaucer's *Pardoner's Tale*," *Exemplaria* 6 (1994): 115–39.

31. See Richard Firth Green, "Further Evidence for Chaucer's Representation of the Pardoner as a Womanizer," *Medium Ævum* 71 (2002): 307–9 and "The Sexual Normality of Chaucer's Pardoner," *Mediaevalia* 8 (1985): 351–8.

32. See Glenn Burger, "Kissing the Pardoner," *PMLA* 107 (1992): 1143–56; and Robert S. Sturges, "The Pardoner, Veiled and Unveiled," in *Becoming Male in the Middle Ages*, ed. Jeffrey Jerome Cohen and Bonnie Wheeler, The New Middle Ages 4 (New York: Garland, 1997), 261–77.

33. Haweis uses Richard Morris's 1866 Aldine edition of *The Poetical Works of Geoffrey Chaucer* (xiv).

Borges and the North

Vladimir Brljak

Old English? Why don't you study something more useful,
like ancient Greek?[1]

Jorge Luis Borges's affair with the Boreal Muse is no secret. The precise
beginning of this affair, however, the chronology of its subsequent develop-
ment, the number and nature of its plentiful and diversiform progeny, its
place in the work of one of the twentieth century's major writers, its signifi-
cance in understanding that century's interpretations and uses of the medi-
eval past – these are all matters that have thus far received relatively little
attention from Borgesians and medievalists alike.[2] In the absence of scholar-
ship, fables thrive. Indeed, it might seem that one can actually point to a
precise year, a key one in the Borges mythology: that same 1955 in which
God, as he later wrote, "with such splendid irony/ granted me books and
blindness at one touch" (*SP* 95).[3] In 1955 Borges was appointed director of
the Argentine National Library in Buenos Aires, even as his sight was deteri-
orating to the point of leaving him unable to read the books on its shelves.
And, according to the account he gave in the lecture "Blindness" (1964), it
was then that:

> I thought: I have lost the visible world, but now I am going to
> recover another, the world of my distant ancestors, those tribes of
> men who rowed across the stormy northern seas [...]. I thought: "I
> am returning to the language my ancestors spoke fifty generations
> ago; I am returning to that language; I am reclaiming it. It is not
> the first time I speak it; when I had other names this was the
> language I spoke." [...] So I began my study of Anglo-Saxon,
> which blindness brought me. And now I have a memory full of
> poetry that is elegiac, epic, Anglo-Saxon.
> I had replaced the visible world with the aural world of the

Anglo-Saxon language: I went on to the *Eddas* and the sagas. I wrote *Ancient Germanic Literature* and many poems based on those themes, but most of all I enjoyed it. (*SNF* 477–8)

By this date, these were old memories: it is perhaps not to be expected that they will conform to the truth. For what it is worth, however, the true story of Borges's encounter with the North is not that of one deliberate, fateful decision but rather of a gradual, uneven development, spanning many years and a variety of works and publications. Telling it, in however crude and incomplete a form, thus requires a patient retracing of Borges's northernist footsteps rather than placing one's trust in his own accounts of the matter, which, it will be seen, are more often than not of a palpably "auto-mythographical" nature.[4]

The passage cited above is but one example: Borges says he turned to Old English about 1955, then progressed to Old Norse, and eventually wrote a book on early Germanic literatures. In fact, however, he had already published such a book – *Antiguas literaturas germánicas* [Ancient Germanic Literatures], of which, as discussed below, the later *Literaturas germánicas medievales* [Medieval Germanic Literatures] is but a partial revision – back in 1951. On other occasions, he preferred to date his involvement with the North to a much earlier point. "What secret paths led me to the love of the Scandinavian," he asks himself in the Preface to the 1966 *Seis poemas escandinavos* [Six Scandinavian Poems], and in answer to this question he mentions, among other undatable references, his father giving him a copy of the Morris–Magnússon translation of *The Saga of the Volsungs*, "some half a century ago" (*TR* 3:110), which would have been around 1916. Yet elsewhere, describing experiences that he dates explicitly to 1916, he says that Old English and Old Norse literature were something he was to find only "years and years afterwards."[5] And even if we allow that Borges was familiar with at least some Old Germanic literature at a fairly early date, this only raises the question of why there are comparatively few traces of that familiarity in his work up to the early 1950s, in contrast to the abundance found from that date onwards. For such reasons, one needs to turn to the biographical and bibliographical records and, even more importantly, the works themselves: only once these have been given a chance to tell their own version of the story shall we arrive at a more objective understanding of what is surely one of the most interesting chapters in the history of twentieth-century medievalism.

The Making of a Northernism

Borges's northernist interests can be safely traced at least as far back as 1932, when a "Noticia de las *kennigar*"[6] [Note on the *kenningar*] was published in the Buenos Aires journal *Sur*. What scattered references appear prior to this date do not seem to testify to much beyond a general interest in ancestral roots. Borges's paternal grandmother, Frances "Fanny" Haslam, was an Englishwoman of Northumbrian origin. Edwin Williamson notes that Borges's father was brought up "in what was to all intents and purposes an English household [...]. They all spoke English at home, and as a great reader herself, Fanny encouraged the boys to read English books."[7] A quarter-English, Borges grew up as "Georgie" in a partly English-speaking household and would later make much of this precious ancestral link with the North. "It may be no more than a romantic superstition of mine," he notes in the "Autobiographical Essay," "but the fact that the Haslams lived in Northumbria and Mercia [...] links me with a Saxon and perhaps a Danish past."[8] Indeed, according to Williamson, it was his grandmother's tales of England that instilled a "childhood interest" in early English history that "he would revive as a grown man in his study of Anglo-Saxon and Norse literature".[9]

Be that as it may, it was his ongoing investigations in poetic language, rather than in his ancestry, that led him to the kennings.[10] During the 1920s he had published a number of texts dealing with poetic language, and in particular with metaphor, all of which, including the "Noticia," must be understood in the context of the Ultraist polemic with their "modernist" elders. Here Borges promoted such views on poetry and poetic language as were, in chief principles at least, shared by many other contemporary avant-garde movements. In opposition to the poetry of their predecessors, which was seen as conventionalized and verbose, they call for a revitalization of poetic language, through which one is also to attain a reawakened experience of life. This might seem an unlikely context for a semi-scholarly study of skaldic kennings but in fact the subject, as Borges viewed it, was well suited to the purpose.

Basically, the kennings, "one of the most frigid aberrations recorded in literary histories" (*OC* 1:368), serve Borges as an illustration of the terminal stage of the conventionalization of metaphor, and poetic language more generally, as well as a point of departure for the critique of any poetry, past or present, that is perceived to be moving in that direction. Thus, in the Spanish literary tradition, the kennings are comparable to nothing so much as to the "frenzy of the academic mind" (*OC* 1:377), that is, the poetry of a Gracián or a Góngora. They are a mirror held up to any poetry neglecting the call of the avant-garde: its ultimate destiny is "a vain/ herbal of

metaphors and sophistries," as Borges would later describe the work of Gracián (*SP* 185). His inscription in a copy of the 1933 separate publication of the study under the title *Las kenningar* refers to it as "this ancient Gongorine alphabet."[11] Interestingly, Borges, who by that point had read through R. K. Gordon's *Anglo-Saxon Poetry* as well as through some secondary literature on the subject, makes careful distinctions in this respect between Old Norse and Old English poetry. The skaldic kenning is an "exhaustion and almost a *reductio ad absurdum* of a predilection common to all Germanic literature: that of compounded words" (*OC* 1:377). But the compounds found in the oldest surviving Germanic literature, that of the Anglo-Saxons, present an earlier stage of development:

> The skalds use these very same figures [as the Anglo-Saxon poets]; their innovation consisted in employing them in torrential effu-sions and combining them to form more complex symbols. We may presume that time also conspired toward this end. Only once *the moon of the Viking* had become an immediate equivalent of *shield* could a poet formulate the equation *serpent of the moon of the Vikings*. This took place in Iceland, not England. (*OC* 1:377)

This sets the stage for Borges's later view of the Old English language and its poetry, for a perspective that was almost diametrically opposed to his view of the skaldic craft.

The essay also testifies to a certain amount of reading on the subject. In a postscript added to it in 1962, Borges distances himself from some of the arguments in the piece and submits a list of books that are said to be a selec-tion of the sources used for it. Besides Gordon's anthology, the list includes John Earle's *Deeds of Beowulf*, one English (Brodeur) and several German translations of the Eddas (Gering, Neckel and Niedner, and Ranisch), English translations of three major sagas, and two of Niedner's studies of Old Icelandic culture and literature. Whatever one makes of this list, the essay itself testifies to a decent introductory overview of the subject, especially by the standard according to which Borges must be judged. Indeed, it is no overstatement to say that he himself set the standard, as the "Noticia" is apparently one of the very first treatments – perhaps *the* first – of an Old Germanic subject in the Spanish language, a fact that seems to have eluded even some Spanish Anglo-Saxonists (see n. 30 below).

One wonders whether Borges – who boasted of such things as being "the first traveler from the Hispanic world to set foot upon the shores of *Ulysses*" (*SNF* 12) – was aware of this. If he was, then it might have had something to do with his decision not to include the "Noticia" among the writings collected in the 1932 volume *Discusión*, but rather to republish it in

the following year as a separate booklet, under the more confident title *Las kenningar*.[12] More than thirty years later, in the Prologue to the *Seis poemas escandinavos*, he would employ the same metaphor: "I am not the first Spanish-speaking intruder to explore these latitudes. Who can forget the *Castalia barbara* (1897) of Jaimes Freyre and these verses which still resound: 'A strange and mysterious God visits the forest/ He is a silent God with wide open arms'" (*TR* 3:111). These are the opening lines of Freyre's "Eternum vale": Christ, the silent and mysterious god with wide open arms, visits the forest of the old deities of the North. There are other northernist-inspired poems by Freyre, yet he was not a scholar: in effect, by acknowledging Freyre as a predecessor in the domain of northernist-inspired poetry in the Spanish language, Borges, consciously or not, underlines his own primacy in Spanish-language Old Germanic scholarship. The text on the cover of the first edition of *ALG* would also describe the subject of that book as "almost completely unknown to the Spanish-language reader."

There is thus the polemical cause of the avant-gardist and the thrill of the intruder upon virgin latitudes. There is also the appeal to the erudite: why not extend that trademark pose of the benevolently omniscient deity of the library to things Old Germanic, a subject irradiating such profuse quantities of the antiquarian sublime. And then there is another perspective on the piece, one which is perhaps properly the business of biographers, but which can hardly be ignored if attempting to explain why a man who had apparently shown no particular interest in Old Germanic literature up to that point suddenly became fascinated by it. This perspective thrusts itself on the reader in the very last words of "Las *kenningar*," where the piece is dedicated "to an unsullied companion from those heroic days. To Norah Lange, whose blood will perhaps remember them" (*OC* 1:380) – remember the kennings, that is, as well as the kenningesque "games" of Ultraism.

Norah Lange was a member of the Buenos Aires Ultraist group. In 1925 Borges arranged the publication of her collection *La calle de la tarde*, to which he contributed a Foreword. According to Williamson, the mentor soon became infatuated with the protégée, who happened to be of Scandinavian descent: Lange's father was Norwegian, her mother Norwegian-Irish. Williamson could have cited this dedication to Lange and her Norse blood in further support of his claim that Borges, "who spoke to Norah Lange mostly in English, entertained a fantasy of an ancient ethnic affinity with her, deriving from his paternal family's roots in the north of England."[13] Yet it was not meant to be, for Lange fell for another man – no less than Borges's literary rival, Oliverio Girondo. But the relationship between Lange and Girondo was to be unstable until 1934, and Williamson suggests that Borges may have still hoped to win her back. This might be of interest, since Borges apparently renewed his contacts with Lange sometime around 1931 in a

move that took on a distinctly northernist aspect. Norah Lange was supposed to contribute a piece on the Eddas to the same June 1931 issue of the journal *Azul* to which Borges contributed his essay "The Postulation of Reality"; Williamson does not think this a coincidence and takes it to indicate that possibly "some kind of rapprochement had taken place" between them.[14] And then, in April of the following year, Borges published the "Noticia," his very first Germanicist piece, the last line of which dedicates it to Norah Lange and appeals to her Norse blood.

What to make of all this? Williamson constructs an elaborate and rather compelling theory ascribing to Borges a life-long obsession with Lange, intimately related with his life-long obsession with the North and culminating, many years later, in the writing of the story "Ulrikke," which he persuasively demonstrates to be "sown with secret autobiographical allusions" to Lange (397–99). It is hard to determine the extent to which Williamson's Borges, a man possessed by this and other such intricate private mythologies – a man who, having been spurned by a Norsewoman in his late twenties, was still writing his way out of this trauma half a century later – is a faithful portrait of the artist, whether as a young or an old man. Suffice it to say that Williamson is definitely on to something and that phrases such as "private mythology" or "poetic sense of destiny" (392) seem to be fairly adequate denominations of this something.[15]

What is certain is that Borges did "entertain fantasies" about Germanic identity. As early as 1923, we find the young poet of the Buenos Aires *barrios* claiming kinship with "the Saxons, the Arabs, and the Goths/ who, without knowing, would engender me" (*SP* 31), a theme to which he would return on numerous later occasions. Indeed, it is no understatement to say that re-inventing himself as Germanic – and as a Germanicist – was one of the key trajectories of both his public and private life. Yet to ascribe it wholly to romantic fantasies, in either sense of the word, would be an exaggeration. Nor should one overestimate the overall impact of Borges's northernism on his work, even though it is much greater than appears to have been generally noted. The first flourish of Borges's northernist interests resulted in the piece on kennings and a solid introduction to Old Germanic literature. He had read the major texts in German and English translations, along with some scholarship on the subject. After 1933, however, there comes a marked slump in the bibliographic record with respect to northernist material, lasting until the beginning of the 1950s.[16] It is precisely in this period that Borges wrote the work that made his name and that is still considered to be most characteristically "Borgesian." Indeed, the fact that relatively little overt northernist influence is to be found in these writings goes a long way towards accounting for the neglect of Borges's northernism, in spite of the fact that it looms so large in his later work.

Moreover, when references to Germanic matters do begin appearing in Borges's non-literary output of the war years, it is in a mood wholly different from the one that informs either "Las *kenningar*" or his post-1950 writings. For example, in a 1941 article he cites Bertrand Russell's attribution of the origins of fascism to the thought of Fichte and Carlyle, with the latter accused of such iniquities as having "praised the Middle Ages," "defended the memory of the god Thor," and "adulated and invented the Teutonic race" (*SNF* 209–10). In 1944, "[t]o be a Nazi" is "to play the energetic barbarian, Viking, Tartar, sixteenth-century conquistador, gaucho, or Indian" (*SNF* 210–11). The review of Gilbert Waterhouse's 1943 *Short History of German Literature* is another opportunity for voicing the same sentiments, this time with an explicit comment on the medievalist fantasies of the Third Reich: "The Germans seem incapable of working without some hallucinatory apprenticeship: they can win battles or compose languid and infinite novels, but only on the condition that they conceive of themselves as 'pure Arians,' or Vikings molested by Jews, or characters from Tacitus' *Germania*" (*OC* 1:279). Ultimately, "[t]o say that England has triumphed is to say that Western Civilization has triumphed, that Rome has triumphed" (*SNF* 212).

Particularly interesting is the poem "El enemigo generoso" [The Generous Enemy], first published in the October 1946 issue of *Los anales de Buenos Aires*.[17] The poem is cast as an imaginary "greeting" from the Irish king Muirchertach to Magnus Barfod, the twelfth-century king of Norway who met his untimely end in an unsuccessful attempt at a conquest of Ireland. The greeting, said to have been delivered to Barfod on the night before his death, begins deceptively, with Muirchertach, the generous enemy of the title, wishing his Norse opponent glorious victories against the Irish forces he is to meet at dawn. The Irish king even throws a couple of kennings – the weaving of the sword's cloth, the red swan – into his "generous" greeting to the Viking conqueror, before arriving, in the final lines, to its unexpectedly terrifying ending:

> May none of your numerous days shine more brightly than the
> day of tomorrow.
> Because this will be your last day, King Magnus, I swear it.
> Because before its light is snuffed out, I will defeat you and snuff
> you out, Magnus Barfod. (*SP* 141)

The ending of the greeting is not, however, the ending of the poem, for this final verse is followed by a postscript, presenting the poem as an extract "from *Anhang zur Heimskringla* (1893), by H. Gering."

As might be expected, it is this postscript that holds the key to the

poem's meaning. "H. Gering" must be Hugo Gering (1847–1925), the German scholar whose translation of the *Edda* was among those Borges claims to have used in the period of "Las *kenningar*." However, Hugo Gering never published a work entitled *Anhang zur Heimskringla* [Supplement to the *Heimskringla*], and the postscript is to be taken as a Borgesian conceit, alluding, through the accidental similarity offered by this abbreviated form of the German scholar's name, to Hermann Göring. In his memoirs, Richard W. Sonnenfeldt records that in the early days of Hitler's Germany the Nazis were still a subject of jokes, including the one where "Hermann Göring was referred to as 'Gering,' a German word meaning 'little nothing,' a play on his enormous girth."[18] The publication date of the fictional book is most likely also an allusion to Göring, who was born on 12 January 1893. The title of Snorri's history of the kings of Norway – which, as Borges of course knew, means *orbis terrarum*, the globe – is made to echo the appetites of the Nazi regime, fed, among other things, by romantic visions of a heroic Germania. Borges's sympathies are obviously on the Irish side, the side of Rome, while the conqueror, again, is the barbarian Viking. The defeat of the Norwegian by the Irish king prefigures the defeat of Germany by the Allies, and, by extension, the inevitable demise of any further "supplements" of the same sort – the ultimate triumph of good over evil, of Rome over the Barbarians.

It would seem, then, that during the war and its aftermath Borges shared the experience of many a "Germanophile" – a word that had by 1940 taken on a meaning that he felt called upon to sharply denounce (*SNF* 203–5) – namely, the outrage felt at the appropriation and misinterpretation of German(ic) culture by the Nazi regime. The pronouncements on Carlyle are revealed in their proper light only when one recalls that it was Carlyle with whom he was "overwhelmed" in his Geneva teens, and that it was Carlyle who had "sent [him] to the study of German," as well as to something else, which by that point must have taken on a terribly sinister aspect, namely:

> the idea of Germanism. [...] I was led by Carlyle to think that I could find it in German literature. I found many other things [...]. But the idea I had – the idea of men not at all intellectual but given over to loyalty, to bravery, to a manly submission to fate – this I did not find, for example, in the *Nibelungenlied*. All of that was too romantic for me. I was to find it years and years afterwards in the Norse sagas and in the study of Old English poetry.[19]

And now he has to concede that Carlyle was a fascist, and he sees what his beloved fatalistically unintellectual Germanism can turn into once it descends from the realm of ideas and puts on a uniform.

There is not much, then, that can be seen as anticipating the publication in September 1951 of a monograph entitled *Antiguas literaturas germánicas*, a slender book listing Delia Ingenieros as a collaborator and enfolding a vast design of introducing its Spanish-speaking reader to the literatures of the Gothic, Old English, Old Norse, Old Saxon, Old High and Middle High German languages. This book is something of a mystery. What were the circumstances of its publication, in Mexico City, as part of the series "Breviarios del Fondo de cultura económica"? Why did Borges decide to write such a book? Why at this time? He had, as we have seen, taken a significant interest in the subject long before 1951, yet we have also seen that the evidence prior to that date does not seem to paint a picture of a man at work on, or even contemplating the writing of, such a book. Why with Delia Ingenieros? The daughter of the distinguished Argentine psychiatrist and thinker José Ingenieros was by all accounts a rather remarkable woman of many interests and passions, but there is not much, except of course the book itself, to testify to her interest, let alone competence, in Old Germanic literature.[20] The nature and extent of her "collaboration" are unspecified. On top of all this, Borges would later pretend that the book had never existed, preferring instead the demonstrably automythographical chronology related in "Blindness" and elsewhere in which he first discovers Old English around 1955, then progresses from it on to Old Norse, and eventually gets around to writing *Literaturas germánicas medievales* (1966), which, in reality, is just a slightly revised version of the 1951 monograph. Indeed, the earlier book is not mentioned at all in *LGM*, where, along with the book she supposedly co-authored, Delia Ingenieros also disappears and María Esther Vázquez is listed as the sole collaborator.[21]

Did Borges feel uneasy about the fact that he had published a work of scholarly pretensions without the required qualifications? The "Breviarios" series was definitely scholarly in character: as stated on the back cover, each of the titles was supposed to constitute a "complete introductory treatment of the matter announced in its title" and to be "composed by universally acknowledged specialists." Needless to say, Borges was not a universally acknowledged specialist in early medieval Germanic literatures. He did not even hold a university degree. It can also be demonstrated quite conclusively that he had very little knowledge of Old English at that point, let alone of the other Old Germanic languages. His own description of the Old English reading group formed during the period of his professorship at the University of Buenos Aires, which is to say sometime after 1956, leaves little doubt of this. Preparing the first session, the account goes, he remembered two forgotten books, Sweet's *Reader* and a text of the *Anglo-Saxon Chronicle*, which he had placed "on the highest shelf, thinking I would never use them" (*SNF* 478). Armed with these two, and with what Williamson describes as "a

large dictionary given him by a Scots friend in Buenos Aires",[22] the group
met in the National Library:

> It was Saturday morning. We gathered in Groussac's office, and we
> began to read. There was a detail that pleased us and mortified us,
> and at the same time filled us with a certain pride. It was the fact
> that the Saxons, like the Scandinavians, used two runic letters to
> signify the two sounds of *th*, as in "thing" and "the". This
> conferred an air of mystery to the page.
> [...] You must remember we knew nothing of the language;
> each word was a kind of talisman we unearthed.
> [...] Blindness is a gift. [...] It gave me Anglo-Saxon, it gave me
> some Scandinavian, it gave me a knowledge of a medieval litera-
> ture I didn't know [...]. (*SNF* 477–83)

This, again, took place at least five years after he had published a scholarly
monograph on early medieval Germanic literatures.[23]

Did Borges suppress the earlier book because it fell below his improved
Germanicist standards? In their Foreword to *LGM*, published in Madrid –
very much like in the 1962 postscript to "Las *kenningar*"[24] – the authors
consider it "most important to point out that the conception and composi-
tion of this book have been based directly on the ancient texts, except in the
case of the Ulfilian Bible" (*LGM* 390). In 1951, Borges was still not interna-
tionally famous and the chance was exceedingly slim of the obscure Mexico
City monograph ever coming under the scrutiny of professional, mostly
European and North-American, Germanicists. A decade later, however, even
such works were liable to raise previously unexpected interest and reach
previously unlikely readers.[25] Whatever the reason, the fact remains that
Borges not only authorized the publication of the 1966 book knowing that
it nowhere acknowledges the existence of its 1951 original, but contributed
to the latter's oblivion by failing to mention it where such mention would be
expected.

A more important question, however, is that of why he wrote it in the
first place. In the 1930s Borges was interested in the kennings as a "frigid
aberration" of poetic diction, while in the 1940s he equated the Nazis with
the Vikings and used the name of a Germanicist medievalist as an allusion to
Hermann Göring – how, then, are we to account for the full-blown
northernist "turn" that occurred around 1950?

Perhaps the reason is to be sought in the social climate of those years.
Perhaps we do well to remember that for Borges the end of one war also
meant the beginning of another, indeed a more personally immediate one –
his war with the Perón regime, which was at the height of its power around

1950. In the same year in which *ALG* was published Borges gave his lecture on "The Argentine Writer and Tradition," denouncing the "nationalists [who] pretend to venerate the capacities of the Argentine mind but wish to limit the poetic exercise of that mind to a few humble local themes, as if we Argentines could only speak of neighborhoods and ranches and not of the universe" (*SNF* 424). In the 1949 "Story of the Warrior and the Captive Maiden" he had already written of Droctulf, a Langobard chieftain who, as recorded in the *Historia Langobardi* of Paulus Diaconus, joined the forces of Rome in fighting against his own people. With the help of Droctulf and his men, Ravenna defended itself from the Langobard onslaught and its citizens were so grateful that they built Droctulf a sepulcher inscribed with an epitaph praising him and his deeds. Borges quotes two lines from this epitaph in the story, the Latin of which roughly corresponds to the italicized portion of the following:

> Loving the standards of Rome and the emblems of the republic,
> Aid unto them he brought, *crushing the power of his race.*
> *Love unto us he bore, despising the claims of his kindred,*
> *Deeming Ravenna his own fatherland, dear to his heart.*[26]

"Droctulf was not a traitor," the text continues, "[h]e was an *illuminatus*, a convert" (*CF* 209). In the 1953 "The Innocence of Layamon" Borges again meditated on the fate of, in his eyes at least, a similar character: "this forgotten man, who abhorred his Saxon heritage with Saxon vigor, and who was the last Saxon poet and never knew it" (*SNF* 357). These paradoxical – and Germanic – figures strike one as emblematic of Borges's own position. Droctulf is most Langobard, and Layamon most Saxon, in despising the claims of their kindred. In its dreary footnote to Plato, the regime demanded a social realism of neighborhoods and ranches: perhaps Borges only did the one thing that seemed truly Argentine in such circumstances – write a book on ancient Germanic literatures.

Professor Borges

It is ironic that Borges bothered to erase the 1951 *ALG* from his bibliographical record, for along with the 1932 kennings piece, it is precisely with this work that his claim to Germanicist fame lies. It has already been noted that the 1932 "Noticia" may have been the very first study of any length on the subject of vernacular medieval Germanic literature in the Spanish language, while the 1951 *ALG* is certainly the first book-length Spanish-language study on the same subject. Two further publications appeared in 1965–66, in collaboration with María Esther Vázquez: the 1965 *Introducción a la*

literatura inglesa, containing a chapter on the Anglo-Saxon period, and the silent revision of *ALG* as *LGM* in 1966. There are also a number of translations, most notably those included in the 1978 *Breve antología anglosajona* and the 1984 translation of *La alucinación de Gylfi*, the first section of the Old Norse *Prose Edda* (both co-authored with María Kodama). Perhaps the most important of these translations is that of *The Dialogue of Solomon and Saturn*, a verse from the Old English Exeter Book: this was originally published under the title "Un diálogo anglosajón del siglo IX" [A Ninth-Century Anglo-Saxon Dialogue] in a 1961 issue of the Buenos Aires journal *La biblioteca* and thus barely beats the 1962 *Beowulf* translation by Orestes Vera Pérez for the title of the first separate and complete translation of an Old English poem into the Spanish language. In addition to these authorized publications, a sizeable portion of the posthumously published transcripts of the 1966 lectures for Borges's English literature class at the University of Buenos Aires is also devoted to Old English and other northernist matters.

The initial thing to note about *ALG* and *LGM* is that these are, by and large, the same book – or rather, that the latter is a fairly slightly revised version of the former. Entire chapters were left almost completely untouched. The only substantial revisions take place in the chapter on Anglo-Saxon literature – the "Literature of Germanic England," as Borges first called it in *ALG* – where several new sections and paragraphs were added, along with some modifications to the chapter's overall layout. As far as Borges's views of his material are concerned, they fall firmly within the "paganist" tradition of nineteenth and early twentieth century Old Germanic studies, the tradition that would, within Borges's lifetime, outlive most of its academic usefulness and give way to more objective and inclusive approaches to Old Germanic literature. That being said, *LGM* is slightly less "paganist" than *ALG*, a good example of which is the change in the treatment of the pagan–Christian problem in Old English poetry. In *ALG* the section on *Beowulf* was followed by one on "Otras poesías precristianas" [Other pre-Christian poetry], including brief discussions of *Widsith*, *Deor*, *The Wanderer*, *The Seafarer*, *The Ruin*, and the charms. The new layout has the section on *Beowulf* followed by one on the "Finnsburh Fragment," which is followed by one on "Poesías precristianas" (the plural is misleading, however, since the only pre-Christian Anglo-Saxon poetry to be had is *Widsith*, and not the whole of it but only the "central nucleus" [*LGM* 403]). By the time of *LGM*, then, Borges had ceased to view the Old English "heroics" and "elegies" as pre-Christian poetry, and in another decade or so he would be comfortable with considering *The Seafarer* as a Christian allegory (*Breve antología anglosajona*, *OCC* 2:316). Similarly, in *LGM* *Beowulf* is no longer "perhaps the oldest poem of the Germanic literatures"

but rather their "oldest epic monument" (*ALG* 18, *LGM* 398), while its author is a "Northumbrian cleric" acquainted with the *Aeneid* (*ALG* 24–5, *LGM* 402–3).

The chief modification to this chapter, however, is the addition of separate sections for the heroic poems and the late poem known as *The Grave*, which he describes as "memorable," emphasizing that "there is nothing Christian in it; it does not speak of the soul, only of the body decomposing in the ground" (*LGM* 425). In both its versions, the chapter contains sections on Cædmon and Cynewulf, yet the fame of the former is ascribed "to reasons other than aesthetic pleasure" (*ALG* 33, *LGM* 409), while the latter is most interesting for his runic signatures. Nor does Borges's definition of Anglo-Saxon literature include the Latin writings of the Anglo-Saxons: "Bede wrote in Latin, but his name cannot be disregarded in a history of Anglo-Saxon literature" (*ALG* 48, *LGM* 411).

The "paganist" bias also governs the German and Scandinavian chapters. The former first discusses those Old High German and Old Saxon texts that are seen to belong to, or contain traces of, the pre-Christian culture of the Germans. A short section then covers the production of the eleventh through thirteenth centuries, where, in a comment added in the *LGM* revision, Borges delivers the most explicit statement of the book's rationale. The study of the chivalrous epic falls outside of the scope of his study, he says, partly "for linguistic reasons" and partly because they "have nothing in common with the forms and the spirit of primitive Germanic poetry" (*LGM* 438). The chapter then moves on to the *Heldenbuch*, the *Nibelungenlied*, and *Kudrun*. The real subject of the book(s), then, is not ancient or medieval Germanic literature but rather "primitive Germanic poetry": the primordial poetic expression of, or at the very least springing from, pre-Christian Germanic culture, composed in the Old Germanic vernaculars.

It is interesting to observe the pull of Borges's northernism when it comes into contact with his interest in post-medieval English literature. In his *Introducción a la literatura inglesa*, for example, William Morris gets more space than most other writers, Gerard Manley Hopkins is mentioned solely as a resurrector of alliterative diction in English verse and as a forerunner of W. H. Auden, while the entire treatment of the latter is one half of a sentence about "the unforgettable Wystan Hugh Auden (1907–1973), who translated the Elder Edda" (*OCC* 2:368). Dating from the same period are the transcripts of lectures given by Borges at the University of Buenos Aires, edited from notes taken from dictations recorded by Borges for the benefit of those students who were unable to attend the course regularly. As duly noted by the transcripts' editors, their most striking peculiarity is the fact that no fewer than seven of the twenty-five sessions were devoted to Old English literature and Anglo-Saxon culture, again with a distinctly "paganist" outlook.[27]

Then there are the translations. Again, whatever competent reviewers may make of their quality, these are of undeniable historical importance. It has already been noted that Borges's 1961 annotated translation of *The Dialogue of Solomon and Saturn* appears to be the first of its kind in the Spanish language. The 1978 *Breve antología anglosajóna* is also a first: the first Spanish-language anthology of Anglo-Saxon texts, including the first translations into Spanish of *Deor, The Seafarer, The Grave*, and of the account of Ottar from the *Old English Orosius*, apparently the first extended translation into Spanish of a piece of Old English prose. The 1976 *Libro de sueños* [Book of Dreams] includes the first Spanish-language translation of *The Dream of the Rood*. The *Gylfaginning* translation is also a pioneering effort, appearing only one year later than that of Enrique Bernárdez.[28]

Finally, there are several works that deserve mention here even though they are situated on those fluid Borgesian borders between fiction, essay, and scholarly writing. A series of such pieces followed the publication of *ALG*, all of which contain material from the 1951 book or were reworkings of entire sections. Five were published in 1953 – the already mentioned "Innonence of Layamon" and "The Dialogues of Ascetic and King," as well as "The Scandinavian Destiny," "El destino de Ulfilas" [The Destiny of Ulfilas], and "La apostasia de Coifi" [The Apostasy of Coifi] – with "El dios y el rey" [God and King] appearing in the following year. It is also worth mentioning that Borges was planning a second book on Old English and Old Norse literature: he mentions this in a 1968 interview, specifying that it is not to be, like *ALG/LGM* was, "a book of information, but rather a book with my personal opinions, a book wherein I try to say what I thought that poetry might have meant to the Saxons and to the Norsemen."[29]

These, then, are the scholarly and semi-scholarly fruits of Borges's northernism.[30] It is up to Germanicists to judge them, as it is up to those competent in the relevant languages to determine the value of Borges's translations. Certainly in 1951 the "paganist" view was still widespread, and in his approach Borges was merely following some of the most respectable literature on the subject. In all senses of the word, he was a dilettante. If there is no reason to doubt that he acquired a little Old English and less Old Norse in the period from around 1955 (at the earliest) onwards, by his own admission he knew next to nothing of them prior to that period, when *ALG* was published. As late as 1980, he claimed to be "now [...] attempting Old Norse."[31] In the meantime, 1966 saw the publication of *LGM*, explicitly claiming to be based on a competent reading in the original of all the texts in question save the Gothic of Ulfilas.

Regardless of the obvious objections that might be raised here, there is still much to praise in these works: if they are inferior scholarship, they *are* scholarship and apparently the first of its kind in the Spanish language. Also,

if Borges works within the bounds of outmoded scholarly and interpretive traditions, he also brings certain original, characteristically Borgesian, touches to the subject. There is, for example, his habit of comparing these old texts with later as well as earlier ones, of seeking in them analogues and prefigurations. Thus the skalds prefigure Gracián; the sagas prefigure the technique of the modern novel or even of film; the vision of Cædmon prefigures those of Stevenson or Coleridge; and so on. In general, Borges displays a remarkable, if idiosyncratic, ear for Old English poetry *as poetry* and always insists on presenting this poetry as fully relevant to the contemporary reader, rather than of merely historical and antiquarian interest.

One fictional text should probably be mentioned before moving on to the next section of the paper: the story entitled "The Bribe," included in the 1975 *Book of Sand*. The story involves two Anglo-Saxonist scholars, the American Ezra Winthrop, professor of Old English at the University of Texas at Austin, and Eric Einarsson, a younger Icelander who receives an appointment at the same university. In the Afterword to *The Book of Sand*, Borges writes that he has "always been surprised by the Americans' obsession with ethics; 'The Bribe' is an attempt to portray that" (*CF* 485). This is certainly one part of the story: by an appeal to his "curious American passion for impartiality" (*CF* 470), Einarsson manipulates Winthrop into recommending him for chairing an Anglo-Saxonist conference. Winthrop has to decide between Einarsson and another candidate, Herbert Locke; Einarsson publishes an article indirectly, but unmistakably, critical of Winthrop; just as Einarsson had planned, Winthrop reacts by choosing him over Locke so that he would not be perceived as holding a grudge. The irony is that the passion for being impassionate is just as much of a passion as any other: "perhaps we aren't so different, you and I," says Winthrop in the end, "[w]e share one sin, at least – vanity. You've come to my office to throw in my face your ingenious stratagem; I gave you my support so I could boast my integrity" (*CF* 471).

But certainly the stated theme could have been handled in any number of ways: that Borges chose to raise it through a story about Anglo-Saxonists and Anglo-Saxon studies is just as interesting as the theme itself. Also interesting are the narrative details that have little or nothing to do with the theme, but have a great deal to do with Borges's adventures in the Old North. Thus Herbert Locke is the author of a study entitled *Toward a History of the Kenning*, in which he argues – just as Borges had done in his essay – "that the Saxons put aside those somewhat mechanical metaphors they used [...], while the Scandinavian poets were combining and intermingling them almost to the point of inextricability" (*CF* 466). Similarly, Eric Einarsson publishes a controversial edition of *The Battle of Maldon* in which he claims that "the poem's employment of moving circumstantial details oddly prefigures the methods we admire, not without good reason, in the Icelandic sagas"

(*CF* 467) – basically restating Borges's comment in the Foreword to the very collection in which the story is found (346, cited below; Einarsson later admits to Winthrop that the hypothesis is "absurd" and "unthinkable," and was included only "in order to flatter English readers"). There is a little bit of Borges in Winthrop as well: on the shelves in Winthrop's office, Einarsson spots a copy of Resen's 1665 edition of the *Edda Islandorum*, a book that Borges also appears to have possessed (see *SP* 365).

The story triggers further northernist resonances: even as Borges pauses to parody his own "thesis" on the prefiguration of Icelandic sagas in Anglo-Saxon poetry, we are certainly meant to perceive that the conflict between Winthrop and Einarsson at the University of Texas at Austin is prefigured by the conflict between the Saxons and the Danes at Maldon. The Norsemen won the day only because the Saxons opted for fair play: already then, it is implied, the "passion for impartiality" was a characteristic of the Anglo-Saxon race. But what is the real nature of this passion? Did Byrhtnoth act out of an impassionate sense of ethics, or is this sense of ethics a dangerous passion in its own right? Whatever the answer, one does not imagine that many other stories about machinating Anglo-Saxonists at the University of Texas at Austin have been written by major twentieth-century writers, and while an interesting piece of short fiction, "The Bribe" is just as interesting for its autobiographical allusions and its indirect testimony to Borges's own scholarly efforts and aspirations in the field.

The Northernism of a Making

It has already been noted that comparatively few overt northernist references appear in Borges's pre-1950s work, especially in the fiction. There are, however, several pieces worth mentioning. One of these is "The Library of Babel," originally published in 1941: the infinite library contains all possible books, including "the treatise Bede could have written (but did not) on the mythology of the Saxon people" (*CF* 115). The narrator of "The Zahir," first published in 1947, writes a story retelling a part of *The Saga of the Volsungs* from the dragon's perspective (*CF* 245–6). "Dante and the Anglo-Saxon Visionaries," one of the *Nine Dantesque Essays* that were first published as a collection in 1982 but are dated collectively in Weinberger's edition to 1945–51, contains an extended digression on the same subject touched upon in "The Library of Babel": Bede leaving England without its Snorri.[32] There are also texts that lack overt references but do contain more subtle northernist allusions, such as the famous "Tlön, Uqbar, Orbis Tertius" (1940).[33] A careful reading of Borges's stories would no doubt unearth other such subtle allusions, but in what follows only definite, overt references will be noted.

From about 1950, then, Borges's northernism begins to leave consider-able traces in his non-scholarly work, both essayistic and more strictly literary. A 1981 postscript added to the 1948 "Last Voyage of Ulysses" is emblematic of this turn:

> *Postscript, 1981:* It has been said that Dante's Ulysses prefigures the famous explorers who, centuries later, arrived on the coasts of America and India. Centuries before the *Commedia* was written, that human type had already come into being. Erik the Red discovered Greenland around the year 985; his son Leif disem-barked in Canada at the beginning of the eleventh century. Dante could not have known this. The things of Scandinavia tend to be secret, as if they were a dream. (*SNF* 283)

From the 1950s onwards, northernist references become ubiquitous. As far as the essayistic opus is concerned, the most revealing testimony to Borges's altered view of, and expanding interest in, the North is to be found in "The Scandinavian Destiny" (1953), a piece that is nothing short of a paean to early medieval Germanic, and especially Norse, culture. Borges enthusiasti-cally cites runic inscriptions, Icelandic sagas, and W. P. Ker. He elaborates on the "remarkable" fact of the "perfect" realism of the sagas, that oasis amid the arid desert of medieval allegorism, peacefully co-existing alongside the "baroque" poetry of the skalds. Where he had once used it as an allusion to Nazi ambitions of world conquest, he now says that the "geographic nomen-clature" of Snorri's *Heimskringla* is a "testimony to the breadth of the Scandi-navian sphere." The essay ends with a melancholic, Ker-influenced meditation on how:

> In universal history, the wars and books of Scandinavia are as if they had never existed; everything remains isolated and without a trace, as if it had come to pass in a dream or in the crystal ball where clairvoyants gaze. In the twelfth century, the Icelanders discovered the novel – the art of Flaubert, the Norman – and this discovery is as secret and sterile, for the economy of the world, as their discovery of America. (*SNF* 381)

Clearly, we have come a long way from the view that equated Western civili-zation with Rome and its enemies with the barbarian Viking.

To this northernist manifesto and the pieces discussed in the preceding sections can be added, as far as the essayistic opus is concerned, the northernist references found in: "The Enigma of Edward FitzGerald" (1951); "Coleridge's Dream" (1951), where Bede's account of Caedmon is

retold at some length; "Forms of a Legend" (1952), where there is mention of *Barlaam's Saga*; "German Literature in the Age of Bach" (1953); "A History of the Tango" (1955), which in spite of its quintessentially Latin-American subject contains – a uniquely Borgesian stunt – choice cuts of *Beowulf*, skaldic poetry, *Færeyinga saga*,[34] and even Jordanes's *History of the Goths*; the lecture on "The Concept of the Academy and the Celts" (1962); and "Immortality" (1978), where he relates that he has "devoted the last twenty years to Anglo-Saxon poetry, and I know many Anglo-Saxon poems by heart" (*SNF* 490); as well as some of his prologues.[35]

It is in verse, however, that Borges's northernist muse found its medium of expression. By the late 1950s, Borges's work makes a general turn to poetry, which he had not published since the 1929 *San Martín Copybook* – a development at least partly due to the increasing deterioration of his sight. Already in *The Maker* (1960) we start to come across poems partly or even wholly northernist in inspiration, such as the well-known "Embarking on the Study of Anglo-Saxon Grammar" or "Poem Written in a Copy of *Beowulf*."[36] Besides these, however, there are many other poems containing northernist references of one kind or another, lengthy or brief, most of which do not appear to have received any attention in this respect,[37] as well as two collections devoted exclusively to northernist-inspired poetry: *Seis poemas escandinavos*, published in 1966 in Buenos Aires, and the bilingual *Siete poemas sajones/ Seven Saxon Poems*, hand-printed in Verona by Richard-Gabriel Drummonds and published in 1974 for his Plain Wrapper Press. Both of these are reminiscent of the 1933 *Las kenningar* booklet in being small-run, limited-edition prints, indicative of a particular reverence for these subjects.[38]

It is in these poems that Borges expressed himself most freely, creatively, and, perhaps, intimately on these subjects. Some envisage alternative histories, such as "The treatise on Saxon myths that Bede omitted to write," or "The vast empire the Vikings declined to found" (*SP* 407). Some long for impossible memories: "What would I not give for the memory/ of the ships of Hengist,/ that set sail from the sands of Denmark/ to conquer an island/ which was not yet England" (*OP* 435). Some run fingers down the blade of a rusty sword in York Minster (*SP* 209). Some pledge "love, ignorant love" (*OP* 376) to Iceland. And some are simple expressions of the poet's gratitude for the northernist revelations that were clearly of such exceptional importance to him: "for the language which, centuries ago, I spoke in Northumbria,/ for the Saxon sword and harp,/ [...] for the verbal music of England,/ for the verbal music of Germany,/ for the gold that glitters in its verses" (*OP* 250). If the scholarly and essayistic writings are the head, then these poems are the heart of Borges's northernist opus, paced by "the iron beat of Saxon syllables" (*SP* 431).

There remains the fiction of the post-1950 period. Borges would, apart

from the narratives included in *The Maker* (which contains the short piece "Ragnarök"), publish three further collections of stories: *Brodie's Report* (1970), *The Book of Sand* (1975), and *Shakespeare's Memory* (1983). *Brodie's Report*, set in a world of gauchos and knife-fighters of suburban slums and rural nowheres of late nineteenth- and early twentieth-century Argentina, would seem to be a most unlikely place to look for northernist influence. Still, to a reader of Old English literature the very first story in the collection, "The Interloper," about two brothers who take to sharing one woman between them – a ménage which eventually ends in a brutal and, for the woman, tragic manner – might call to mind that lurid passage from the *Sermo Lupi ad Anglos*, where Wulfstan admonishes those who:

> pool money together and buy a woman in common as a joint purchase, and with the one woman commit foul sin, one after another and each after the other, just like dogs who do not care about filth, and then for a price they sell out of the land into the hands of the enemy this creature of God, His own purchase that He bought so dearly.[39]

There are further Anglo-Saxon echoes: the woman's name is Juliana, clearly alluding to the legend of St. Juliana (and specifically, given the context, to Cynewulf's Old English poem on the subject), another story where a woman is bartered like a thing only to end up gruesomely murdered; and the Nilsen brothers "were tall, with reddish hair – the blood of Denmark or Ireland (countries whose names they probably never heard) flowed in the veins of those criollos" (*CF* 349).

Some of the other stories include such northernist details as the claim that the "bloodcurdling gauchos" in "The Duel" are "as tall as Norsemen" (*CF* 383), and beyond such minute parallels lies a broader similarity between the world of the sagas and that of *Brodie's Report*: tough men in tough circumstances, personifying their weapons and commodifying their women, their fates turning on a volatile economy of honor, chance, brute force, and alcohol. Moreover, this general similarity extends even to matters of style and narrative technique: "I have tried [...] to write plain tales," claims Borges in the Foreword, adding, however, that they do "abound in circumstantial details that writers are required to invent – details that we can find such splendid examples of in the tenth-century Anglo-Saxon ballad of the Battle of Maldon and the Icelandic sagas that came later" (*CF* 346). Similarly, in the Foreword to *In Praise of Darkness* (1969) he lists among his "few tricks" the manner of "narrating events (this I learned from Kipling and the Icelandic sagas) as though I didn't fully understand them" (*CF* 331).

One should not take all this too seriously, of course, even though any

reader of both will probably agree that there is an air of the sagas to *Brodie's Report*,[36] but in *The Book of Sand* northernism clearly takes center-stage, as four out of the thirteen stories in the collection are wholly and overtly northernist in inspiration.[40] "The Bribe" has already been discussed, as well as "Ulrikke," the curious semi-allegorical piece that revolves around an old Colombian professor named Javier Otárola and a young woman named Ulrikke, who refer to each other as Sigurd and Brunhild. But the collection also includes possibly the most extravagant of Borges's northernist fantasies, "'Undr,'" in which the narrative supposedly comes from a newly discovered manuscript by Adam of Bremen, who claims to be merely relaying the words of an Icelandic skald he met "in Uppsala, near the temple" (*CF* 456). "The Mirror and the Mask" takes a very loose cue from the historic Battle of Clontarf (1014) between mixed Irish-Scandinavian armies, focusing on an Irish bard commissioned to compose a poem on his king's victory. In "The Disk," Odin pays a visit to an Anglo-Saxon woodcutter. Brief references are also found in "The Other" – "I'm studying Anglo-Saxon," elderly Borges informs his younger self, "and I'm not at the foot of the class" (*CF* 415) – as well as in three of the four stories in his final collection, *Shakespeare's Memory*: "August 25, 1983" (*CF* 491), "Blue Tigers" (495), and "Shakespeare's Memory" (508).

No claim of inclusiveness is made with respect to any of these catalogues; surely further items could be added. They do, however, offer a wider overview of Borges's northernist opus than previous accounts: around one-hundred items have been mentioned here that are at least partly northernist in inspiration, and a good number of them are wholly so. Most deal with a handful of themes to which Borges returns time and time again, many of which fall squarely into the mainstream of the northernist imaginary. He never tires of referring to familiar motifs from the most famous Old Norse texts or the corpus of what used to be called "heroic" or "secular" Old English poetry, to key historical figures and events, to the famous battles. Indeed, it could almost be said that the most remarkable thing about Borges's views of the peoples and literatures of the ancient North is that they are, for the most part, rather unremarkable – except, of course, for the rather remarkable fact that they are Jorge Luis Borges's.

Nevertheless, there are some certain original touches, such as Borges's mobilization of his northernist aesthetics in the cause of his views on poetic diction. An early instance of this is found in the well-known "Embarking on the Study of Anglo-Saxon Grammar." The natural first step for the beginner is to translate Old English words into their English and German equivalents, but Borges's ultimate goal is a much more profound and elusive understanding, for these words, which for him are now "symbols of other symbols," were once:

> fresh images
> and a man used them to invoke the sea or a sword.
> Tomorrow they will come alive again:
> tomorrow *fyr* will not become *fire* but rather
> some vestige of a changeable tamed god
> whom no one can confront without feeling an ancient fear.
> (*SP* 129)

The poem concludes with an ecstatic exclamation of gratitude for "this perfect contemplation/ of a language at its dawn." Here and elsewhere, Borges seeks the experience of a language at its primitive origins, a language still immersed in the mythical consciousness of the primitive man, which, however, is at the same time a model for the poetic use of modern language. Poetry is to remythify language, reclaiming its ancient power of speaking in "fresh images" rather than in "symbols of symbols."

This is the view of poetic language that Borges held in his early Ultraist days. In the 1922 essay "The Nothingness of Personality," published in the first issue of the Ultraist *Proa*, he denounces the "fallacy" committed by those who falsely proclaim themselves "witness[es] to the unicity of things" and whose "Romantic ego-worship and loudmouthed individualism are in this way wreaking havoc on the arts" (*SNF* 7). "If ever I made mention of the dawn," a representative of these impostors is made to say, "it was not merely to follow the easy current of usage. I can assure you I know what the Dawn is [...]. It matters little whether I have proclaimed it in feeble verse or in rough-hewn prose." On the contrary, protests Borges, this is all that matters, for to truly *bear witness* to the unicity of things means precisely to struggle with language, to abandon the possibility of resting on the withering laurels of metaphor and embark on an uncharted quest "After Images" (1924): "To add provinces to Being, to envision cities and spaces of a hallucinatory reality, is an heroic adventure" (*SNF* 11). And the heroes, the true witnesses to the unicity of things, the genuine wielders of the word and envisioners of hallucinatory realities, are rare. Joyce was one such "millionaire of words and styles," and this is why a "total reality teems vociferously in the pages of *Ulysses*"; "In no other book," says Borges, with what was for him the greatest of praise, "do we witness the actual presence of things with such convincing firmness" (*SNF* 14).

In the essentials of this view of poetic language, which is part and parcel of what has been referred to as the modernist avant-garde's "Orphic" poetics[41] and its "perceptual millenarianism,"[42] Borges was neither unique, nor prescient, nor particularly radical. He was still in his teens when, for example, Viktor Shklovsky demanded the "resurrection of the word." Yet

half a century later he would employ the exact same phrase, in almost exactly the same sense, when a book is said to be a "set of dead symbols" until "the right reader comes along, and the words – or rather the poetry behind the words, for the words themselves are mere symbols – spring to life, and we have a resurrection of the word."[43] This sentiment made itself felt throughout the early twentieth century West. As Borges himself would write, looking back on this period:

> Scattered in scattered capitals,
> solitary and many,
> we played at being the first Adam
> who gave names to things. ("Invocation to Joyce," *SP* 287)

In some cases, lines of influence can be traced; remarkably, however, most of the resurrectors of the word seem to have sprung up independently of each other. The affinity, at any rate, is unmistakable, and many other poets and thinkers could be mentioned who, scattered in their scattered capitals, shared this dream of a language that communicates in "images" rather than in words, invokes rather than refers.

Most of them also entertained this related conviction: if the word is now dead and in need of resuscitation, there was a time, in a more or less distant past, when it was still alive. It could be as early as Shklovsky's "beginning," or, in the case of Eliot's "dissociation of sensibility," as late as the seventeenth century. Alternatively, the distance could be cultural rather than temporal: the word was still alive, only in remote, non-Western traditions, and in their quest for the living word many avant-garde poets immersed themselves in the study of ancient and/or distant languages and literatures. As can be seen in the passage above from "Embarking on the Study of Anglo-Saxon Grammar," Borges's choice was the ancient North. Another particularly explicit pronouncement is found in the 1969 Prologue to *The Self and the Other*:

> The roots of language are irrational and of a magical nature. The Dane who pronounced the name of Thor or the Saxon who uttered the name of Thunor did not know whether these words represented the god of thunder or the rumble that is heard after the lightning flash. Poetry wants to return to that ancient magic.
> (*SNF* 149)

This claim is reiterated elsewhere in the late poetry (cf. *SP* 305, 343, 351), where northernist medievalism finds itself at the heart of a quintessentially modernist conception of poetry and poetic diction, espoused by Borges, as

these passages testify, long after he had supposedly broken with the avant-garde poetics of his early years.

The Cult

In the final stage of Borges's northernism, literary and scholarly pursuits were joined by an increasingly personal involvement with the North. This development was well underway by the mid 1960s, when the audience of the 1966–67 Charles Eliot Norton Lectures was made privy to the following anecdotal remark: "Whenever I walk into a bookstore and find a book on one of my hobbies – for example, Old English or Old Norse poetry – I say to myself, 'What a pity I can't buy that book, for I already have a copy at home.'"[44] In the index to the published text of these lectures "Old English" comes in second – just below "Homer" and just above "Bible." Around the same time, he published *LGM* with María Esther Vázquez, who had previously accompanied him on a 1964 tour of Europe that included a visit to Schleswig, where he "asked to be taken to the beach and, falling to his knees, dipped his hand in the sea, reciting out loud a number of Anglo-Saxon poems about the Vikings."[45] Anthony Burgess relates an anecdote presumably dating to the mid-1970s, when Borges was out of favor with the revived Peronist regime in Argentina: "At a party in the Argentine Embassy in Washington DC, when he was dogged by spies listening for words of disaffection, he and I spoke in Anglo-Saxon. This baffled completely the polyglot agents of a repressive state; it was very Borgesian."[46] Moreover, there are various other reports of Borges reciting Old English poetry in interviews or at social events during this period.[47]

Indeed, it is in this final decade or so of his life, marked by his relationship with María Kodama, that Borges's northernism reaches its apogee. In the "Autobiographical Essay," he had written of the wish to make "a pilgrimage to Iceland."[48] In 1971, a friend surprised him by arranging such a visit. Borges had divorced his wife Elsa some months earlier; he invited María Kodama to join him in Iceland. The quotes assembled by Williamson speak for themselves: the visit was "'the greatest revelation of my life,'" "'a kind of ecstasy,'" "'a dream come true'"; "he was moved to tears by the emotion of it all, for in Iceland, he would explain to Carrizo, 'you have the sagas and the Eddas, and I have always felt very deeply about all of that.'"[49] According to Williamson's interpretation, his new relationship with Kodama was an integral part of this northernist epiphany and the private northernist mythology rooted in the Norah Lange affair. Kodama and Borges had met in Borges's English class in Buenos Aires, continued to see each other in his Old English reading group, and now it was in the *terra sacra* itself that "the failures of the past

would be repeated one more time or finally redeemed in the person of María Kodama."

They made another visit to Iceland in 1976, and a paragraph of Williamson's account of this second visit is worth quoting at length:

> Borges kept quizzing his hosts as to the grammar and pronunciation of Old Icelandic and about the customs of the island. He was curious to know whether the old pagan culture of the sagas had survived into the modern times. The Icelandic poets assured him that it had, but several days later, while visiting a Lutheran church, he learned from the pastor that there was in fact only one pagan priest to be found on the island. The latter turned out to be a tall man in his fifties, with bright blue eyes and a long white beard, who lived on his own out in the country in a house full of black cats and shelves displaying assorted animal bones. He claimed that there was a revival of interest in the old religion, and a great many people came to him to be married. When Borges inquired whether he and María might be wed according to the ancient rite of the god Odin, the priest was only too pleased to oblige.[50]

Williamson says no more of the pagan wedding and does not cite his source. A year later, Borges opened the 1977 *History of the Night* with an inscription to Kodama rich with the recollections of their northernist romance:

> For the blue seas of the atlas and for the great oceans of the world. For the Thames, the Rhône and for the Arno. For the roots of a language of steel. For a pyre on a Baltic promontory, *helmum behongen*. For the Norsemen who cross a bright river, shields on high. For a Norse ship, which my eyes did not see. For an old stone in the Althing. (*SP* 391)

In short, from being one among his innumerable interests, Germania eventually became, in his own words, a "cult which illuminates my decline" (*SP* 371).

One can hardly read through a dozen pages of late Borges without coming across some northernist reference. The cult is evidenced in such intimate flotsam and jetsam of a literary life as a calling card that is now in the Borges collection at the University of Texas at Austin and bears on its back some forgotten citation from the *Prose Edda*,[51] as well as in more enduring and public monuments. The North remained with Borges to the grave, and very literally so. Even when viewed from afar, his gravestone in the Geneva Plainpalais cemetery, a roughly cut slab of plain grey rock, inevitably

reminds one of the Scandinavian runestones. The impression is only confirmed by the engravings and inscriptions it bears: on the front is an Old English citation from *The Battle of Maldon*, "and ne forhtedon na,"[52] above which is an engraving of the seven armed figures found on the so-called Lindisfarne Stone. On the back is the same *Völsunga saga* citation that appears as the epigraph of "Ulrikke" – "Hann tekr sverthit Gram ok leggr i methal theira bert" (*CF* 418)[53] – and below it an engraving of a Viking longship similar to those found on Norse image-stones, coupled with the words "De Ulrica a Javier Otárola" ("From Ulrica to Javier Otárola"), confirming Williamson's interpretation of "Ulrikke."

The great Argentine writer, buried in neutral Geneva, under a modern-day runestone, leaving behind a widow in Odin: there is no escaping the intended effect of this, of Borges's final Droctulfian gestures. Not merely do they turn their back on nationalism as a political and cultural atavism – they call into question the very notion of nationality. "It was Switzerland," writes Williamson, "with its diverse cantons and languages and races, that could offer Argentina an example of concord, a fruitful 'confederacy' of reason and good faith."[54] Yet a multi-cultural or multi-national "confederacy" is still composed of irreducibly mono-cultural and mononational ingredients. Commenting, in the Preface to the Spanish translation of *Moll Flanders*, on Defoe's *True-Born Englishman*, Borges notes how "Defoe explains that to speak of pure-blooded Englishmen is a *contradictio in adjecto*, since all the continental races had already mixed in England, the sink of Europe," adding that it was this poem that cost Defoe his pension.[55] Typically, Borges makes no overt pronouncements in this text, one of the last he ever wrote, but the implications for his situation in 1985–86 are unmistakable.[56]

Thus Borges's final work, his Genevan *ars moriendi*, issues a far more radical statement than that of the "Confederates." Just like the Langobard *illuminatus* Droctulf, he, too, decided to die in a foreign city, despising the claims of his kindred, buried under an epitaph in a language he could not, or could barely, read. Here again Borges's northernism takes the most unexpected turns: the gravestone – at first glance a quaint, almost distasteful artifact, informed by a cultural phenomenon whose origins are paradigmatically nationalist and whose politics has often been staunchly reactionary – reveals itself as a radically cosmopolitan political statement. In the same way, Borges's poems and stories on the North, at first glance so escapist, so self-indulgently private, also reveal themselves as intensely public and political. But these observations are offered only as afterthoughts: much remains to be said about this northernist oeuvre and the Droctulfian "destiny of Borges, perhaps no stranger than your own" (*SP* 231).

NOTES

1. The alleged words of Borges's mother, Leonor, to her son; cited as "undoubtedly apocryphal" in Carlos Gamerro, "Borges y los anglosajónes" (paper, "Borges y la Ley," Jornada anual del Departamento de humanidades, Universidad de San Andrés, Buenos Aires, 16 November 2006), http://www.udesa.edu.ar/files/ Events/ archivos/Gamerro-Borges-y-los%20anglosajones.pdf (accessed 25 February 2010).

2. See, however, Enrique Bernárdez, "Borges y el mundo escandinavo," *Cuadernos hispanoamericanos* 505/507 (1992): 361–70; Sigrún Á. Eiríksdóttir, "'La alucinación del lector': Jorge Luis Borges and the Legacy of Snorri Sturluson," *Iberoamerikanisches Archiv* 12 (1986): 247–60; Eiríksdóttir, "Borges' Icelandic Subtext: The Saga Model," *Neophilologus* 71 (1987): 381–7; Eiríksdóttir, "'El verso incorruptible': Jorge Luis Borges and the Poetic Art of the Icelandic Skalds," *Variaciones Borges* 2 (1996): 37–53; Fernando Galván, "Jorge Luis Borges, poeta anglosajón," *Revista de filología de la Universidad de La Laguna* 1 (1982): 139–52; Galván, "Rewriting Anglo-Saxon: Notes on the Presence of Old English in Contemporary Literature," *SELIM* 2 (1992): 72–93; Martín Hadis, "Borges y el anglosajón," *El Lenguaraz* 4 (2003): 59–74; Margrét Jónsdóttir, "Borges y la literatura islandesa medieval," *Acta poética* 16 (1995): 123–57; Karen Lynn and Nicolas Shumway, "Borges y las Kenningar," *Texto crítico* 28 (1984): 122–30; Hugh Magennis, "Some Modern Writers and Their *Fontes Anglo-Saxonici*," *Old English Newsletter* 24 (1991): 14–18; Joseph Tyler, "Borges y las literaturas germánicas en *El libro de arena*," *Hispanic Journal* 2 (1980): 79–85.

3. Where possible, Borges's works are quoted from the Penguin translations – *Collected Fictions*, trans. Andrew Hurley (Harmondsworth, 1999); *Selected Non-Fiction*, ed. Eliot Weinberger (Harmondsworth, 2000); *Selected Poetry*, ed. Alexander Coleman (Harmondsworth, 2000) – henceforth abbreviated as *CF, SNF,* and *SP.* For works not included in these editions, the reader will most often be referred to the *Obras completas,* 3 vols. (Buenos Aires: Emecé, 1996); *Obra poetica* (Buenos Aires: Emecé, 2005); *Obras completas en colaboración,* 2 vols. (Madrid: Alianza Editorial, 1983); and the *Textos recobrados,* ed. Sara Luisa del Carril and Mercedes Rubio de Zocchi, 3 vols. (Buenos Aires: Emecé, 1997–2003); these will be abbreviated as *OC, OP, OCC,* and *TR.* The abbreviations *ALG* and *LGM* will be employed for Jorge Luis Borges and Delia Ingenieros, *Antiguas literaturas germánicas,* Breviarios del Fondo de cultura económica 53 (Mexico City: Fondo de cultura económica, 1951), and Jorge Luis Borges and María Esther Vázquez, *Literaturas medievales germánicas* (Buenos Aires: Falbo Librero Editor, 1966), even though the latter will be cited from *OCC.* Unattributed translations are my own; I thank Tomislav Brlek for his assistance with these. The numerous bibliographical references throughout the paper rely mostly on Fabiano Seixas Fernandes, "Bibliografia de Jorge Luis Borges," *Fragmentos* 28/29 (2005): 245–431; Annick Louis and Florian Ziche, "Bibliografía cronológica de la obra de Jorge Luis Borges" (Borges Center, University of Pittsburgh, 1996), http://www.borges.pitt.edu/louis/main.php (accessed 25 February 2010); and Sergio Pastormerlo, "Bibliografía de los textos

críticos de J. L. Borges" (*Borges Studies Online*, Borges Center, University of Pittsburgh, 1999), http://www.borges.pitt.edu/pastorm.php (accessed 25 February 2010).

4. A coinage borrowed from Robert Lefere's *Borges: entre autorretrato y automitografía* (Madrid: Gredos, 2005).

5. Jorge Luis Borges, *This Craft of Verse*, Charles Eliot Norton Lectures 1967–68, ed. Cālin-Andrei Mihāilescu (Cambridge, MA: Harvard University Press, 2000), 104.

6. Thus Pastormerlo and Louis and Ziche; Fernandes, "Bibliografia," 262, lists the title as "Noticias [*sic*] de los kenningar."

7. Edwin Williamson, *Borges: A Life* (New York: Penguin, 2005), 25.

8. Jorge Luis Borges, "An Autobiographical Essay," in *"The Aleph" and Other Stories, 1933–1969*, with Norman Thomas di Giovanni (New York: E. P. Dutton, 1971), 178.

9. Williamson, Borges, 36.

10. Cf. the 1966 interview in Derek Wolcott, *Latin American Writers at Work* (New York: Modern Library, 2003), 9–10.

11. The copy is offered for sale by "Lame Duck Books" of Boston and their description of it, from which the inscription is cited, is available at http://lameduckbooks.com (accessed 22 May 2009).

12. This was published for Francisco A. Colombo in Buenos Aires; reprints of the essay in subsequent collections appear under the title "Las *kenningar*." See also Fernandes, "Bibliografia," 165, for the series of anonymous vignettes on "Antiguos mitos germánicos" published in four 1933 issues of the newly founded *Crítica*.

13. Williamson, *Borges*, 145.

14. Williamson, *Borges*, 182.

15. Williamson, *Borges*, 392.

16. For some exceptions see Borges, "Autobiographical Essay," 172; *OC* 2:151; *SNF* 241.

17. Curiously, *SP* gives the title as "The Generous Friend" (*SP* vi, 141) – perhaps "fiend" was intended?

18. Richard W. Sonnenfeldt, *Witness to Nuremberg* (New York: Arcade Publishing, 2006), 107. Strictly speaking, *gering* is an adjective meaning "small," "meager," and so on.

19. Borges, *This Craft of Verse*, 104–5.

20. See Mauro A. Fernández and Ernest G. Küng, "Delia Kamia: entre la realidad y la illusion," *Todo es historia* 354 (1997): 44–50 ("Kamia" is a pseudonym Ingenieros adopted by 1952 at the latest). Delia Ingenieros is also acknowledged as co-author of the short story entitled "Odín," published in the *Antología de la literatura fantástica*, that is actually a separately published extract from *ALG* (see *ALG* 57–8, *LGM* 455) and is also found incorporated in "The Dialogues of Ascetic and King" (*SNF* 385). For two other separately published extracts from *ALG*, see Fernandes, "Bibliografia," 343.

21. There is only one instance known to me where Borges makes mention of *ALG*: in the Prologue to the *Historia de la eternidad*, dated 24 May 1953, referring the book to that "improbable and perhaps nonexistent reader" whose interest is raised by "Las *kenningar*," which was included in that collection; see *Historia de la*

eternidad (Madrid: Alianza Editorial, 1978), 12. Apparently this Prologue continued to be printed in the separate editions of *Historia de la eternidad*, but in the text included in *OC* the sentence is altered to read: "The improbable and perhaps nonexistent reader of 'Las kenningar' may consult the handbook *Literaturas germánicas medievales* that I have written with María Esther Vázquez" (1:351). It may also be noted that in the 1962 postscript to "Las *kenningar*" (included in the *Historia*) – thus prior to the publication of *LGM* in 1966 – Borges takes time to correct errors and to provide a bibliography of the works he had used in writing the piece, but does not refer his reader to *ALG*, the book that actually includes a revised version of that same essay (*ALG* 87–95). So when the old 1953 Prologue disappears from at least some of the later editions of the *Historia*, *ALG* disappears with it. Vázquez has acknowledged the relation between the two books in a recent interview on the book and her legal battle over it with María Kodama, while at the same time greatly exaggerating the extent of revision in *LGM*; see Juan Manuel Bordón, "Reeditarán una obra de Borges con Vázquez," *El Clarín*, 10 September 2008, http://www.clarin.com/diario/2008/09/10/sociedad/s-01756834.htm (accessed 25 February 2010).

22. Williamson, *Borges*, 343.

23. In a 1968 interview, Borges claimed that he had never, beginning his study of Old English subsequent to the deterioration of his sight, even *seen* the two runic letters representing the "th" sounds in Old English until he asked the students in his seminar to draw them in great scale "on the blackboard in the National Library [...]. The students drew them very large, in chalk, and now I have some idea what those unseen pages look like"; Jorge Luis Borges, *Conversations*, ed. Richard Burgin, Literary Conversations Series (Jackson: University Press of Mississippi, 1998), 45.

24. In this postscript, it may be added, Borges presents us with yet another chronology of his involvement with Old English: "Two years devoted to the study of Anglo-Saxon texts," he says, have driven him to modify some of the views maintained in the 1932 piece (*OC* 1:380).

25. Thus, for example, a Norwegian translation of the Scandinavian chapter of *ALG* appeared in 1969, with Delia Ingenieros duly listed as collaborator: Jorge Luis Borges and Delia Ingenieros, *Den nørrone Litteratur*, trans. Hans Erich Lampl and Niels Magnus Bugge (Oslo: Capellen, 1969). Predictably, the only Scandinavian review of the book unearthed by Jónsdóttir is "highly critical"; "Borges y la literatura islandesa medieval," 141.

26. Paul the Deacon, *History of the Langobards*, trans. William Dudley Foulke (Philadelphia: University of Pennsylvania, 1907), 120.

27. See Jorge Luis Borges, *Borges profesor: curso de literatura inglesa dictado en la Universidad de Buenos Aires*, ed. Martín Arias and Martín Hadis (Buenos Aires: Emecé, 2000).

28. Cf. Bernárdez, "Borges y el mundo escandinavo," 361.

29. Borges, *Conversations*, 83.

30. The relevant bibliographies and surveys have significantly under-represented Borges's contribution to Spanish-language Old Germanic studies: see Fernando Galván, "Medieval English Studies in Spain: A First Bibliography," *Atlantis* 11 (1989): 191–207; Antonio Bravo García, "Old English in Spain," *Medieval English Studies Newsletter* 25 (1991): 4–7; Antonio Bravo García, Fernando Galván,

and Santiago Gonzalez y Fernández-Corugedo, *Old and Middle English Studies in Spain: A Bibliography* (Oviedo: Selim – Universidad de Oviedo, 1994); Juan Camilo Conde-Silvestre and Mercedes Salvador, "Old English Studies in Spain: Past, Present and . . . Future?" *Old English Newsletter* 40 (1995): 38–58 (38, n. 2). These fail to include a number of relevant items, while those included are misrepresented by being dated to later reprints. For example, none of these surveys notes the original date of the "Noticia de las *kenningar*," which must be acknowledged as "the pioneering paper [. . .] in the study of medieval Scandinavian, and especially Icelandic, literature in the Spanish-speaking world" (Bernárdez, "Borges y el mundo escandinavo," 362) – to which it only needs to be added that it is just as pioneering as far as Old English studies are concerned.

31. Jorge Luis Borges and Daniel Bourne, "A Conversation with Jorge Luis Borges," *Artful Dodge* 2 (1980), http://www.wooster.edu/artfuldodge/interviews/borges.htm (accessed 28 September 2009).

32. This particular essay, however, might date from 1951 or even later: in Weinberger's edition at least, it bears a later date than the other *Dantesque Essays*: 1945–51/1957.

33. See Eiríksdóttir, "'El verso incorruptible,'" 44; Ernesto Porras Collantes, "Texto y subtexto: de 'Tlön, Uqbar, Orbis Tertius' de Jorge Luis Borges," *Thesaurus* 36 (1981): 464–526, 38 (1983): 82–117 (2:104); Jónsdóttir, "Borges y la literatura islandesa medieval," 134–8.

34. *Via* a footnote in W. P. Ker, *Epic and Romance: Essays on Medieval Literature*, 2nd ed. (London: Macmillan, 1908; repr. New York: Dover, 1957), 206.

35. Cf. *SNF* 437, 443, 446, 449, and *Biblioteca personal: prólogos* (Buenos Aires: Emecé, 1998), 143, 204–5.

36. See also, in order of publication: "A Saxon (A.D. 449)" (*SP* 189–91); "Fragmento" [Fragment] (*OP* 214); "Hengist cyning" (*OP* 212–13); "Snorri Sturluson (1179–1241)" (*OP* 218); "To a Sword at York Minster" (*SP* 209); "A un poeta sajón" [To a Saxon Poet] (*OP* 216–17); "To a Saxon Poet" (a different poem, *SP* 243); "A Islandia" [To Iceland] (*OP* 375–6); "Hengist Wants Men (A.D. 449)" (*SP* 335); "Brunanburh, 937 A.D." (*OP* 411); "991 A.D." (*OC* 3:144–5); "En Islandia el alba" [In Iceland at Dawn] (*OP* 457); "Einar Tambarskelver" (*OP* 456); "Nightmare" (*SP* 373); "Iceland" (*SP* 403); "Midgarthorm" (*OP* 606); "Un lobo" [A Wolf] (*OP* 605).

37. These include, in order of publication: "Matthew XXV: 30" (*SP* 173); "The Moon" (*SP* 109–13); "The Other Tiger" (*SP* 117–19); "The Hourglass" (*SP* 99–101); "Ariosto and the Arabs" (*SP* 123–7); "A Carlos XII" [To Charles XII] (*OP* 219); "Al vino" [To Wine] (*OP* 229); "El hambre" [Hunger] (*OP* 233); "Elegy" (*SP* 361–2); "España" [Spain] (*OP* 244–5); "Otro poema de los dones" [Another Poem of the Gifts] (*OP* 249–51); "Someone" (*SP* 225); "To a Coin" (*SP* 235); "Cambridge" (*OP* 298–9); "In Praise of Darkness" (*SP* 299–301); "Un lector" [A Reader] (*OP* 331–2); "El mar" [The Sea] (*OP* 364); "El pasado" [The Past] (*OP* 341–2); "Los cuatros ciclos" [The Four Cycles] (*OC* 2:504); "The Gold of the Tigers" (*SP* 339); "The Watcher" (*SP* 325); "Things" (*SP* 317–19); "Tú" [You] (*OP* 358); "Browning Resolves to Be a Poet" (*SP* 351); "Elegy" (*SP* 231); "Espadas" [Swords] (*OP* 396); "Talismans" (*SP* 365); "Quince monedas" [Fifteen Coins] (*OP*

399–402); "Elegía del recuerdo imposible" [Elegy to an Impossible Memory] (*OP* 435–6); "Herman Melville" (*SP* 377); "Los ecos" [The Echos] (*OP* 459); "Things That Might Have Been" (*SP* 407); "Fame" (*SP* 453); "Notes for a Fantastic Story" (*SP* 437); "That Man" (*SP* 431); "The Cloisters" (*SP* 435); "Estambul" (*OC* 3:408); "Esquinas" [Corners] (*OC* 3:430); "Alguien sueña" [Someone Dreams] (*OP* 600–1); "Christ on the Cross" (*SP* 471); "Haydée Lange" (*OP* 618); and "La trama" [The Plot] (*OP* 590).

38. *Seis poemas escandinavos*, originally a limited edition of 84 copies, is included in *OP*. According to information gathered from rare-book dealers and other sources, *Siete poemas sajones/ Seven Saxon Poems* was a limited edition of 120 lavishly manufactured copies signed by Borges and the artist Arnoldo Pomodoro, after whose work the etchings included in the book were made. In 1975, a hand-printed Italian translation, *Sette poesie sassoni*, was published in Verona in a limited edition of 150 copies.

39. Wulfstan, *Sermo Lupi ad Anglos*, in *Beowulf*, Roy Liuzza, ed. and trans. (Peterborough: Broadview Press, 2000), 199.

40. Cf. Gamerro, "Borges y los anglosajónes": "just as the sea is the Englishman's pampa, so are Borges's Anglo-Saxons the gauchos and ruffians of the British Isles."

41. On the northernist element in *The Book of Sand* see also Tyler, "Borges y las literaturas germánicas en *El libro de arena*."

42. Gerald L. Bruns, *Modern Poetry and the Idea of Language: A Critical and Historical Study* (New Haven: Yale University Press, 1974; repr. Urbana-Champaign: Dalkey Archive Press, 2001).

43. Katerina Clark, *Petersburg, Crucible of Social Revolution* (Cambridge, MA: Harvard University Press, 1995), 30.

44. Borges, *This Craft of Verse*, 4.

45. Borges, *This Craft of Verse*, 9.

46. Williamson, *Borges*, 356.

47. Anthony Burgess, "Foreword by Anthony Burgess," in Evelyn Fishburn and Psiche Hughes, *A Dictionary of Borges* (London: Duckworth, 1990), xi–xii.

48. See for example Borges, *Conversations*, 1, 42, 200.

49. Williamson, *Borges*, 394.

50. Williamson, *Borges*, 422.

51. "Autobiographical Essay," 183.

52. Catharine E. Wall, "The Jorge Luis Borges Collection at the University of Texas at Austin," *Latin American Research Review* 36 (2001): 154–62 (159).

53. "[A]nd that they should not feel scared at all"; S. A. J. Bradley, ed. and trans., *Anglo-Saxon Poetry* (London: J. M. Dent, 1982; repr. London: J. M. Dent, 2004), 520.

54. Williamson, *Borges*, 492.

55. "He took the sword Gram and placed it unsheathed between them"; Jesse L. Byock, ed. and trans., *The Saga of the Volsungs* (Berkeley: University of California Press, 1990; repr. London: Penguin, 1999), 81.

56. *Biblioteca personal*, 143. See *The Works of Daniel Defoe*, Cripplegate Edition, 16 vols. (New York: George D. Sproul, 1908), 11:224, 242.

57. The Prologue was written in 1985. On Borges's deliberate decision to die in Geneva see Williamson, *Borges*, 481–2.

O Rare Ellis Peters:
Two Rules for Medieval Murder

Alan T. Gaylord

Thereafter, on occasions and for what he feels to be good reasons, he may break the rules. He will never transgress against the Rule, and never abandon it.

<div align="right">Ellis Peters, "Introduction," A Rare Benedictine[1]</div>

Edith Pargeter, a professional writer of copious invention and range with more than fifty novels to her credit, invented the *nom de plume* of Ellis Peters primarily for the writing of mysteries. Her first ten featured the English policeman, Inspector Felse, and his family; but the eleventh, *A Morbid Taste for Bones*, published in London in 1977, introduced a new kind of investigator: Cadfael ap Meilyr ap Dafydd, a twelfth-century monk in an abbey in Shrewsbury, in Shropshire on the Welsh borders. She never called it a "project of medievalism," but that is what it was.

One must begin, and probably end, with what Pargeter knew about medieval Wales and England and the medieval world. Although it is clear that she kenned the matter of the histories that are drawn upon and worked into her medieval stories, when she discusses her sources she begins by characterizing such knowledge not as a subject matter in an academic or theoretical structure, but as a richness of experience, geography, curiosity, and memory. She had no intentions of writing an autobiography, or even a thinly disguised autobiographical novel. What her intentions actually were are best revealed in a charming volume, *Shropshire. A Memoir of the English Countryside*,[2] where she writes about the county of Shropshire, including its medieval history, and makes clear on every page her knowledge and love of that region:

I can think of places in other counties, other countries, where I can imagine being happy every moment of the day and night. But none of them displaces this vague circle of earth, three miles or so in diameter, in which I have lived, or at least made my base, all my life. I can travel joyfully to any of my favourite haunts abroad, but only to this place can I come home. It can even be a love–hate relationship between us, but it is a powerful compulsion, strong enough to pull me back across the world from any earthly paradise. Other places can be where I exult and wonder. This is where I put my feet up and thank God.[3]

Shropshire, of course, is bounded by the Marches, and Wales and the Welsh are right over the border. There was some Welsh in Pargeter's blood, and its medieval DNA flows through several series of novels, with special attention to the thirteenth century. In a sense, the set of novels she wrote before she began the Cadfael series was more "conventional," which is not to say that she did superficial reading in medieval Welsh history. But she did not introduce the medieval/modern hybrid features of "history-mystery," nor did she worry much about her capacity to imagine the hearts and souls of her medieval Welsh characters. It was her subject matter that would be unique to most of her readers, not new techniques of plotting, narration, or characterization. The Welsh novels were rich – massive even – and complex. She had done her homework well. The borderlands and the medieval Welsh princes began to stimulate her creative imaginings:

The Heaven Tree and its sequels [1960–63] took me over a good part of western Shropshire [...] especially along the Roman road on the flank of the Long Mountain, with the Breiddens looming at the northern end of the ridge, and a grand, stormy view of the river valley, the meadows that hold all that remains of Strata Marcella, and the town of Welshpool. This was still history, even though the fictional story woven into it took pride of place, so all that was historical had to be exact. But the castle that never existed I could place where I chose, provided I took care to account for its absence in the end.[4]

Then she turned her gaze intensely on a more exotic subject comprised in the four volumes of her The Brothers of Gwynedd Quartet [1974–77]:[5]

I think the fictional biography of Llywelyn ap Griffith important because I went to great trouble to dig up every source and every detail I could find, and changed nothing of what I found. And

because as far as I know, no one, Welsh or English, has produced anything so complete about him before.[6]

But after she had adventured into crime fiction, with her invention of the policeman, Inspector Felse, she carried her crime writing back to this real and imaginary world of the borders.[7] Her expert and knowing eyes looked out from a Benedictine monastery at Shrewsbury into a world of chaos, intermittent battle and political jockeying, as the princes of Wales battled each other and the English, and the Empress Maud and King Stephen fought for the crown, oppressing England with destructive strife. As she summarizes the medieval borders history, she witnesses her own fascination with the subject:

> Every frontier, every critical line where two separate cultures, two systems of law, two social organizations, both meet and separate presents a heightened tension, intensified colours, a sense of drama that settled hinterlands do not know. By the nature of frontiers, they are often foothill country, even mountain country, which gives them variety, beauty and awe to begin with, and their inevitable depth and passion of history lift the imagination into high drama, in the most profound places into tragedy.[8]

Pargeter knew histories, the chronicles, the historical names, from the highest royalty to the lowliest peasant, and took pride in getting her facts straight; she exercised her fictional imagination upon the diversity of the nameless, faceless masses of those times. She liked the Shakespearean phrase, "a local habitation and a name";[9] and sums it up superbly:

> I have used this landscape, native and familiar to me, in all my books, sometimes in the veritable shape and by its own names, sometimes with its edges diffused into a topography between reality and dream, but just as recognizable, for those who know it as I do, as if it had been mapped with the precision of an Ordnance Survey sheet. I did not set out deliberately to make use of my origins. Shropshire is simply in my blood, and in the course of creation the blood gets into the ink, and sets in motion a heartbeat and a circulation that brings the land to life.[10]

In changing her detective from a modern policeman to a medieval Benedictine monk, and her name from Pargeter to Peters, she helped define the sub-genre "history-mystery," and produced a curious but curiously popular succession of twenty novels that may be said to fall between two

Rules – one coming out of ancient and medieval ecclesiastical history, and the other out of contemporary popular literary genres (which had nothing inherently medieval about them).

To be sure, it is not easy to see what the natural logic might be of a life in a medieval monastery enclosing a monk who solves, as it were, serial murders. The Rule of the Monk is unworldly, meditative, and internal, and the "warfare" that St. Benedict of Nursia ascribed to monastic life is a matter of discipline, renunciation, and prayer,[11] whereas the Rule of Detective Fiction is the rule of the genre, requiring at least one corpse, many secrets, and the steady unriddling of events and motives to discover a murderer. It might seem that to follow strictly one Rule would of necessity be to contradict the other. And of course, the notion of a medieval monk who plies the practice of a detective is a great big anomaly of medievalism.

I think Edith Pargeter was too cunning, too professional, to be daunted by such contradictions. I intend to follow the way she confronts and deals with these two Rules, starting from the first Cadfael novel, *A Morbid Taste for Bones* (1977), and concluding at the point where she makes the last great turning of her career (*Brother Cadfael's Penance*, 1994). The thematic patterns and narrative techniques we find in that first novel of the series will establish a certain paradigm for the treatment of murder within a larger frame of life and death. For further illustration, I will move to a later novel (the ninth), *Dead Man's Ransom* (1984). My argument will be that Pargeter-become-Peters is exploring a conversion of the "history-mystery" sub-genre to suit her monkish detective and her own creative spirit. She is comfortable within her imagination of the High Middle Ages, being careful to avoid flagrant anachronisms, even as she constructs a discourse for her characters that is neither quite Here nor There – which is to say that she is working within an imaginary that describes (borrowing from Marianne Moore) "imaginary gardens with real toads in them."[12]

By way of further definition, consider a comparison with Umberto Eco's *The Name of the Rose*: its portrait of monastic life is in effect a "Gothick" novel with its post-Rabelaisian grotesqueries, dark shadows, and melodrama, in which the monastery becomes a site of dangers, plots, and perversities.[13] To Eco, the Rule of the monastic regime essentially produces the rule of murder – violent death is implicit in its disorderly Orders – while to Peters, one Rule, the Benedictine (at least as liberally exemplified in Cadfael), subsumes the other. Murder, we might say of the Cadfael Chronicles, is buried in the plot in the name of peace.

The Cadfael chronicles are "Gothic" novels in their time period but not in their genre: I would call them, instead, "Arcadian mysteries" – pastoral idylls disturbed by that *memento mori* we see displayed in Poussin's painting, *Et in Arcadia sum* . (A handsome reproduction of Nicolas Poussin's

seventeenth-century painting, now hung in the Louvre, is reproduced online: <http://arcadia.ceid.upatras.gr/arkadia/engversion/culture/clasarcadia/etinarc.html>)

The category of "Arcadian" is one I apply to the Cadfael Chronicles, even though the term is not developed within their stories and is not medieval in its origins; but in thinking about the relationship between murder, mystery, and the more general theme of mortality, I found the interpretation of "Et in Arcadia Sum," particularly as developed by Erwin Panofsky, of great heuristic value.[14] And of course the meaning of the phrase, as explicated by Panofsky, has affinities with medieval tropes like the Dance of Death, "De Contemptu Mundi" and "Ubi Sunt ...". Not to mention, "Even here, in Shropshire." As I shall explain.

Lacking a reproduction of the Poussin painting (1630–35), I will quote Panofsky's description:

> Three handsome shepherds are both fascinated and moved by an austerely simple tomb, one of them kneeling on the ground, so as to decipher the half-effaced inscription, *Et in Arcadia ego*, the second explaining its meaning to a lovely girl, who listens to him in a quiet, thoughtful attitude, the third trajected into a sympathetically brooding melancholy. It is as though the youthful people, all silent, were listening to or pondering over this imaginary message of a former fellow-being: "I, too, lived in Arcadia, where you now live; I, too, enjoyed the pleasures which you now enjoy; and yet I am dead and buried." We instantly perceive a strange ambiguous feeling which suggests both a mournful anticipation of man's inevitable destiny and an intense consciousness of the sweetness of life. (224)

But Panofsky has more to develop with regard to "the exact meaning of the inscription," which serves to bring its theme and its images closer to our present subject:

> According to the rules of Latin grammar, [...] the correct translation of the Latin formula *Et in Arcadia ego* is "Even in Arcadia, there (am) I," and this, as a matter of fact, is its original and genuine meaning; for the subject of the sentence is not the man buried in the tomb, but the tomb itself – and the tomb in its turn is nothing but a substitute for death in person. (232)

And Panofsky goes on to cite the gloss of Poussin's friend, Giovanni Pietro

Bellori: "cioè che *il sepolcro* si trova *ancora* in Arcadia e che la Morte a luogo in mezzo le felicità" ("'Et in Arcadia ego' means that the *grave* is to be found *even* in Arcadia and that death holds sway in the very midst of delight").

For final evidence, and a bringing together of themes and structures, I will consider what seems to me clearly a narrative and a writerly set of conclusions, as in the last two books that Ellis Peters wrote, *The Holy Thief* (1992) and *Brother Cadfael's Penance*. Here we will find a blending of rule-breaking on the part of both Cadfael and his author, a weaving together of the intensely personal with the political, and a resonant orchestration of multiple homecomings – what amounts to, as I see it, a closure that puts death in its place even as it pays out a kind of writing that can be followed by nothing more than peaceful silence.

Death in the Cadfael novels is in one sense disturbingly "regular," yet within the narrative style of Ellis Peters its detection becomes part of a larger process of accommodation, reconciliation, and resignation.

A Morbid Taste for Bones

I never wished to leave my resting-place here in Gwytherin. (162)

One of the virtues of this "first" volume in an (unintended) series is that it is the product of a mature and experienced writer, striking out in a new direction yet equipped with the stamina and creativity of her best work, now circling back to her roots even as she pursues her interests in the history of the Marches during the twelfth century.

Few of her other Cadfael books venture all the way into Wales as she does here, and none of the nineteen others stays as long in Gwynedd, North Wales. On page 25 of a 192-page novel, the party to recover the Welsh bones of St. Winifred has set out from Shrewsbury, not to return to their abbey until the end of the book (186). So it might seem as if the author has not set herself to recreate "the Benedictine Rule in practice" through depicting the daily life and routines of a monastery. And yet questions of the Rule travel with them and are bound up with the developing plot.

In this way: the story turns into a murder mystery a little more than a third of the way through, when the body of the Welshman Rhisiart, "the biggest landowner in these parts" (40), is discovered dead in the woods with an arrow through him (69). Since his was the strongest voice from the community of Gwytherin opposing the transfer of the Welsh saint's bones back to Shropshire, the suspicions aroused by this foul play threaten serious trouble to the abbey's ambitions. The leader of its delegation, Prior Robert Pennant, may cry out, "Behold the saint's vengeance! Did I not say her wrath would be wreaked upon all those who stood in the way of her desire?" (71).

But he is on shaky ground. From the start, even though he came into Wales to collect the saint with the blessing of his abbot, the sanction of the bishop of Bangor, and the permission of the local Welsh prince, the people of the parish of Gwytherin expected to have their full say. As Sir Huw, the priest at Gwytherin, put it: "Your case can only be vindicated absolutely by public acceptance" (32).

His point went against the hopes of the haughty prior from England. And in assembly, it had been Rhisiart who cried, "You have been deceived by devils! Winifred never said word! [...] These bones you come hunting are also hers. Not ours, not yours! Until she tells us she wills to have them move, here they stay" (52).

In what plot will those bones finally rest? For the abbey's plot, they are to be dug up from their presumably obscure and insufficiently appreciated little parish grave in Wales and brought back in splendor in a specially crafted reliquary-casket to the holy earth of the Abbey of St. Peter and St. Paul in England. At one level, that plot is perfectly realized. Yet there is another plot, unseen by most of the English, contrived by Cadfael, and secretly understood by the Welsh.

It goes like this: When Rhisiart was murdered, his body was buried in the very same grave from which the saint's bones had been removed. But then, when Cadfael discovers that the murderer was in fact the ambitious young monk, Columbanus, and after Columbanus tries to kill Sioned, the young woman who had impersonated St. Winifred in order to frighten a full confession out of him, her swain, Engelard, handles Columbanus so roughly and in such a rage that the monk's neck is broken. The consequent solution to this sudden collection of new and old bones is elegant, and performed by Cadfael and the two young people with a certain smile (173).

The saint's bones are secretly re-buried next to Rhisiart's, and the murdering monk is sealed into St. Winifred's reliquary and thence carried – now miraculously heavier (182) – back to Shrewsbury. This egregious example of plot-switching demonstrates what I am calling the Paradigm of the Two Rules: first, two worthy bodies are returned to earth, and then the crime of murder is "solved" by virtue of so removing the criminal from apparent view that his remains (only his clothes) testify that he has been snatched up from the living into grace – constituting at once a miracle and a holy fraud. The detective-monk has deduced all that is necessary, improvising (with the cooperation of St. Winifred) a distribution of justice and mercy. One plot swallows up the other; one Rule subsumes the other.

Which is not to say that Ellis Peters O.B.E., the mystery writer, the recipient of the British Crime Writers' Association's Diamond Dagger Award and the Mystery Writers of America's "Edgar," had no interest in, or could not control, the rules governing the plotting of murder mysteries! Each

Cadfael Chronicle will have at least one corpse, though frequently late in arriving and tending not to accumulate; there will always be an investigation, with the usual false leads and surprising turns; and there will always be a complete, and completely explained solution. (The one exception is *An Excellent Mystery*, 1985, which has no dead bodies at all.)

These things comprise one set of rules and one layer of plotting. But there are other layers there, and another Rule from the beginning, that are more and more richly developed as the chronicles continue. Let *A Morbid Taste for Bones* help make this overall point: a fresh murder is rarely the center of the action, and almost never the center of the book. Premeditated murders are almost always briefly reported, and as they are occurring, not set before the reader's eyes. Yes, even in Arcadia there death is, but the point has much to do with integrating the tombstone into the landscape (which is what Poussin's painting does); and most to do, literally and metaphorically, with seeing to it that all bodies are buried in peace.

Saint Winifred sees to it that both the old grave in Wales and the spurious relics in Shrewsbury now produce startling miracles. Thus the saint, with a certain sense of humor, produces her own harmony of reconciliation between Wales and England. She is special to Cadfael: "he knew [her] well, he had lifted her out of the Welsh earth with his own hands, and with his own hands laid her reverently back into it, and drawn the sweet soil of Gwytherin over her breast" (*The Holy Thief*, 28). And the saint is special to Ellis Peters: as I will discuss a little further on, it will be the saint that becomes an icon of the particular kind of grace appropriate to Benedictine murder mysteries.

In this, her first experiment in combining, even fusing, generic and Benedictine rules, Ellis Peters went farther than most of her subsequent volumes would go; that is, the villains and the necessary murderer, not to mention the detective, are solely produced from within the monastery. But there was no need to continue such a pattern (indeed, a monastery that produced at least one in-house murder every six months would surely have been evacuated by Rome well before seventeen bloody years had passed). The historical setting, spanning the years of civil war between King Stephen and his cousin, the Empress Maud, could provide enough moral chaos to supply all the betrayal, blood, and evil motives any mystery writer could desire, without smirching a single monk. (And from the civil world would emerge, in the second novel, Hugh Beringar, Sheriff of Shrewsbury, becoming a friend, colleague, and secular partner in detection with Cadfael.) I wish to turn now to a later novel in which the monastery is the physical setting, but its life and its monastic personnel only incidental to the plot, even though there are strong thematic affiliations to what has thus far been discussed.

Dead Man's Ransom

> A man must be prepared to face life, as well as death, there's
> no escape from either. (183)

Dead Man's Ransom. The Ninth Chronicle of Brother Cadfael, published in 1984, has this summary statement offered to Hugh Beringar by Cadfael: "Once, I remember, Father Abbot said that our purpose is justice, and with God lies the privilege of mercy. But even God, when he intends mercy, needs tools to his hand" (190). – Let us call this the instrumental version of our paradigm.

The two men are closing off the latest set of adventures, and Cadfael is reinterpreting, while affirming, the Benedictine Rule. Although he once again has spent most of his time over the border in Wales, he has not been an accessory and onlooker but rather a major player in the main action, nor has he been in any position of resistance or subversion – as he had been while earlier accompanying Prior Robert. With abbatial approval, he solves with Hugh a murder in order to bring justice to the shire – and the result is primarily important to relations between Welsh princes and English sheriffs, and beyond them to the whole question of civil order in the kingdom.

Once again, Cadfael solves the crime by solving the murderer, conniving at his escape into Wales. For the culprit is a young Welshman, over-loyal to both his friend and his lover – passionate, and involved in a web of conflicting desires that, he thinks, only death can solve. The web holds primarily young people, all confusedly in love, and it is their plight that Cadfael "solves" by clearing the way for each soul to recover his or her mate.

So death in this story is nearly an accident, and the murder is once again reported but not directly described. The man who was killed was half a corpse already. The murder obtrudes in the narrative more like a distraction than a narrative problem. Its context is more extensive than the monastic setting: the murdered man was Gilbert Prestcote, a sheriff, and had been injured in a fierce battle in Lincoln between partisans of King Stephen and the Empress. He has been brought home for healing, to be placed within the monastic zone of Arcadian peace and good health. But the zone is general, and generally imputed, without development of individual monks or monkish business.

From a not-too-safe distance is felt the abnormal amount of violence, desolation, and death that menaces the Abbey. There are brigands who roam the borders and prey on villages and isolated convents; there are desperate and bloody battles, just as there are betrayals and false promises, ever-renewing vendettas, and reckless destruction. All of these overrun the

story at various points and leave their mark. Accordingly, the main task of the story is not to unravel a mystery but to restore the peace.

In theory, a monastic order could only hope to achieve such a thing through its prayers; but Cadfael's mission is to be, once the antipathies and murders are sorted out, an active instrument of God's mercy in alliance with civil authority. And in this narrative, resolution is synonymous with recon-ciliation whose personal level is intercalated with the social and the civic.

At one point Cadfael tells Eliud ap Griffith, the young murderer who will shortly be secreted over the border, "God fixes the term, [...] not men, not kings, not judges. A man must be prepared to face life, as well as death, there's no escape from either" (183). The sequence here is significant: the mystery story acknowledges death and its consequences, which stand in the pastoral Arcadia like that tombstone whose epitaph, when puzzled out, reads, "And even in Arcadia, there am I." But the effect of Cadfael's remark is not to deny death, nor to muffle it in sentimentality; rather, it is to affirm the inescapable imperative of life. Thus does one Rule subsume the other.

After Eliud has been spirited away and Hugh comes to examine the connivers, he asks Melicent, one of the young lovers and the daughter of the man who had been killed, this question: "You of all people [...] had the greatest right to require payment from Eliud. Have you so soon forgiven him?" And she gives him this response: "I am not even sure," said Melicent slowly, "that I know what forgiveness is. Only it seems a sad waste that all a man's good should not be able to outweigh one evil, however great. That is the world's loss. And I wanted no more deaths" (188).

I would call that response and that attitude "Winifredian," as conso-nant with, if not directly inspired by, Cadfael's St. Winifred. To be sure, the saint makes no dramatic appearance in *Dead Man's Ransom*, but Melicent's spirit here is in harmony with the same sort of responses discovered in Ellis Peters' first Cadfael Chronicle. And it leads us now to the last two volumes in the series – in which St. Winifred takes command of the themes and even the plot, and in which she dramatically subsumes the rules of detective fiction, confirming the final redemption of Cadfael, who thinks of himself as one who has so far broken the Benedictine Rule as to become apostate. And in so doing, Ellis Peters finds her own writerly mode of redemption and release.

The Holy Thief

and never doubt but she will make her judgement plain. (127)

This is not an essay about St. Winifred in the Cadfael Chronicles, so I have passed by most of the fourteen novels in which she is mentioned and

sometimes featured (most easily confirmed by consulting the useful listing, s.v. "St. Winifred," in that most useful of Cadfaelian references, *The Cadfael Companion*[15]). All I need in the present instance is some accounting for her radiant if somewhat mischievous reappearance in these last two novels Ellis Peters wrote. I would not presume to guess as to what extent this return is the result of deep meditation on Peters' part or the superficial reflex of repeating what had worked before. But I think she would be amused and touched if I said it was clearly the will of the saint.

The story of how Edith Pargeter discovered this rather obscure little Welsh saint of the seventh century is worth telling because it throws light on how Winifred ("Gwenfrewi" or, yes, "Guinevra") became the patron saint and the muse of the Cadfael Chronicles.

Before writing *A Morbid Taste for Bones*, Pargeter had written thirty-six different novels, some of the best of which were set in the Middle Ages. The latter grew out of her assiduous readings in English history of the twelfth and thirteenth centuries, in the course of which she regularly, as she put it, "dipped into" the local history of her own region of Shropshire along the Welsh borders. A happy discovery was Owen and Blakeway's *A History of Shrewsbury*, first published in 1825. In their account based on Prior Robert Pennant's "Life of St. Winifred" ("I've never seen it," noted Pargeter, "it is in the Bodleian Library"[16]) she could read about the translation of the saint's relics – sans murder, of course, and sans the secret return of the bones to Wales. It was thinking of those latter possibilities that led her to write a medieval mystery, not intending any kind of series.[17]

The rest, we might say, is history. But there is more; for her gradual turning to monkish sequels, and then assigning "Ellis Peters" solely to the Cadfael Chronicles, parallel what she has written about how and why Cadfael, after a life as a knight and a crusader, would, at the ripe age of forty, take vows and become a Benedictine monk. She says it was not a conversion, not a blinding blast of light like St. Paul's on the road to Damascus; she was to write, very late in the series, a short-story as an explanation: "A Light on the Road to Woodstock," gathered in the slim volume, *A Rare Benedictine*: "What happens to him on the road to Woodstock is simply the acceptance of a revelation from within that the life he has lived to date, active, mobile and often violent, has reached its natural end, and he is confronted by a new need and a different challenge."[18] It takes very little adjustment to fit this statement directly to the last part of her writing career.

A Morbid Taste for Bones was published in London in 1977, under the name of Ellis Peters – Pargeter had already written ten non-medieval detective mysteries under that name. But after 1977, "Ellis Peters" wrote one more Inspector Felse mystery (*Rainbow's End*), and after that not only was she Ellis Peters only for Cadfael, but she laid aside "Edith Pargeter" and

wrote no more fiction under her own name. She was sixty-four years old when she invented Cadfael, and would go on to spend her last eighteen years in his world. There is no need to resist the accompanying thought, that she went where the money was. If, as seems clear to me, she followed her heart first, then God Bless the profit that followed!

The central mystery in *The Holy Thief* – the armature for the plot – concerns the theft of the (supposed) relics of St. Winifred, though it has no connection this time to opposing claims from her native Wales. Ramsey Abbey in Cambridgeshire, recently occupied by the bandit forces of Sir Geoffrey Mandeville, has now been returned to the Church and needs refurbishing and restoration. The returning monks appeal to neighboring abbeys for help. Representatives are well received at Shrewsbury, but it is a time of river flooding, and in the confusion of moving abbey possessions to higher, drier ground, some well-wishing enthusiast thinks to steal the reliquary of St. Winifred as a crowning gift. But the theft is discovered while the Ramsey party is still on the road; it falls into a third party's hands, and now where does the saint desire to rest – in her old haven or someplace new? Her reliquary (never having been opened, to Cadfael's relief) must now be brought back to Shrewsbury for judicial determination.

Abbot Radulfus has a solution: "Let Saint Winifred herself declare her will openly [...]. We will take the *sortes Biblicae* upon the reliquary of the saint, and never doubt but she will make her judgement plain" (127). As explained, this process of randomly placing a finger on a page of the Bible and reading the line discovered as a providential declaration actually was part of the ceremony of consecrating bishops in the twelfth century.[19] Its introduction here is a witty way of bringing the saint directly into the story.

The ensuing miracle of the *sortes Biblicae* is crisply recounted, and the reader is almost – but not quite! – able to rationalize it with a consideration of breezes and sheer luck. But Cadfael thinks otherwise. Even the blackthorn petals that had fallen earlier from his sleeve unnoticed across the altar and the open Bible come to provide an unexpected index for a final message from the saint, a clue that will lead to the discovery of the murderer. And earlier openings of the Bible had provided scripture that made it clear where the saint would choose to rest, and on what terms: "Ye have not chosen me, but I have chosen you" (160). Unmistakably, she had brought the two Rules together: the "solution" is hers.

It is those accidental blackthorn petals that make a link between beginning and end. They had been the early harvest of March, and Cadfael muses: "Distantly this springtime snow stirred his memory of other Springs, and later blossom, like but unlike this, when the hawthorns came into heady, drunken sweetness, drowning the senses" (151). Spring is about to break out in *The Holy Thief*, as is appropriate for the new lives that have been

protected and confirmed in its story. But the most telling memory, a clue slyly hidden here like the purloined letter, would be of that moment in the first novel:

> Sioned [says Cadfael], I have something for you to do. [...] Take that sheet of yours, and go spread it under the may trees in the hedge, where they're beginning to shed. [...] Shake the bushes and bring us a whole cloud of petals. (*Morbid Taste*, 173)

They are preparing to stage the after-effects of a miracle – the visitation to Columbanus by St. Winifred and his assumption directly to Heaven. "'I do recall now, said the prior, [...] how he cried out to be taken up living out of this world, for pure ecstasy'" (*Holy Thief*, 181). The spring hawthorn flower provided the requisite odor of sanctity when the saint reached out her hand to help, either as masquerade or miracle.

The blackthorn petals in *The Holy Thief* are prophetic, then: they invoke the originating motives of the Cadfael Chronicles, and strew the way towards her final appearance and the crucial, and conclusive, help she gives, in *Brother Cadfael's Penance*.

Brother Cadfael's Penance

There is good evidence by this time that Peters had been intending closure. *The Holy Thief* bore witness, not by themes or speeches in the text, but by the surprising prominence of Saint Winifred as a *material* agent for the dispensation of justice and mercy. In retrospect, hers were the feet on the mountain and she was a sign that we had come full circle and that the end (or The End) was near. Now, in this her twentieth Chronicle, such a sign is charged to overflowing with meanings beyond narrative structure and the sense of an ending.

Saint Winifred returns as the patron saint of two linked Arcadias, the little vale of Gwytherin and the Abbey of St. Peter and St. Paul, in order to preside over the harmony of two rules: of murder and of death, detection and faith, violence and peace, withering and flowering; and to subsume the original elegiac meaning of "Et in Arcadia Sum" within her *terroir*, within the greens and golds of her indulgent protection. As Cadfael says, "She knows what we need and what we deserve. She'll see wrongs righted and quarrels reconciled, in her own good time" (*Penance*, 150).

There is a murder in this volume, and one central to at least part of the story; yet I found, in preparing to re-read the novel, that I could hardly remember it. For this is the story where Brother Cadfael disobeys the order of his abbot, and openly and knowingly breaks the cardinal rule of

obedience, and, after that, of stability. As he puts it: "I am absent without leave from my abbot. I have broken the cord. I am apostate" (*Penance*, 136).

He is looking for his son born out of wedlock, Olivier de Bretagne, the product of his liaison with Miriam of Antioch during his early years of crusading. Olivier is now an English soldier in the forces of the Empress Maud. Father and son had met in recent years, but although Cadfael had learned of their relationship he had not told Olivier: "There is no need for him to know. No shame there, but no pride, either. His course is nobly set, why cause any tremor to deflect or shake it?" (151). Now, as part of the increasingly bitter and destructive changes of loyalty of troops and followers between King Stephen and the Empress Maud, Olivier has been captured, withheld from ransom, and buried alive in some unknown prison. Cadfael feels as a father that he must keep searching until he finds his son. (The most intense "investigation" in this novel is part of that quest, not of his murder-sleuthing.) And to do that he must disobey his abbot.

The account of what Cadfael calls his "penitential quest" takes us back into the heart of the anarchy and its politics of shifting allegiances and betrayals. Olivier is locked into the lowest dungeon, cut out of the rock, in La Musarderie, a castle controlled by the inscrutable Philip Fitzrobert, enemy to the Empress Maud, and estranged from his father, Robert earl of Gloucester. Cadfael has no wish to interpose tiresomely into his son's career and political choices, but this being buried beyond ransom is not to be borne: without hesitation he proceeds to break any rule that declares he no longer has a father's obligation to his son.

The decision, made unwaveringly, nevertheless gives him great pain. If he is convinced that he must follow his search until his son is discovered and released, he is also convinced that the probable price he will have to pay is his life and quite possibly his soul. So huge is his recusancy that, as he prepares to leave, he will not ask Saint Winifred, "an intimate but revered friend" (14), for any particular favor or forgiveness: "So the only prayer he made to her was made without words, in the heart, offering affection in a gush of tenderness like the smoke of incense [...]. Why disturb its sweetness with a trouble which belonged all to himself?" (14).

His journey takes him right into the lion's den: he seeks out his son's captor, finds him at La Musarderie, identifies himself, and stays on (as a guest, not a prisoner) to find Olivier and plead for his release. It is at this point that the internal narrative, as if to demonstrate that its old narrator was still capable of scenes of action and excitement, breaks into an account of an all-out attack on the castle, in which Cadfael is the observer, the medic, and the agent of espionage.

In one sense, like her creation, Peters has herewith broken the rules of her genre – none of this has anything to do with a murder, its mystery, or its

investigation, nor does it demonstrate in Cadfael any of the usual attributes of detective. A father, an old fighter who is now a non-combatant, and an agent of escape – these are his principal roles, shadowed by an abiding sense of near-despair, of being "afraid of having achieved the goal of his journey, and being left with only the sickening fall after achievement, and the way home an endless, laborious descent into a long darkness, ending in nothing better than loss" (232). But it is a jolly good siege! And full of historically valid and quite exciting details.

Furthermore, the generic rules make no explicit accommodation for a writer to convert a murder mystery into a meditation on fathers and sons (unless one or both of them are murderers), nor does it normally expect the greatest achievement of the story, its sublimest emotions, to be built out of, not intellectual deduction or ingenuity, but human needs as desperate and as elemental as the parable of the Prodigal Son.

Peters, of course, broke her authorial rules with serene confidence in her own powers but she, too, was bound for home, as is clear from the way she brings Cadfael back to Shrewsbury. (The murderer is discovered almost parenthetically – another rule broken – as a piece of information given only to Cadfael, and then is sealed off from any other part of the plot [271–4].)

The homecoming begins, "Now, whether he himself had any rights remaining here or not, for very charity they must take in Hugh's tired horse [...]" (287). It is the middle of the night, after Lauds and before Prime. The porter admits him, and Cadfael goes off to tend to his horse and then, as he says, "to have a word or so to say to God and Saint Winifred that will keep me occupied in the church the rest of the night" (289).

It is frosty outside. Inside the stone-cold church he goes up to the choir, "the monastic paradise" (290), but does not step into it yet. Instead, he prostrates himself in the nave, "his overlong hair brushing the shallow step up into the choir, his brow against the chill of the tiles [...]. His arms he spread wide, clasping the uneven edges of the patterned paving as drowning men hold fast to drifting weed" (290).

And then Peters gives him in the midst of his scattered recollections, yearnings, prayers, this matitutinal vision:

> He did not sleep; but something short of a dream came into his alert and wakeful mind some while before dawn, as though the sun was rising before its hour, a warmth like a May morning full of blown hawthorn blossoms, and a girl, primrose-fair and unshorn, walking barefoot through the meadow grass, and smiling. He could not, or would not, go to her in her own altar within the choir, unabsolved as he was, but for a moment he had the lovely illusion that she had risen and was coming to him. Her white foot

was on the very step beside his head, and she was stooping to touch him with her white hand, when the little bell in the dortoir rang to rouse the brothers for Prime. (292)

Here, then, one last time, in this very real illusion, Saint Winifred makes her appearance. It is a surprise in the narrative that comes as no surprise at all; again, it is a surprise of grace, a category normally foreign to the protocols of a murder mystery. One last time, one Rule subsumes the other, and Cadfael re-enters "this order and tranquillity within the pale, where the battle of heaven and hell was fought without bloodshed, with the weapons of the mind and soul" (292). The metaphor of combat is taken from the first chapter of the Rule of St. Benedict (47).

* * * * *

There is an early passage that may now serve as our coda – a meditation from Cadfael's garden, set near the beginning of the novel. Cadfael will tell Hugh Beringar that he was "pondering the circular nature of human life, [...] and the seasons of the year and the hours of the day" (10); but in retrospect, it seems to me as much Ellis Peters' musings on her art and the laying aside of her craft. It has an autumnal, even a Prospero-ish tone.

The Cadfael Chronicles were carefully laid out in chronological order, with attention to the church calendar and the procession of seasons and years. The first novel, Winifred's story, begins in early spring; the last, Cadfael's penitential journey, begins in November – and it is hard to see how the season could be any more appropriate for the kind of leave-taking that will be recorded here:

Brother Cadfael was standing in the middle of his walled herb-garden, looking pensively about him at the autumnal visage of his pleasure, where all things grew gaunt, wiry and sombre. Most of the leaves were fallen, the stems dark and clenched like fleshless fingers holding fast to the remnant of the summer, all the fragrances gathered into one scent of age and decline, still sweet, but with the damp, rotting sweetness of harvest over and decay setting in. It was not yet very cold, the mild melancholy of November still had lingering gold in it, in falling leaves and slanting amber light. All the apples were in the loft, all the corn milled, the hay long stacked, the sheep turned into the stubble fields. A time to pause, to look round, to make sure nothing had been neglected, no fence unrepaired, against the winter.
 He had never before been quite so acutely aware of the particular quality and function of November, its ripeness and its hushed

sadness. The year proceeds not in a straight line through the seasons, but in a circle that brings the world and man back to the dimness and mystery in which both began, and out of which a new seed-time and a new generation are about to begin. Old men, thought Cadfael, believe in that new beginning, but experience only the ending. It may be that God is reminding me that I am approaching my November. Well, why regret it? November has beauty, has seen the harvest into the barns, even laid by next year's seed. No need to fret about not being allowed to stay and sow it, someone else will do that. So go contentedly into the earth with moist, gentle, skeletal leaves, worn to cobweb fragility, like the skins of very old men, that bruise and stain at the mere brushing of the breeze, and flower into brown blotches as the leaves into rotting gold. The colours of late autumn are the colour of the sunset: the farewell of the year and the farewell of the day. And of the life of man? Well, if it ends in a flourish of gold, that is no bad ending. (9–10)

The thematic tones and echoes need no further images from me, yet I do see here the equivalent of the *Et in Arcadia ego* in the "hushed sadness" of November, and the approach of a life's "ending." Yet it is an Arcadian modality whose deepest tone is not regret but fruition. There is Death, implicit in both the rot of old harvests and the promise of seed time. No surprise, no *mystery*, about it at all. But as another Arcadian poet has said, "Nothing gold can stay."

<div align="center">NOTES</div>

1. *A Rare Benedictine* (New York: Mysterious Press, 1988), 3.
2. *Shropshire. Ellis Peters and Roy Morgan. A Memoir of the English Countryside* (New York: Mysterious Press, 1992). Morgan's careful and very beautiful photographs help make this volume a classic of regional description. Morgan and his wife lived next door to Pargeter.
3. Peters and Morgan, *Shropshire*, 9.
4. Peters and Morgan, *Shropshire*, 160.
5. *Sunrise in the West; The Dragon at Noonday; The Hounds of Sunset; Afterglow, and Nightfall.*
6. Margaret Lewis, *Edith Pargeter: Ellis Peters* (Bridgend: Poetry Wales Press Ltd., 1994), 77. Pargeter would not have been able to consult David Stephenson's *The Last Prince of Wales: Llywelyn and King Edward: The End of the Welsh Dream,*

1282–3 (Buckingham, Eng.: Barracuda Books, 1983), or J. Beverley Smith's *Llywelyn ap Gruffudd, Prince of Wales* (Cardiff: University of Wales Press, 1998).

7. Lewis, in her rich and careful study, *Edith Pargeter*, has included an overview of the mystery and poetry of the borders region: "Series Afterward," by John Powell Ward, 147–50.

8. "Preface," in Ellis Peters and Roy Morgan, *Strongholds and Sanctuaries. The Borderland of England and Wales* (Stroud, Gloucestershire; Dover, NH: Alan Sutton, 1993), 9.

9. And as imagination bodies forth
The forms of things unknown, the poet's pen
Turns them to shapes and gives to airy nothing
A local habitation and a name. (*Midsummer Night's Dream*; V, i)

10. Peters and Morgan, *Shropshire*, 26.

11. *The Rule of Benedict*, trans. with an introduction and notes by Carolinne White (London and New York: Penguin, 2008).

12. Marianne Moore, *Observations* (New York: The Dial Press, 1924), 24.

13. For further discussion, see my essay, "Playing with Fire: The Film Version of Eco's *Name of the Rose*," in *Postscript to the Middle Ages: Teaching Medieval Studies through "The Name of the Rose"*, ed. Alison Ganze (Syracuse: Syracuse University Press, 2009), esp. 114–20.

14. Erwin Panofsky, "Et in Arcadia Ego. On the Conception of Transience in Poussin and Watteau," in *Philosophy & History*, essays presented to Ernst Cassirer, ed. Raymond Klibansky and H. J. Paton (Oxford: Clarendon Press, 1936), 223–54.

15. *The Cadfael Companion: The World of Brother Cadfael*, ed. Robin White, intro. by Ellis Peters (London: Macdonald, 1991), 373.

16. Lewis, *Pargeter*, *Clues*, 14, 2 (1993): 4.

17. More recently, the life and Welsh provenance of St. Winifred, with full reference to Prior Robert's "Life," has been attractively described in an illustrated chapter in Rob Talbot and Robin Whiteman, *Cadfael Country. Shropshire & the Welsh Borders* (London: Little, Brown and Company, 1992), 85–97.

18. "Introduction," *A Rare Benedictine*, 3.

19. See Henderson on *sortes Biblicae*, in *England in the Twelfth Century: Proceedings of the 1988 Harlaxton Symposium*, ed. Daniel Williams (Woodbridge, Suffolk, Eng., and Wolfeboro, NH: Boydell Press, 1990). Henderson cites William of Malmsbury's name for the random-page prognostic: *revolutio foliorum*, a way of seeking counsel from authoritative texts, originating in ancient times (e.g., *sortes Virgiliana*), 114. Episcopal prognostics were frequent in twelfth-century England. True enough for the twelfth century, but not so true more generally after The Millennium. That is, as Jonathan M. Elukin has argued from new evidence, "although the prognostic *sortes* had a long life before them, the *sortes* that brought decisions to an entire community disappeared from our records sometime shortly after the millennium," in "The Ordeal of Scripture: Functionalism and the *Sortes Biblicae* in the Middle Ages," *Exemplaria*, 5,1 (Spring 1993): 154. Technically, Peters' choice of the ritual as "bringing a decision" was an anachronism, though perhaps it was a local survival without formal documentation. Or perhaps not.

Performing Medieval Literature and/as History: The Museum of Wolframs-Eschenbach*

Alexandra Sterling-Hellenbrand

In his address at the official opening of the Wolframs-Eschenbach Museum in January 1995, the author Adolf Muschg called the museum a "Guckkasten in die Unerschöpflichkeit eines Universums der Kunst und [...] Spielplatz für Menschenphantasien" ("a peepshow into the inexhaustibility of an artistic universe [...] a playground for human fantasies").[1] The review in *Die Zeit* called the museum, which was the result of five years of planning in a joint effort between state and regional governments, a "Mini-Gesamtkunstwerk"; the museum designers had created "einen spirituellen Erlebnisraum, eine Zauberbude und Lesekammer, bestem 68er Geist entsprungen, ein Literaturmuseum eigener Art" ("a spiritual experience, a magical booth and reading chamber created from the best spirit of 68, a unique literary museum").[2] According to the *Schwäbische Donauzeitung*, the small town of Wolframs-Eschenbach had achieved success "optisch in faszinierender Weise" ("in a visually fascinating manner")[3] where some larger cities might have failed. The national weekly *Frankfurter Allgemeine Zeitung* called the concept a "kühne Idee" ("clever idea").[4]

Town museums, which usually display town history, may occasionally be called fascinating or unusual, but they are not often dedicated to literature ("ein Literaturmuseum"), nor are they considered a "Spielplatz für Menschenphantasien," to say nothing of a "Mini-Gesamtkunstwerk." Certainly, one would expect a town by the name of Wolframs Eschenbach to include in its history (and therefore in its local museum) the story and perhaps even the works of its famous namesake Wolfram von Eschenbach. The town even changed its name to reflect this integral connection to the medieval poet; originally called simply "Eschenbach" (not to be confused

with Untereschenbach or Mitteleschenbach), the town received permission
in 1917 from Ludwig III of Bavaria to call itself "Wolframs-Eschenbach."
This change may have offered the town a way to get "back on the map," as it
were, and regain some of the renown lost when the Teutonic Knights ceded
their authority in Eschenbach to the kingdom of Bavaria in the early nine-
teenth century. But I suggest that this change of name shows a town actively
and intentionally constructing its modern (even postmodern) public identity
around the medieval poet of *Parzival* (as well as *Titurel* and *Willehalm*) and
his texts.

This construction of town identity based on literary interpretation
offers a unique example of modern medievalism at work. Combining
modern performativity and medieval literature, the museum of Wolframs-
Eschenbach invests medieval fiction with the town's history and subse-
quently celebrates that fiction as (f)actual history, at least as the subject of
the town's museum; thus, both the town and the museum stage a remarkable
dialogue between the medieval and the modern. The designers of the
museum, the inhabitants of Wolframs-Eschenbach, and the tourists who
visit the museum all participate as "actors" in crafting the on-going perfor-
mance of medieval texts on display in the twenty-first century. And I suggest
that, in an apparently unlikely combination, the inhabitants of Wolframs-
Eschenbach and their museum engage in the practice of memory that also
occupied the audience of Wolfram von Eschenbach 800 years earlier.
Memory entails the gathering and communication of past experiences, struc-
tured in a certain way so as to make them accessible, to form a creative
response to the present.[5] As they encourage dialogue between medieval texts
and modern audience, the museum and the town of Wolframs-Eschenbach
create a distinctive interpretive community at the intersection of image,
word, history, and modern memory.[6]

A community dedicated to Wolfram von Eschenbach must confront a
familiar interpretive problem, which the film commentary for the museum
puts succinctly: "Direkt neben der Kirche jedoch, im ehemaligen Alten
Rathaus, hat seine Heimatstadt ihm ein Museum eingerichtet. Doch wie soll
man ein Museum gestalten wenn nichts aus dem Leben des Dichters
erhalten blieb als nur seine Werke?" ("Right next to the church, in the
former 'Old City Hall,' his native city built a museum in his honor. But how
is one supposed to design a museum when nothing remains of the life of the
poet except for his works?").[7] The reviewers for regional and local media also
enjoyed the irony of a museum seeking to display the literary "Abdruck einer
Spur" ("outline of a trace").[8] How does one design a town museum around a
famous son when one has few if any artifacts of that person to put on display
in the museum? What is the purpose of this museum and who is its audi-
ence? Questions regarding the museum's purpose and its audience draw

attention to the broader issue of cultural identity: how does one begin to understand a town that reads its history, at least in part, through the literary creations of an author that we suppose to have lived around 1200 but of whom we have no "real" evidence other than his poetry? Finally, this museum requires viewers to address a specific question, explicitly asking "Kann man Literatur ausstellen?" ("Can one exhibit literature?"). This raises two additional questions: can one exhibit not just literature in general but specifically medieval literature for a modern audience, and what place does older literature have as the subject of a modern museum? In the remainder of this article, I wish to explore these questions as they manifest themselves in the design of the Wolframs-Eschenbach Museum. I will first situate the town of Wolframs-Eschenbach geographically and culturally, and I will then discuss the museum in greater detail, particularly with regard to its design and its literary/cultural interpretations. Finally I will address some of the main questions that this small city and its museum raise for modern scholars of medieval literature and culture.

Unlike the Grail castle, the small Franconian town of Wolframs-Eschenbach (population approximately 3000) can be found, if one looks for it. Wolframs-Eschenbach lies just north of what is known as the Franconian "lake district" ("Fränkisches Seenland"), where artificial lakes such as the Altmühl and the Brombach offer excellent venues for outdoor recreation (boating, biking, hiking). About fifteen kilometers to the northwest is the county seat of Ansbach; approximately forty kilometers to the north and east one finds Nürnberg; if one drives thirty kilometers to the west one finds oneself (at least in the summer) among the thousands of tourists from all over the world who have flocked to Rothenburg ob der Tauber and the Romantic Road. The countryside offers an idyllic landscape, consisting of gently rolling farmland, punctuated by church steeples rising from walled medieval towns and criss-crossed by bicycle paths; clusters of trees are often balanced at intervals by newer clusters of wind turbines. The area's towns display well-preserved half-timbered homes and public buildings, inviting tourists to stroll narrow streets before sitting down to enjoy a glass of the local wine. The region is known for tourism and agriculture, literally and figuratively cultivating its history and its land; indeed, the area has a stunning number of local museums (it is truly a "land of museums," as its tourist information suggests).

A snapshot of three museum collections (Ansbach, Gunzenhausen, Merkendorf) in the vicinity of Wolframs-Eschenbach offers a revealing point of comparison for any discussion of the Wolframs-Eschenbach Museum. Although these three towns, like Wolframs-Eschenbach, have constructed museums with the clear objective to share and celebrate local history, their collections are much more traditional. The museum in Ansbach, the county

seat and the historic administrative center of the region, focuses primarily on the story of the margraves of Ansbach, their families and activities, and their times (from the fifteenth through the early nineteenth century). Located on Kaspar-Hauser-Platz, the museum also dedicates several rooms to its own famous son, Kaspar Hauser. In general, the exhibits display the expected traditional objects (portraits, furniture, weaponry), though the objects are arranged in creative and inviting ways, and the museum organizers have recently developed an interactive display in the Kaspar Hauser exhibit. The visitor can, for example, work a video display with musical accompaniment. In a conscious attempt to unite the old and the new, the Ansbach museum also incorporates one of the oldest portions of the medieval city wall as part of a passageway to a second building where there are rotating exhibits of local artists.

The ancient and the new are highlighted in the city museum of Gunzenhausen as well. Located approximately twenty-five kilometers to the south of Ansbach, Gunzenhausen was built on the site of a Roman fort that was part of the *limes* extending through the Germanic territories in the fourth century. In addition to its replica of the Roman fortifications, complete with part of the excavated foundation, the museum in Gunzenhausen offers its visitors a tour through several centuries of life in the region and displays on its five floors many artifacts one would expect, from linens to hunting weapons and parlor furniture. The museum is a traditional collection of artifacts, organized in approximate chronological order. Clearly this museum understands itself as a repository of information (and objects) about the city and its past.

The same holds true for the museum in the tiny hamlet of Merkendorf, population approximately 1000, about three kilometers from Wolframs-Eschenbach. The Merkendorf "Heimatmuseum" is housed in the "Alte Scheune" (the old barn), where tithes were collected in the early twentieth century. While the residents indulgently joked about how much "stuff" had been packed into that space by a fanatical old collector of family "junk," and about how the old barn was more like a communal attic than a "real" museum, they were obviously proud of what these material artifacts said about their town's past; they believed these "things" were important pieces of a common history shared by those who called the town home.

These three collections represent aspects of the collective regional history that central Franconia ("Mittelfranken") and its many museums wish to celebrate and cultivate for the modern public (for its visitors and its natives). As the museums generally place more emphasis on collection rather than innovation, the region and its towns would not necessarily seem to be at the forefront of a cultural avant garde. And the town of Wolframs-Eschenbach and its museum would seem to be no exception.

In its promotional materials, readily available at the city hall and in other locations frequented by tourists, Wolframs-Eschenbach markets its public self as part of this area and as part of this shared historical and cultural landscape. It also capitalizes on its name, which identifies it as the Stadt des Parzivaldichters ("city of the Parzival poet").[9] But, of course, appearances can be deceiving (Fig. 1). Housed in the picturesque half-timbered old city hall, the museum in Wolframs-Eschenbach offers a surprising contrast to its neighbors in Ansbach or Gunzenhausen or Merkendorf. The museum eschews more traditional approaches in its desire to engage visitors with the two-fold question of whether one can exhibit not just literature in general but the literature of Wolfram von Eschenbach. Answering both questions with a resounding "yes!", the museum offers a very provocative and unconventional approach to these questions and opens a creative dialogue with alterity.

The Wolframs-Eschenbach Museum opened in January 1995, and the presentation of the collection has not changed since that time. The rooms can be explored in any order, although there is only one entrance to the museum; one must begin at the beginning with the introduction (*Einführung*) in Room I (Fig. 2).[10] The entrance invites inquiry and curiosity, attempting to pull the visitor into another world, visually and intellectually. According to museum director Oskar Geidner (and the audio guide), the designers intended this room to offer a transition from the world of the present and the world of the original old Rathaus into the world of Wolfram von Eschenbach.[11] In one corner, the museum's central question is displayed in a series of interlocking cubes whose wooden frames complement the half-timbers of the building's original architecture. The display also engages (and engages the viewer) literally with the "art" of the word *literature* and the expression "Kann man Literatur ausstellen?" in that it visually plays with the words in different formats (Fig. 3a).

The playful, more abstract art is balanced by an equally artful but more concrete didacticism. Prominently placed next to the cube structure is a bulletin board that offers a very efficient (and eye-catching) way to disseminate a good deal of information about the twelfth and thirteenth centuries in a relatively small space. The audio guide is very well constructed, not only reading some of the questions and answers from the bulletin board but also offering interesting details of further information (section 140 gives general background on the Crusades, for example, and then directs the listener to 141 for an excerpt of Pope Urban's call for the first Crusade).[12] Geidner commented in our interview that too often museums have white walls that are actually rather generic and boring. Modern museum visitors have been shaped by a world that operates and communicates through multiple media and technologies. Modern visitors react differently to, and concentrate

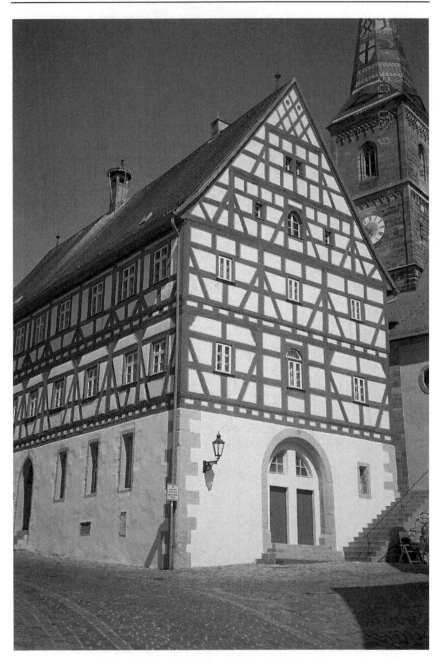

Figure 1. The Museum of Wolframs-Eschenbach

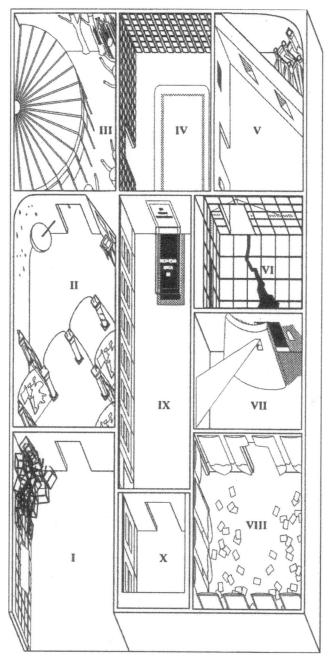

Figure 2. Layout of the Museum Wolfram von Eschenbach.

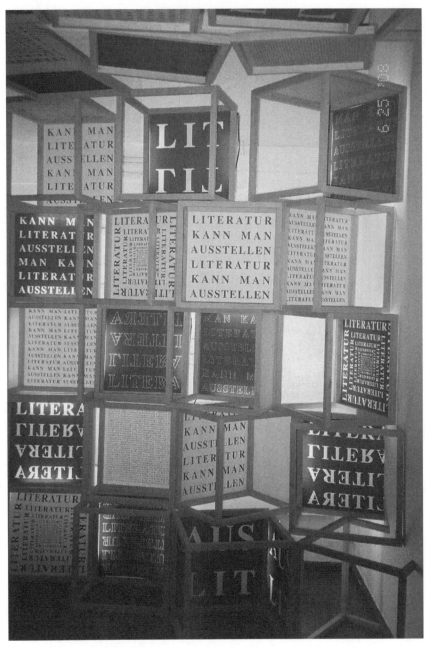

Figure 3a. Room I (detail) of the Museum Wolfram von Eschenbach.

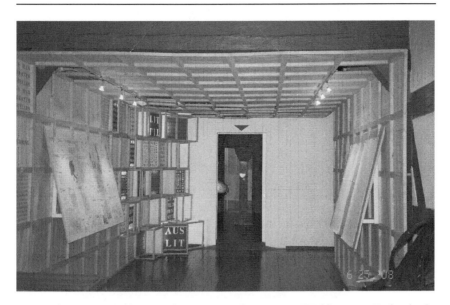

Figure 3b. Room I with view of Room II in the Museum Wolfram von Eschenbach.

differently on, what they see; furthermore, they also expect to be engaged and entertained through interactive exhibits.[13] Therefore, the introductory exhibit sets the stage, in sound and image and creative display, for the rest of the museum (Fig. 3b).

Room II is designed to show Wolfram's world, his biography (such as it is), and his knowledge. The blue color of the introductory logo / display becomes the dominant color of Room II, providing a visual connection that accompanies the visitor across the threshold from Room I. In a sense, the color of the word "literature" becomes the color of Wolfram's world, aesthetically underscoring the literary nature of Wolfram's world as well as his biography, since most information about his life and his environment is drawn from his own statements about himself.[14] The textual nature of Wolfram's world and his life is also highlighted in text, inscribed on six plexiglass panels (Fig. 4). Shaped in the form of what could be a knight's shield, each of the panels has at its center an outline of Wolfram's famous portrait from the Manesse manuscript, created out of lines in white lettering that repeat the statement "ich, Wolfram aus Eschenbach" ("I, Wolfram from Eschenbach").[15] The outline of Wolfram's image is itself "filled in" with the dark cobalt blue of the walls one can see behind the glass.[16] In yellow text, on the flag of the portrait image, there is commentary from the museum team on each of six topics, accompanied by text (in red) with quotations from Wolfram's own texts about himself and about his life.[17]

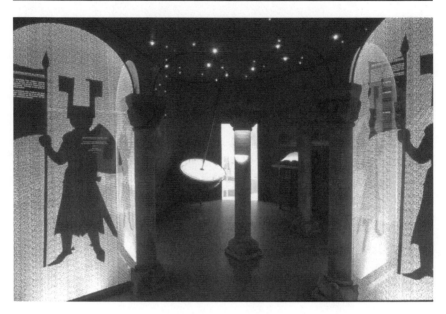

Figure 4. Room II of the Museum Wolfram von Eschenbach.

As stated earlier, the designers had to deal with the very real problem of how one manages to display the life of a poet about whom there is very little actual biographical data. One solution is found in the series of self-portraits. Another solution can be seen in the obvious sense of humor with which they constructed the remainder of the display. The plexiglass panels, for example, are flanked by columns on either side. Each column has a mouse at its base, referring to *Parzival* 184,27–185,8. The humor and the pedagogy continue throughout this room (and indeed throughout the museum). In the far left-hand corner, there is a globe (cut in half) that is supposed to represent Wolfram's world and symbolize the geographical understanding of the time: the flat portion has been overlaid with a medieval world map and a lance (pointed toward the ceiling) thrusts out of the center. As Geidner showed us the globe, he chuckled and said they had to take Jerusalem out of the center of the medieval world and replace it with Wolframs-Eschenbach. In fact, Wolframs-Eschenbach is located at the map's center, and the map does indeed illustrate the places that Wolfram mentions in his texts in a geographically and spatially appropriate manner, radiating outward from Wolframs-Eschenbach. On the ceiling, if one follows the direction of the lance pointing out of the globe-map, one can see the seven planets known to Wolfram, depicted with their names in modern German, Middle High German, Arabic (in Roman letters), and Arabic (in Arabic). In the right-hand corner of Room II, a small exhibit demonstrates how many lambs or

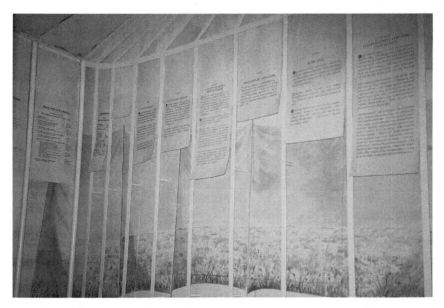

Figure 5. Room III of the Museum Wolfram von Eschenbach.

calves one would need in order to make a medieval book, giving a nod to the patronage system without which Wolfram's works could not have been written. And the miniature animals also have the "ich, Wolfram von Eschenbach" quotation inscribed repeatedly on them.[18]

In the remaining portion of this essay, although all the rooms deserve attention, I wish to discuss several of the rooms (III, IV, VI, and VIII) as representative examples of the museum's unique interpretive vision. Rooms III–VIII deal with specific texts; rooms III, IV, and V are dedicated to *Parzival*. The visitor goes through the rooms in succession, following the key points of the narrative: the Arthurian court (III), Parzival's family (IV), and the Grail castle (V). The viewer steps into room III onto a white floor and into a semi-circular tent that covers approximately half of the room. The tent looks on to a meadow painted on the full length of the left-hand wall, and under it one can see a green semi-circle with a white semi-circular center (Fig. 5). The images speak clearly. Wherever Arthur is, as he is the May king, it is May time (regardless of season), and it is time for a celebration and a picnic. Furthermore, Arthur also takes the image of the Round Table with him wherever he goes. Around the inner edge of the "table" one can see: "Sag mir doch, wer die ritter erschafft?" ("Who creates knights?"). The words follow around the circle, with these: "Das tut König Artus aus eigener Kraft!" ("King Arthur does this himself!").[19] Between the poles of the tent are hung real parchment sheets with very brief synopses of each book of

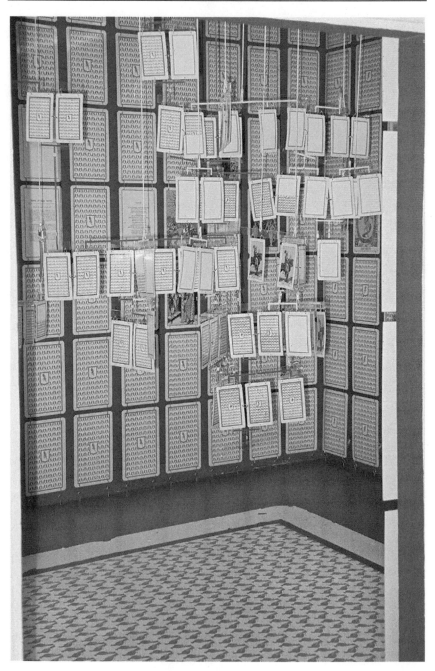

Figure 6. Room IV of the Museum Wolfram von Eschenbach.

Parzival in different inks (blue for the Gahmuret-books, red for the Parzival-books, green for the Gawan-books).[20] The tent has an interior and an exterior, of course. While the interior (floor) depicts the green of grass and the white of a tablecloth (symbolizing the Round Table), the white floor on the tent's exterior is supposed to represent snow. There are the tracks of a hare ("daz vliegende bîspel" 1,15) and a reference to the three drops of blood from book VI of *Parzival* that mesmerize the hero by reminding him of his absent beloved (282,20–283,19). On the outer walls of the room are trees that are being turned into lances. The images of forest trees and lances are juxtaposed in Wolfram's three major texts (*Parzival*, *Titurel*, and *Willehalm*). The museum designers clearly wish to emphasize the connection between the forest and the destruction of that forest to provide weapons for war. Because Wolfram's texts thematically support this reading, the designers draw the modern viewer's attention to the connection between trees and lances by reproducing and illustrating the verses in the rooms dedicated to *Parzival* and *Willehalm*, respectively: as a banner on the wall in Room III next to spear shafts emerging from tree trunks or as the inscription on one of the shields on the battlefield depicted in Room VIII. Wolfram's words ("Wälder zu Lanzen!" or "forests into lances!") thus resonate through text and image in each of the displays.[21]

The next room is the "family room," meant to display the family relationships in *Parzival* (Fig. 6). The narrow room looks like it is wallpapered with cards; half of the cards have a design of green falcons on them while the other half have a design of red doves. The falcons and the doves symbolize each of Parzival's worlds: the Arthurian world and the Grail world, respectively. The floor is red and white, with a huge card in the middle of the floor, facing the same card painted on the ceiling. In the middle of the room is a huge mobile that depicts Parzival's family tree; the red lines of the Grail family connect to the green lines of the Arthurian family, and among them one can glimpse the white lines of other characters who are unaffiliated. When one considers the importance of family relationships in *Parzival*, the mobile is a brilliantly efficient and effective model for illustrating both those relationships and the interconnectedness of all the characters in the text.

The characters within this highly effective depiction of Parzival's exceptionally complex family tree are also ingeniously interpreted by the cards chosen to represent them: Tarot cards. The audio guide explains the choice of the cards as a result of the episodic nature of the plot, which could resemble a Tarot reading (one learns something new, or Parzival learns something new, every time a new card is turned over), and as a result of the many game-metaphors in the text. The designers chose particular cards for particular people (e.g., Parzival, Condwiramurs, Gawan, Feirefiz), and then they used more generic cards for those figures in the narrative that have their own

names but end up repeating each others' actions. The Eastern queens
Belakane and Secundille, for example, play interestingly parallel (though
minor) roles in *Parzival*, and for this reason they are represented by an iden-
tical figure; Cardiz, Segramors, and other "miscellaneous" knights are also
each represented by the same image. This interpretation demonstrates how
figures play their parts as types and as individuals in the game of courtly
love, as they are also all connected and related.[22]

The reverse sides of the cards are also symbolic of the game; there are
only two colors: red for the doves that represent the Grail family and green
for the falcons that represent the Arthurian family. The falcon, a bird of the
hunt and a symbol of nobility and courtliness, logically represents the world
of the Arthurian court. The green color for the falcon picks up on the green
of the floor in the previous room, which sought to create the festive atmo-
sphere of a May outing on a sunny spring day. Green emphasizes the motifs
associated with Arthur and the Round Table: courtly ritual, life, love, spring-
time, peace. Red, the color of blood, may seem an unusual choice to
symbolize the Grail family in contrast to the court of King Arthur, but the
red of the doves resonates with key images from the narrative, including: the
three drops of blood against the backdrop of pure white snow that serve to
remind Parzival of his absent wife in book VI; the blood of the mysterious
lance that Parzival sees at the Grail castle; and the festering wound of the
Grail king (Anfortas) that will not heal until Parzival asks his question.
Moreover, in tandem with the figure of the dove, the color red overtly
invokes the blood of the Eucharist. The intelligent yet playful representation
of Parzival's story in this room is apt and imaginative, reflecting the sense of
humor so often expressed by Wolfram the narrator in the text.

Equally imaginative are two rooms that deal with texts that are not so
familiar, creatively displaying themes of love, betrayal, and disaster. I will
describe only the first here.[23] Room VI portrays the *Titurel* fragment, which
tells the story of Parzival's cousin Sigune and her lover Schionatulander (Fig.
7).[24] Bathed in a harsh fluorescent light, the room appears constructed of
white tile outlined in black. The light, along with the severity of the color
contrast, creates an atmosphere of discomfort in a narrow, sterile, and imper-
sonal space. The room feels like a hospital emergency room. There is a frag-
ment of the *Titurel* poem (in black text) on a transparent plastic banner
running through the room (a broken lance is visible embedded in the wall).
Over the wall that leads to the next room, there is an image of Sigune with
Schionatulander in the tree (from *Parzival*). The juxtaposition of images in
this particular room is amazingly creative. The hospital atmosphere empha-
sizes the tragedy and finality of the courtly love game when it goes wrong.
Sigune challenges her knight to prove his love and pursue a magnificent dog
leash (with a text she has not finished reading). Schionatulander pays for his

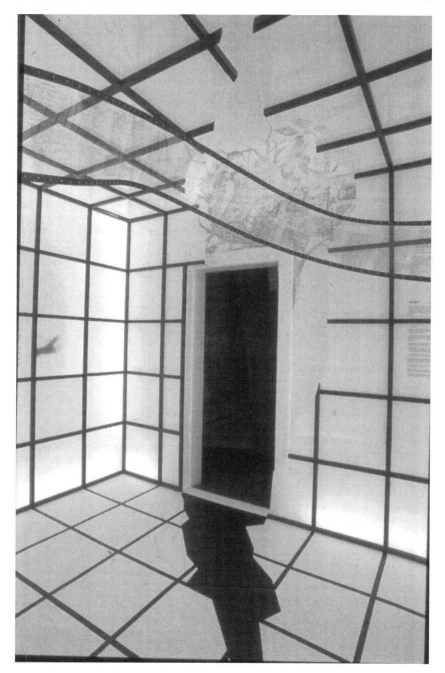

Figure 7. Room VI of the Museum Wolfram von Eschenbach.

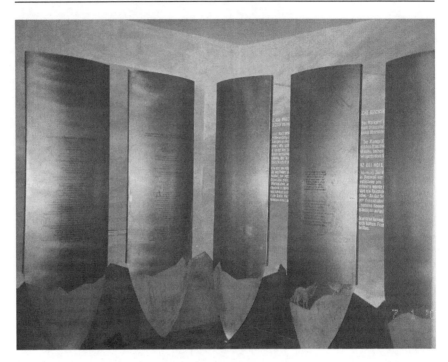

Figure 8a. Room VII of the Museum Wolfram von Eschenbach.

devotion with his life, pursuing for his lady what might appear to be a trivial object. Indeed, on the left wall as one enters the room, one can glimpse the dog running away, the leash trailing behind. And Sigune pays as well, as we know from *Parzival*; one can also see the image of a mourning Sigune cradling her dead lover above the door leading to Room VII. Young people still play these courtship games, and the cost can still be as high, which of course calls the entire game into question. A harsh and painful reality threatens all players, and that reveals the hollow (and potentially tragic) fantasy of the ideal. The space leaves the modern viewer with a physical and emotional impression in the moment of the themes the medieval text wishes to communicate: the constraints of propriety, the dangers of courtly love as an unreal fiction, the potential costs of impulsive action.

Space also impacts the feeling of the final literary room, dedicated to Wolfram's *Willehalm*. Of all the rooms, this is perhaps the most visually stunning. One may feel a little apprehensive entering this dimly lit room glowing with a fire-like mixture of oranges and reds and yellows and browns (Fig. 8a and 8b). Shields have been propped along the walls; cards appear to have been scattered over the floor; and the light seems to flicker as the room evokes the fire, metal, and horror of war. The only missing piece might be

Figure 8b. Room VII (detail) of the Museum Wolfram von Eschenbach.

the sound of clashing metal swords or loud battlecries, but one does not need to hear the soundtrack on the audio guide to feel the room's impact. It has a kind of sensory and emotional impact that the other rooms do not have, as the designers try to connect our human experience in the present (or 1995) with the human experience Wolfram describes in *Willehalm*. While our modern selves are physically and historically far removed from the Crusades of the thirteenth century, we still experience war, tragedy, and conflagration. Thus, differently from the preceding rooms, this one representing Wolfram's last work seems crafted to engage the viewer on a deeper level; its colors, its images, and its mood elicit not only a question ("What is this about?") but also an answer to that question ("It is about us/me."). As the commentary in the museum's video suggests, the objects set against the wall certainly represent shields, but they also bear an uncanny resemblance to modern bombs, the ones that fall from the sky and the ones still found unexploded from wars that are supposedly past. In fact, Geidner related that the design team struggled with how to represent the cast (and the cost) of war in *Willehalm*. Eventually, they wrote the names of the dead (people and animals) on index cards, shuffled the deck, and let the cards lie where they fell. In this way, strewn across the floor, the plaques for the dead ("*Totentafeln*")[25] represent the random cost of war in a very authentic and moving fashion (Fig. 8b).

The last rooms bring the visitor out of Wolfram's texts, out of the

realms of literary and historical creation, and into a kind of mausoleum. Room X houses an empty tomb (because there really is nothing to put there) and a series of windows that let the viewer look literally and figuratively into the reception of Wolfram's work through the centuries up to the present. Where do Wolfram's remains lie? They are behind every window, which is inscribed with the text: "Hier ligt der streng ritter herr Wolffram von Eschenbach" ("Here lies the good knight Sir Wolffram von Eschenbach"). This is the inscription noted in a travel diary by Johann Wilhelm I Kress von Kressenstein, who apparently visited the church of Ober-Eschenbach (now Wolframs-Eschenbach) around 1608 and recorded this inscription on a tomb in the church. But that tomb also no longer exists. In effect, Wolfram is everywhere and nowhere in Wolframs-Eschenbach.

And then we have arrived back at the entrance, left with our varied impressions of an amazingly creative and fairly compact museum. The museum seems to have as many descriptors as there are visitors: for some town residents, it is an oddity in the old Rathaus;[26] for students, from their comments on the museum bulletin board, it is a "cool" field trip; for tourists, it may offer a pleasant surprise and departure from the ordinary; for some critics, as Gohlis in his review for *Die Zeit*, it is perhaps even a "Mini-Gesamtkunstwerk"; for scholars of medieval literature in general (and German medieval literature in particular), it is a fascinating case-study of reception (*Mittelalterrezeption*). I would like to conclude here with a few thoughts on the museum and its purpose. In the case of the former, one is compelled to ask: what is the audience for a city museum? This raises once again the question of the museum's role in the town, in the town's self-representation, in the town's history. In other words, if museums are organizers of culture, whose culture does this museum organize?[27] One would imagine that the local inhabitants of that city might want to have some connection to (and some sense of ownership of) the museum, its contents, and its representation of collective identity. One such connection is evident in the efforts of the museum designers to emphasize social themes in their interpretations of Wolfram's work. They repeatedly portray, for example, the phrase "Wälder zu Lanzen!" ("forests turning into lances"), which Wolfram uses to describe the destructive effects of war (of knightly activity) on nature and on the people who inhabit it. The designers clearly understand art-making as social action, which also suggests that the art must then connect "to other things."[28] This connectedness means that "an artwork is not complete unless it earns a response from someone else" and it is the audience that "completes the utterance."[29]

How does the audience now respond to the museum in Wolframs-Eschenbach? In the entrance room, opposite the bulletin board, there is also space for visitor comments (as from school groups, etc.).

Geidner said school groups often come, and university groups also are inter-ested in lectures held in the seminar room.[30] These educational endeavors are supported by the mayor's office and the city government (visitors who come for field trips or for weekend seminars, for example, stay overnight in the local school). The comments from younger visitors about the museum that are displayed at the entrance show that they obviously believe that the museum (and whatever they did there) was "fun."[31] One couple opined that this museum was better than those they had visited in nearby Rothenburg ob der Tauber. They said this is really interesting as a museum, and they were "angenehm überrascht" ("pleasantly surprised") by what they found there; both also expressed surprise that people actually come to the museum, but they thought that more should visit.[32] But many other tourists do come, according to Geidner, and they are similarly surprised by what they find.[33] After all, visitors have certain expectations when they come to a "Heimatmuseum"; they rather expect what one finds in the Merkendorf "Alte Scheune" (e.g., linens, furniture, farm implements, cobbler's tools), where the proprietor of our guesthouse proudly showed us the old school benches like the ones she sat in as a pupil. In the Wolframs-Eschenbach Museum, they find a totally different and perhaps appealing approach to the history of a place.[34] In addition, the locals in Wolframs-Eschenbach are admittedly proud of their museum, because they have it; nonetheless, one also has the feeling that they are amused and even rather apologetic, as they acknowledge the museum's peculiarity.[35]

And yet I would suggest that the museum succeeds because of this peculiarity;[36] it recognizes (and attempts to make use of) the distinct advan-tage offered by intentional dissonance, of alienation (Verfremdung) in a good Brechtian sense. As Adolf Muschg indicates in his remarks at the museum's opening, the museum designers and the people of Wolframs-Eschenbach have a good understanding of the place and the project, and they do have a sense of humor about this admittedly odd situation. Muschg describes the place (the museum and the town) as the "Abdruck einer Spur, die hier nicht gefunden, sondern geschaffen wurde" ("the outline of a trace, that wasn't found here but rather created").[37] This description reflects historian Kathleen Biddick's assessment of why the Middle Ages function so well (and so often) as a frame for a variety of narratives over time: "as both nonorigin and origin, the Middle Ages can be everywhere, both medieval and postmodern, and nowhere, sublime and redemptive. What better material for a dream frame for popular culture, a truly relative past that can be read as either the present or the future?"[38] I do not necessarily believe that the past is truly relative; however, in this particular case, the city has allowed its museum to (re)create an actual (or represent-able) past from few certain facts and from literary texts that few people know. The museum makes very

concrete connections between medieval literature and the present; if the actual town history is neglected, then one could perhaps say it is mirrored in the presence of the individuals who visit the museum. For Mary Carruthers, memory or *memoria* involves the process through which text is imbued with social context and meaning: "Whether the words come through the sensory gateways of the eyes or the ears, they must be processed and transformed in memory – they are made our own."[39] The "gateway" that leads to memory depends on how a text is presented to any given audience on any given occasion.[40] The audience of the museum in Wolframs-Eschenbach is presented with a display that demands response; the multivalent presentation in multiple media enables response and interaction on a variety of levels.[41] In this way, Wolfram's withering assessment of his own contemporaries, who are "unripe wits" lacking "the power to grasp" the story that "will wrench past them like a startled hare" (*Parzival*, 1,15–19), will hopefully not apply to the audience of today.

Thus, as it involves its audience in the practice of memory, the Wolframs-Eschenbach Museum offers a most unique example of modern performativity and medieval literature. The practice of memory includes the performance of texts as well as the ability to recognize opportunities for interaction with texts in signs (or cues) or in images. Again we are reminded that performance and performers rely on the response elicited from the audience; image (or text) and response combine to make memory and, through the element of surprise, allow the kind of interpretation that gives memory meaning.[42]

The resonances among aural, visual, and literary adaptations to well-known texts work to support the creation of shared cultural memory. And the practice of memory is the practice (post)modern interpreters continue to share with Wolfram von Eschenbach and Wolframs-Eschenbach. The designers of the museum, the inhabitants of Wolframs-Eschenbach, and the tourists who visit the museum are all "actors" who craft the on-going performance of these texts in the twenty-first century. This is, to the best of my knowledge, a unique juxtaposition of the medieval and the modern in Germany. And in this juxtaposition, in the active encounter between museum and audience (designed to take a variety of forms at a variety of levels, for children and adults, for tourists and professors), I wish to suggest that the inhabitants of Wolframs-Eschenbach continue the practice of memory in their dialogue with the past. The town, its museum, and its visitors create a new interpretive community at the intersection of image, word, and history. I believe they can provide us with a model to emulate in future dialogues generated at similar intersections, where the past and the present meet to create an understanding of the Middle Ages that can live and breathe for a modern audience.

NOTES

* This project was funded in summer 2008 by a University Research Council grant from Appalachian State University. I also wish to extend thanks to the city of Wolframs-Eschenbach and especially to Mr. Oskar Geidner, director of the Museum Wolfram von Eschenbach, for taking the time to offer a detailed tour of the museum and for generously allowing us to photograph the exhibits.

1. Adolf Muschg, "Abdruck einer Spur. Rede für Wolframs-Eschenbach," *Literatur in Bayern* 39 (1995): 2–5 (3).

2. Tobias Gohlis, "Der Ritter mit der Leier," *Die Zeit* (July 1996), <http://www.zeit.de/1996/07/Der_Ritter_mit_der_Leier>, accessed 14 August 2009.

3. Robert Gegner, "Ritterschilde tragen den Parzival-Text. Das neue Wolfram-von-Eschenbach-Museum: Mittelalterliche Dichtung in Raumschrift übersetzt," *Schwäbische Donauzeitung* (7 January 1995): 3b.

4. Holger Noltze, "Wolfram hinterließ keine Spur. Gleichwohl gibt es in Wolframs-Eschenbach ein Museum zu Ehren des Parzivaldichters," *Frankfurter Allgemeine Zeitung* (15 October 1994): 35.

5. Carruthers defines the task of a memorial culture as "making present the voices of what is past, not to entomb either the past or the present, but to give them life together in a place common to both in memory." See Mary Carruthers, *The Book of Memory: A Study of Memory in Medieval Culture* (Cambridge: Cambridge University Press, 1990), 260.

6. Vitz describes the audience of medieval romance as a community involved in "an intense, interpersonal, heavily-mediated, and strongly interactive situation." See Evelyn Birge Vitz, *Orality and Performance in Early French Romance* (Cambridge: D. S. Brewer, 1999), 275. The interactive nature of the encounter between text and audience is something that the modern audience of the museum actually shares with the medieval audience of Wolfram's texts. As the museum creates a bridge thus between past and present, by connecting textual communities through interaction with texts, the museum offers a fascinating example of the process of medievalism at work.

7. This is part of the commentary in the video text by Hans Lampe, *Wolframs Museum* (Aladin Filmproduktion. dr. hans s. lampe GmbH, 1995).

8. Muschg, "Abdruck einer Spur," 1.

9. Wolframs-Eschenbach was also an important seat of the Teutonic Knights from the thirteenth century to the nineteenth century, hence the name *Stadt des Deutschen Ordens*.

10. From Room I (*Einführung*), the visitor can proceed either to Room II (*Biographie*) or to Room X (*Bibliothek*). Figure 2 shows the layout of the entire museum: Rooms III–V deal with *Parzival*, Room VI with *Titurel*, Room VII with the Dawn Songs (*Tagelieder*), Room VIII with *Willehalm*, Room IX with reception. Room X contains a small library of representative critical works.

11. Munich designer Michael Hoffer was responsible for the artistic layout of the museum; medieval scholar Karl Bertau worked closely with the creative team.

Others on the team included Oskar Geidner (current museum director), Hartmut Beck, and Dietmar Peschel-Rentsch.

12. The audio guide reinforces the pedagogy behind much of the museum's design. Other topics on the bulletin board include: maps (modern and medieval), reproductions from manuscripts, caricatures from a Scottish Germanist, and other drawings. There is factual information about general living conditions, about sport, about tournaments, about language (e.g., Middle High German).

13. Interestingly, Geidner said they took much from American concepts of interactive display in the 1990s when they were discussing the plans for the museum. The designers needed and wanted to make a museum that *any*one could take *some*thing away from, if only an interest in perhaps finding out more about the Middle Ages or the poet Wolfram. All the texts in the museum should take only about two hours to read in total, as that is about as much time as the average visitor will take for the museum.

14. Reviewers also comment on the blue color as the blue of a night sky (highlighting the metaphor of the new "world" of Wolfram von Eschenbach or the medieval "cosmos"). The blue also evokes for some an atmosphere of mystery, since not much is known about Wolfram the person.

15. According to the museum's publication, Wolfram makes this particular statement three times: twice in *Parzival* (185,7 and 827,13) and once in *Willehalm* (4,19).

16. The designers wanted to do something new with this image because it is so familiar.

17. The six topics of these transparent "self"-portraits are: self-portrait with ladies (*Selbstbildnis mit Damen*), self-portrait in the community (*Selbstbildnis mit Landsleuten*), self-portrait as knight (*Selbstbildnis als Ritter*), self-portrait with family (*Selbstbildnis mit Familie*), self-portrait as illiterate (*Selbstbildnis als Analphabet*), and self-portrait as poor man (*Selbstbildnis als armer Mann*).

18. As one can see, the displays are extremely dense and multi-layered and all details were carefully thought through. The *Schwäbische Donauzeitung* quotes the mayor Anton Seitz as saying that nothing is coincidence in the museum. This is also evident in conversation with the museum director as well as in the museum's accompanying materials.

19. Again the images and Wolfram's text reinforce one another.

20. With this brief history of Arthurian romance (*Artusroman*) and the synopsis of *Parzival*'s narrative, the museum designers clearly intend the audience to take this information and go along Parzival's journey with him through the next rooms.

21. The museum guide quotes the three sections from *Parzival* (379,3–8), *Titurel* (31,1–4), and *Willehalm* (389,20–390,8) that contain this phrase and this image. See Karl Bertau et al., *Museum Wolfram von Eschenbach* (Wolframs-Eschenbach, 1994), 25. The citation from *Parzival* refers to a battle scene from book VII in which Wolfram says of the knight Poydiconjunz: "He came riding up with such a host that, if every bush in the Black Forest were a spear shaft, you could see there no greater forest" (trans. Helen M. Mustard and Charles E. Passage [New York: Vintage, Random House, 1961], 203).

22. On each wall, the designers have chosen to represent what they consider one of the most important concepts of Parzival's life and story: heaven and hell (from the prologue), simplicity (*Einfalt*), murder (*Mord*), blood and snow, and finally "du und ich" (you and I). The latter representation shows a trio – Parzival, Feirefiz, Condwiramurs – as husband, brother, wife, family past and present and future.

23. Room VII deals with Wolfram's lyric. Space constraints do not permit further discussion here.

24. Readers will recall that Sigune appears in *Parzival* only with the corpse of her lover. The *Titurel* fragment, dated after *Parzival*, tells their story in a kind of prequel to the longer *Parzival*.

25. As the plaques are also cards, they recall in this battlefield setting the game metaphor of the mobile in the second *Parzival* room. Yet again the game of knighthood reveals its dangerous and deadly reality.

26. Personal conversation with the Lenz family, longtime residents of nearby Merkendorf and proprietors of a local bed and breakfast; also with a reporter from the local *Fränkische Landeszeitung* on 25 June 2008.

27. I borrow here an image from Diepeveen and Van Laar, who describe museums as "organizers of culture." See Leonard Diepeveen and Timothy Van Laar, *Art with a Difference. Looking at Difficult and Unfamiliar Art* (New York: McGraw-Hill, 2001), 10.

28. Diepeveen and Van Laar contend that "art-making is social action," which implies "the *connectedness* of artworks and artists to other things," and argue that this interconnectedness is "essential to understanding art and its conflicts." See Timothy Van Laar and Leonard Diepeveen, *Active Sights. Art as Social Interaction* (Mountain View, CA: Mayfield Publishing, 1998), 109.

29. Van Laar and Diepeveen, *Active Sights*, 110.

30. Typical for our visit in summer 2008 was my experience in the museum at two o'clock in the afternoon on a Wednesday in June; there were, at that time, six other visitors in the museum. Other visitors during my week at the museum included tourists cycling through the area as well as a GAPP exchange group (German–American Partnership Program) of American high-school students with their German counterparts.

31. In summer 2008, the comment board dedicated to responses from younger visitors had positive comments such as "Mir hat das Grab gefallen" ("I liked the tomb") and a very emphatic "war echt voll cool" ("really cool").

32. Another couple, in response to my question, asserted that it is true that one needs a bit of background in order to understand what the rooms mean; however, in that case, it is very helpful to have the audio guide.

33. Because of the television coverage at its opening, the museum reportedly had about 10,000 visitors the first year, then about 5000; in summer 2008, the director reported that the number has now settled to an average of about 3000 per year.

34. I noted on the comment board several comments, probably from older visitors, like: "Einfach fantastisch" ("simply fantastic"), "Danke für Esprit und große

Mühe" ("Thank you for wit and great effort"), and "Weitermachen!" ("Keep it up!").

35. One of the pamphlets from the tourist office (*Wolframs-Eschenbach Bürger- und Tourismusbüro*) proudly states that the city is the birthplace of the great medieval poet Wolfram von Eschenbach, whose name is known through his epic poems and songs: "Aber auch die Stadt trägt seinen Namen mit Stolz und ehrt ihren Dichter mit dem sehenwerten *Museum Wolfram von Eschenbach*." ("But the city also bears his name with pride and honors its poet with the noteworthy *Museum Wolfram von Eschenbach*.").

36. After all, it is still in existence (in its original form) after fourteen years.

37. As Muschg puts it, Wolfram does not really need Wolframs-Eschenbach for validation of his importance for the history of German language and literature; similarly, those who make use of his narrative and his work are not necessarily located in Wolframs-Eschenbach. Thus, Muschg chooses an apt description of the place (the museum and the town).

38. Kathleen Biddick, *The Shock of Medievalism* (Durham, NC: Duke University Press, 1998), 84.

39. Carruthers, *The Book of Memory*, 12–13. Carruthers takes up this image of the gate again in her discussion of Richart de Fournival later in her analysis: "Memory has two gates of access, sight and hearing, and a road particular to each of these portals. Both are equal means of access to the 'house of memory,' which holds all human knowledge of the past, and each has cognitively the same effect" (223).

40. Carruthers emphasizes the combination of a text's mode of composition (orally or in writing) and the audience's mode of reception in determining the sensory "gateway" to memory: "which one of these two senses affords the 'gate' to memory thus depends not on whether a text was composed orally or in writing, but on how it is presented to its audience on a given occasion, whether by being read aloud or silently to oneself" (*The Book of Memory*, 224).

41. These levels include the medievalists as well as the children who simply wish to try out the *Titurel* melody on the chimes in Room VI.

42. Carruthers, *The Book of Memory*, 257.

Celtic Tattoos:
Ancient, Medieval, and Postmodern

Maggie M. Williams

Introduction

In the biographical section of her website, the contemporary Celtic tattoo artist Pat Fish writes:

> On many pilgrimages to Celtic lands I have researched the manu-
> scripts, tramped through muddy fields to see standing stones and
> Neolithic monuments, and spent many an hour in deserted grave-
> yards with charcoal and paper, taking rubbings from high crosses.
> Everywhere I see patterns and motifs that suggest themselves as
> ways to embellish the human body [...]. It is my fervent wish to be
> granted many more years in which to explore the possibilities for
> translating Celtic and Pictish art into skin.[1]

This intimate description expresses the artist's devotion to seeking out inspirational patterns and motifs for her work. Her use of the term "pilgrimage" suggests an intensely spiritual journey, and has intriguing reso-nances for scholars of medievalism. It seems as if certain ancient designs call out to her from Neolithic monuments and early Christian crosses like the relics of centuries-old martyrs. Instead of offering salvation or healing, however, the pictures beg to be replicated in the medium of modern body art. For medievalists, the trope of relics resurfaces when Fish chooses to describe her artistic process using the word "translation". Like the bodies of Christian saints, her Celtic designs emerge from a distant past, become encased in the jewels of medieval culture, and arrive in the twenty-first century coated with glorious patinas of antiquity.

Fish's elision of ancient, medieval, and modern imagery is typical of many contemporary tattoo artists, who are effectively creating Celtic bodies

in the modern world. Their notion of a transcendent Celticism derives from a familiar moment for scholars of medievalism: the nineteenth century. In the context of literary and political movements of the period, the term Celtic began to circulate as a marker to differentiate Irish, Scottish, and Welsh culture from the Anglo-Saxon and European traditions.[2] Such an eternal Celtic collective, standing in contrast to the mainstream, provides a perfect analog for the current practice of tattooing: both the term and the images are markers of simultaneous difference and belonging, and both encompass past, present, and future identities. From this perspective, Celtic culture lies outside the norms of the dominantly Anglo-Saxon Western tradition, and yet it beckons to those who long for a sense of communal identity. In the same way, tattoo culture has always existed beyond the borders of conventional Western society while serving to unite its practitioners in their alternativity.

In this paper, I present examples of contemporary Celtic tattoo artists, including Fish and Aaron Ryan, whose work draws upon both ancient and medieval sources. Specifically, they look to the carved stone crosses, delicately illuminated manuscripts, and elaborate examples of metalwork that also fascinate scholars of medieval art. Their brand of medievalism allows for the interpenetration of prehistoric, medieval, and even early modern imagery, which is ultimately collaged into a thoroughly contemporary art form. In the end, their designs visualize an expansive Celticism that includes prehistoric druids, medieval monks, fierce warriors, and mythological queens. The resulting tattoos encode a slippage between disparate historical moments, rendering and transforming medieval images as a means of visibly constructing (post)modern Celtic bodies.

Ancient, Medieval, and (Post)Modern Celtic Tattoos

The practice of permanently decorating the human skin is an ancient and widespread one, and evidence for it survives from as early as the Neolithic era.[3] The remains of tattooed prehistoric bodies have been found from Russia, China, and Europe to South America, and written sources provide additional information about tattooing in later periods. In the British Isles, knowledge of ancient tattoos derives primarily from written sources.[4]

Perhaps the most famous early reference to Celtic tattooing is Caesar's first-century BCE text on the Gallic wars. When describing his opponents, the Roman wrote that "[…] all the Britanni paint themselves with woad, which produces a bluish colouring, and makes their appearance in battle more terrible."[5] Around the seventh century, Isidore of Seville refers to the practice of pricking the skin with needles in order to create a design.[6] The twelfth- to fifteenth-century *Lebor Gabála Érenn* (*The Book of the Taking of*

Ireland) includes a secondary Latin gloss that reads, "the Scots are the same as the Picts, so called from their painted body [...] inasmuch as they are marked with an impression of a variety of devices by means of iron needles and ink."[7] Unfortunately, no depictions of ancient or medieval tattooed Celts survive.

Although recent scholarship has demonstrated the long history of body modification in European contexts, tattoo remained a fringe activity in Western culture until the late twentieth century, practiced primarily by sailors, criminals, and sideshow performers.[8] By the 1980s, Fish and her mentors, Ed Hardy and the late Cliff Raven, had emerged as powerhouses in what has been called the "Tattoo Renaissance."[9] Each artist pursued an individual style, with Fish opting for Celtic designs because they resonated with her personal life and suited her particular skill set. In fact, the intricacy of Celtic knots can be so challenging to some artists that they avoid the style altogether. Interestingly, Fish is tattooed by both Raven and Hardy, each of whom said they would never again do Celtic work.[10]

Hardy worked especially hard to legitimize the art form, organizing conventions that were geared towards education, rather than just servicing the existing tattoo community. In his words:

> by the early eighties the conventions had become a regular thing. There was one big convention each year in different cities and they became more and more heavily attended. But some others and I became kind of disillusioned. We wanted the convention to be more than just a chance to get together and get really whacked out and take as many drugs and drink as much as you could with friends that you only saw once a year. We thought we should have conventions where we focused on really informing people about tattooing.[11]

These events, and the subsequent media coverage, exposed a wider swath of the public to the artistic value of tattoos. They also popularized a new stylistic trend, which Hardy's magazine, *Tattootime*, dubbed "New Tribalism."[12] Cliff Raven wrote an article on the style, which he was actively pursuing in his own work. Stylistically and philosophically, "New Tribalism" was a tattoo movement devoted to reviving and appropriating ancient and non-Western imagery. According to Hardy, "They took everything from Celtic knot work to Pacific Island designs and Northwest Coast Haida designs."[13]

The patchwork of "New Tribalist" motifs was collected from a diverse array of global and historical civilizations. For tattoo artists and collectors, the common thread was a tribal or primitive quality that could be located in

both the cultures of origin and the designs themselves. The tattoos utilize abstract, geometric forms, often rendered starkly in black against flesh. For the most part, patterns derive from non-Western sources, with the exception of Celtic interlace designs. While the historical Celts were certainly barbarian in a literal (i.e., non-Roman) sense, most of the imagery that modern audiences read as Celtic actually originates on medieval monuments. Such knotwork designs evoke an alternative, and somehow primitive, kin-based social structure, allowing collectors to declare their difference from the Eurocentric norm.

For contemporary artists like Fish and Ryan, medieval sources offer the artistic inspiration that cannot be found in the Celtic world per se. Interlace designs on the margins of illuminated gospel books provide one set of motifs, while carved stone crosses and delicate metalwork objects present others. Medieval texts recount the ancient myths and legends that furnish characters, gods, and heroes, and the pastiche of neo-pagan religion yields a panoply of ancient, medieval, and modern symbols. The resulting tattoos embrace pagan and Christian culture, native and diasporic communities, and past and present moments, generating an amalgam of continuity and innovation.

Aaron Ryan's Celtic Warriors

Ryan, formerly of Wild Eagle Studio in Dublin, is an Irish tattoo artist who works in a Celtic mode. Ryan is a young designer whose imagery is primarily figural, sometimes narrative, and often derives from written sources. His vision of Celticness touches upon mythological and literary themes, frequently presenting either hyper-masculine or sweetly romanticized figures and vignettes.

When I interviewed him in 2000, Ryan was in his early twenties, just embarking on his career as a Celtic tattooist. Although he had not had much formal artistic training, his drawings revealed a raw, natural talent, and his skill as a tattoo artist was apparent. Moreover, his genuine interest in Irish mythology and medieval literature was impressive, and his artwork reflected his efforts to educate himself on a variety of topics. Since then, he has moved on to parts unknown, but his name appears frequently on tattoo fan websites.

At the time, the majority of Ryan's clientele were native, male, working-class Dubliners from the north side of the city, for whom flash designs with a particularly Irish bent were the norm. These tattoos often had explicitly nationalist overtones, including variations on the Irish tricolor flag, the logos of favorite football teams, or even elaborate rebel tattoos, such as an enormous back piece with a lengthy quotation from the diary of hunger striker

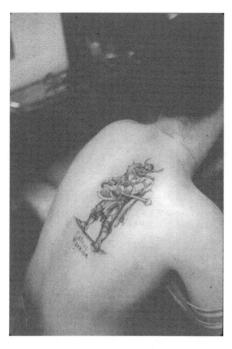

Figure 1. Aaron Ryan, *Celtic Warrior.*

Bobby Sands. Manic, of Manic Fish Tattoo Studio, also in Dublin, confirmed some of Ryan's assessments of client preference. Manic's shop was located in a slightly more posh area of the city, and as a result he did more business with foreign clients. In his experience, Dublin tourists who selected Celtic imagery, whether figural or abstract, were generally ethnically Irish. For them, the tattoos represented an external marker of their heritage, denoting their membership in a modern, global Irish tribe.

The originality and complexity of Ryan's designs can be off-putting to some clients, and many of his tattoos only exist as drawings. I had the opportunity to watch him install one Celtic warrior design, a large back piece that depicts an intimidating figure brandishing an axe (Fig. 1). The warrior stands on the client's shoulder blade, extending nearly halfway down his back, and he is rendered in strong black contour lines. With booted feet firmly planted and an immense horned helmet, he looks out threateningly at the viewer. His helmet blends Anglo-Saxon with pseudo-Scandinavian features, such as cheek protectors that resemble the helmet unearthed at Sutton Hoo and horns like those that appear on Wagnerian Viking helmets. The figure's left arm holds a long-handled axe with a spiral design on its head, which he extends forward, perpendicular to his body. Beneath the image are the words, "Celtic Warrior". This design represents precisely the type of imagery that Ryan has developed as a way of reconciling his own,

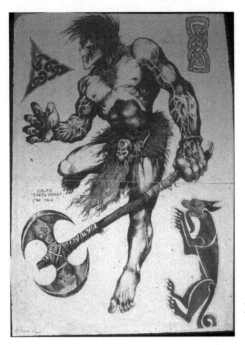

Figure 2. Aaron Ryan, *Celtic "Earth Frenzy" (The Tain)*.

erudite interest in ancient and medieval Ireland with the more pedestrian interests of his clientele. For this collector, Ryan's Celtic Warrior stands guard, literally watching his back, as a menacingly virile version of ethnic and cultural identity.

Another remarkable Ryan design was inspired by the epic tale *Táin Bó Cúailnge (The Cattle Raid of Cooley)*. In Ryan's drawing, *Celtic "Earth Frenzy" (The Tain)*, a massive, semi-nude male with bulging biceps and prominent veins twists his body and clenches one claw-like hand (Fig. 2). Spiky hair covers his fierce head, which turns towards an unseen enemy. His only clothing consists of a loincloth made from animal pelts and held in place by a tiny human skull. He wears a necklace and bracelet and brandishes an enormous double-headed axe with incised spiral designs. He is the embodiment of an enraged, battle-charged Celtic warrior.

Although set around the first century, the *Táin* was written down sometime in the twelfth.[14] As such, the text itself is an interesting amalgam of Celtic and medieval moments. It tells the story of the fiercest Irish warriors, who battle one another for possession of the brown bull of Cuailnge, believed to be the finest animal in the country and therefore both culturally and economically valuable. Several passages are devoted to describing the "battle frenzy" or "warp-spasm," a kind of fit of rage that precedes a warrior's entry into the fray:

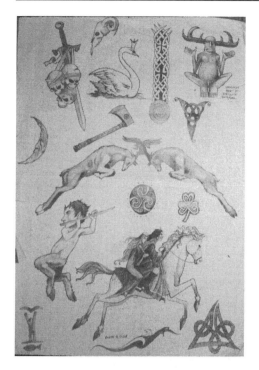

Figure 3. Aaron Ryan, *Assorted Tattoo Designs*.

The Warp-Spasm overtook him: it seemed each hair was hammered into his head, so sharply they shot upright. You would swear a fire-speck tipped each hair. He squeezed one eye narrower than the eye of a needle; he opened the other wider than the mouth of a goblet. He bared his jaws to the ear; he peeled back his lips to the eye-teeth till his gullet showed. The hero-halo rose up from the crown on his head.[15]

Ryan's *Celtic "Earth Frenzy"* captures the wild energy of this text, which is already layered with ancient, medieval, and modern retellings.

Other examples of Ryan's tattoo designs derive from mythological sources, such as a depiction of Niamh and Oisín on horseback, galloping off to the otherworld, Tír Na nÓg (at bottom centre of Fig. 3). Like the *Táin*, surviving texts of this story are all medieval or later, which presents certain scholarly questions about their dates but is not a concern for artists like Ryan. In Ryan's view, the story's antiquity and cultural authenticity far outweigh its potential connection to any particular moment in Irish history. In his drawing, the mythical couple is shown astride a regal white steed with a golden mane that matches Niamh's yellow locks. She sits behind Oisín, clutching his waist, and her hair billows behind her, swirling into spirals that

mimic the forms found in both ancient and medieval interlace designs. The blue blanket that they use as a saddle is also adorned with similar spirals. This romanticized image of the beautiful, young couple offers a different vision of Celticness, one that prioritizes mystery and myth over battle and aggressive masculinity. Nevertheless, both designs draw upon ancient Irish texts and imagery, which are viewed through the lenses of the Middle Ages and ultimately serve to constitute modern Celtic bodies.

Another interesting Ryan design depicts Cernunnos, an ancient horned god of fertility (at upper right of Fig. 3). In the drawing, Cernunnos squats with his knees akimbo, raising his hands at forty-five degree angles, palms facing the viewer. He displays both male and female sexual characteristics, revealing a dangling penis and rounded breasts. On each side of his head are enormous antlers that extend outwards and include curving protrusions, culminating in sharp and rather threatening points; he is a powerful creature indeed. Here, Ryan fuses his interest in mythology with his clients' apparent preference for ferocity. He also marries the masculine and feminine principles that dominate some of his other imagery. Moreover, he draws explicitly on ancient pagan religious imagery, a theme that also appears in Fish's designs.

While Ryan's tattoos are more figural and narrative than many other Celtic tattoo artists' work, they are equally devoted to generating timeless images of a unique cultural identity. For Ryan, Celticness is about strength and passion, storytelling, and legends. Much of his conception of Irish cultural identity is transmitted through medieval sources, both literary and visual. When he was working at Wild Eagle, Ryan's vision of Celticness met his clients' expectations in the realm of the warrior. In that arena, both artist and collectors were able to visualize a kind of muscular, medievalized Celticism.

Pat Fish: The "Queen of Celtic"

Fish says that she always knew she was "a Celt," despite having been adopted by parents of Russian descent. She recalls going to sleep at night praying, "God, when I find out who I really am, please can I be Irish?"[16] At the age of thirty, she met her birth mother – who was indeed of Scots-Irish descent – and began her career as a tattoo artist in earnest.[17] She was particularly excited to be descended from the Picts, whom she describes as "the famous tattooed warriors of Scotland."[18] In her words, "by specializing in this type of tattooing I get to meet people who are my same kind of dog, who think bagpipes are thrilling and knotwork mazes are a kind of visual prayer of complexity."[19]

She earned undergraduate degrees in Studio Art and Film and was working as a journalist, illustrator, and art teacher when she decided that she

wanted to turn her training to the medium of tattoo. She identifies herself as both "otherwise abled" and "severely dyslexic," noting that she can write backwards and forwards at the same speed with both hands.[20] Fish believes that her unusual ways of thinking, learning, and perceiving the world have directed her choice to work with Celtic designs: she is particularly drawn to pattern, repetition, and negative space, and she happily executes intricately interwoven designs that tend to frustrate many other artists. In her words:

> I have a kind of dyslexia that allows me to be ambidextrous and see things backwards and forwards with ease, so looking at the negative spaces and interlacings in Celtic weaves is endlessly fascinating for me. The ancient monks and stone carvers had this same pleasure, working geometries and spirals to a pleasant representation of the intricacies of the universe.[21]

Her invocation of ancient (medieval) monks and stone carvers here is particularly intriguing. She takes a liberty that many scholars would balk at when she assumes that, centuries ago, these artists experienced pleasure in working geometries and spirals; however, even without documentary evidence to back up that assumption, it certainly seems logical, and, truthfully, rather satisfying. Perhaps the notion that the artists experienced pleasure is too untenable, but it is certainly likely that their experience of designing interlace passages bore a psychological relationship to their devotional practice.

Regardless, Fish undoubtedly derives pleasure from her work. Often referred to as the "Queen of Celtic," Fish arranges her intricate, visually compelling designs so that they rarely replicate ancient or medieval imagery exactly, instead subtly transforming centuries-old works of art for use in contemporary contexts and a new medium. Her tattoo designs are frequently culled from monuments that most art historians would classify as medieval but she repeatedly uses the term "Celtic" to define her style, allowing the ancient pagan world to dominate both the medieval and the modern. At the same time, her appropriations, recreations, and re-uses of the imagery are entirely consistent with a postmodern context, one that allows for slippery symbolism and depends heavily upon audience interpretation.

According to her website, Fish's creative goal is to make "the intricate designs from the ancient Irish illuminated manuscripts and Pictish stones come to life in the skin of modern Celts," a process that involves active research as well as intensive artistic method.[22] After selecting a source of inspiration, which she does by traveling throughout the British Isles, Fish conducts research to learn more about the historical significance of the image. She then chooses a model and reinterprets the design to suit her

medium. Using computer-based technologies, her assistant, Colin Fraser Purcell, is able to transform Fish's freehand drawings into templates that can be transferred onto human bodies. After the template (or transfer) is complete, the tattoo design is applied as an outline.

Shading and color are both added later, and a heavily shaded or very colorful tattoo can take multiple sessions to complete. Fish describes her process of "whipshading," a technique in which the tattooist pulls the needle backwards, writing, "I do this with a quick application of pure black. [...] I like the painterly effect that the pure black gives the finished piece, a good contrast to the precision of the lines."[23]

Once the piece has been shaded, Fish often re-traces the contour lines for emphasis. Her method includes using white ink for clarification. As she says, she will "run a bead line of white ink between the lines to serve as insurance against them bleeding and blurring together after time [...]. It is amazing how white ink can open up a design."[24] Next, Fish sometimes adds color. She writes:

> Color can be very beautiful in knotworks, but dark colors will defeat the purpose of taking a lot of care with the braid lines. I use a bright light color in the knots, or none, and save the dark colors for the negative spaces in the backgrounds. That serves to bring the design forward in space, and since many of the smaller negative bits would close up to black anyway a dark color fills them nicely.[25]

The painstaking process of Fish's tattoo method generates impressive results, as she literally transforms ancient imagery into modern art.[26] Unlike Ryan's figural drawings, Fish's work is primarily abstract and generated directly from visual models. Her sources are often medieval, and usually Irish or Scottish in origin, although she also incorporates Welsh and occasionally Scandinavian motifs. In addition, she creates original designs that draw upon both medieval and modern imagery.

Some of Fish's designs are nearly precise replicas of ancient and medieval works of art, such as her *Killamery Cross* tattoo, which is based on a carved stone cross that dates to around the eighth century from Killamery, Ireland (Fig. 4). The sandstone sculpture stands about 3.7 meters in height, tapering towards the top with a small ring encircling the cross' head. The monument is primarily adorned with geometrical interlace reliefs on all sides, as well as images of animals and scenes that have been identified as Jacob and the Angel, scenes from the David stories, hunting scenes, and a Crucifixion.[27] Fish's tattoo reproduces the cross' more abstract east face quite precisely, adding a green and maroon color scheme to accentuate the design.

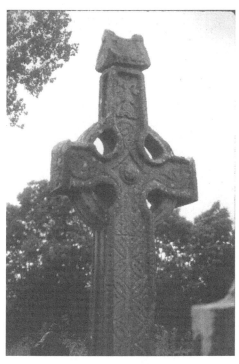

Figure 4. *Killamery Cross*, Killamery, Ireland.

According to her interpretation of the imagery, "The unique integration of serpents and spirals in the center represents the joining of the Pagan forces of the Earth with the new Christian religion. The floral patterns in the base are a celebration of the vegetative powers in union with the spiritual."[28]

Not surprisingly, her assessment of the design as both pagan and Christian differs dramatically from the accepted academic analysis of the imagery on the cross, which defines its interlace decoration as purely ornamental, drawing stylistic comparisons to similar motifs in contemporary metalwork and illuminated manuscripts.[29] In this example, Fish transforms the medieval object into a contemporary image by changing its meaning, but not its form. She prioritizes multilayered and inclusive interpretations over strictly defined periodizations and cultural divisions. Her use of the medieval image is akin to any contemporary artist's inclusion of older works of art in a collage, a process that would also have been familiar to medieval artists and audiences, as evidenced by innumerable instances of reused spolia and classical motifs.

Another instance of this type of reappropriation and reinterpretation is Fish's *Duleek Knot* design, which is also derived from a medieval carved cross (Fig. 5). She analyzes the imagery on her website:

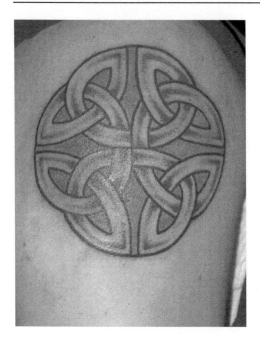

Figure 5. Pat Fish, *Duleek Knot*.

> This symbol is found in many old druid and pre-Christian patterns. The circle which encompasses the pattern is a symbol for completeness and also represents the sun, which was an object of worship [...]. The inner pattern can also be seen as a cross, thus symbolizing the integration of Christian and druid beliefs [...].[30]

For Fish and her clients, this design embodies a timeless Irishness that extends from prehistory through the Middle Ages and into the twenty-first century. She locates the image's origins before the medieval period, citing connections to druid culture and pagan sun worship. At the same time, she acknowledges the design's Christian associations. Indeed, it would be difficult to deny a link to medieval Christian culture, as Fish's direct inspiration for this tattoo was a ninth- or tenth-century relief from the stone cross at Duleek, Ireland (Fig. 6).

The medieval cross includes panels of abstract geometric and interlace decoration on its east face, but none of them is identical to Fish's tattoo design. Her *Duleek Knot* consists of four triquetras arranged into a cross shape and inscribed within a circle, resting on a rich, kelly-green background. According to Fish, "Each triquetra represents the forces of nature: earth, air and water as interpreted through each of the four seasons."[31] The triquetra is a prehistoric design in which three pointed ovals are intertwined into a roughly triangular shape; it appears on ancient stone monuments in

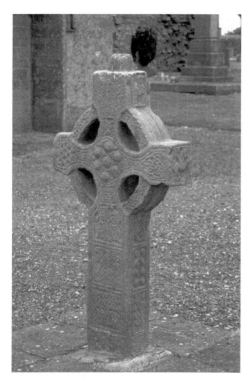

Figure 6. *Duleek Cross*, Duleek,
Ireland.

Scandinavia and the British Isles, and it has been found in both pagan and
later Christian contexts. Despite Fish's assertion that it signifies nature and
the seasons, no definitive symbolic meaning has been linked to the triquetra.
Indeed, the iconography of such Iron Age Celtic patterns continues to elude
the academic community, which until recently has focused its energies on
questions of style, date, and function. As D. W. Harding states in his recent
monograph on Celtic art, "Only very occasionally can we expect archaeolog-
ical evidence to provide 'answers' to these questions."[32]

For Fish and her clients, the visual resonance of such designs trumps
any proof of their meaning. She traces the formal similarities of ancient and
medieval spirals and interlaced knotwork patterns, invoking their visual
constancy as a means of articulating a continuum of Celtic identity.

Since that lineage begins prior to the Middle Ages, some of her designs
replicate older works of art, such as her *Newgrange Triple Spiral*, which
derives from a carving inside the Neolithic passage tomb of the same name.
Built around 3200 BCE, Newgrange precedes the arrival of the historical
Celts to Ireland, yet Fish and her audiences consider these curvilinear motifs
to be the essence of Celtic spirituality. The Neolithic carving is a simple,
linear design with three spirals, measuring about twelve inches in diameter,

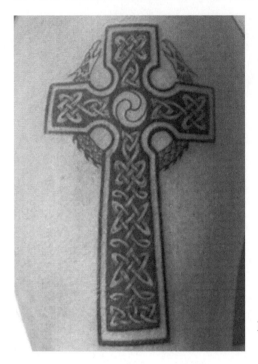

Figure 7. Pat Fish, *Viking Dragon Cross*.

and Fish transforms it into an almost identical tattoo, shrinking the scale and enhancing its impact on skin by using a blue-green color. Her analysis of the image is quite accurate, except that we have little evidence of who was buried at Newgrange. She writes, "Deep within the innermost chamber of the Newgrange passage tomb in Ireland's Boyne valley, 6,000 years old, older than the Egyptian pyramids, this evocative spiral stands eternal watch over the burial place of the high kings."[33]

Another piece that Fish associates with burial is her *Viking Dragon Cross*, which is inspired by the general form of an Irish high cross but altered to incorporate Scandinavian-inspired imagery (Fig. 7). The tattoo depicts the familiar outline of a ringed medieval cross, adorned with interlace designs. The ring, however, consists of two beasts whose snouts reach up towards the cross' capstone. In the center of the cross' head there is a spiral design.

Fish's interpretation of the tattoo is fascinating, and parts ways with academic understandings of the interactions between Vikings and the Irish in the Middle Ages. She writes:

Even the wild heathen Vikings who came to pillage Ireland some-times converted to Christianity, and a cross like this marked the

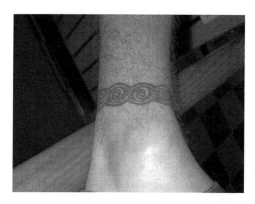

Figure 8. Pat Fish, *Saint Matthew Band.*

grave of such a convert. The knotwork is traditional, from a high cross gravestone, but the ring is changed to add two Viking dragon heads to form the top portion of the circle.[34]

While her dramatic invocation of the Vikings paints them as uncivilized aggressors, a notion that some scholars have refuted, she ultimately pays homage to the culture by weaving it into her work.[35] What is more intriguing is Fish's assertion that such a cross once stood above the burial places of pagan Scandinavians who had converted to Christianity. In reality, there is no evidence of such a composite sculpture, whether placed over a tomb or not.

Here, Fish links her knowledge of the modern tombstones known as Celtic crosses with her general understanding of the Vikings' role in medieval Irish culture. In her postmodern creative context, her design has the capacity to signify many things at once. It is a medieval image, a Celtic cross, a Viking-influenced design, and the marker of a converted heathen. It represents ethnicity, the prospect of religious enlightenment, and it also commemorates the dead. It depicts the ancient past, the Middle Ages, and the modern world, allowing collectors of mixed Scandinavian and Irish heritage to construct and promote their multilayered identities.

In addition to tattoos that derive from the form of the medieval ringed cross, Fish also renders abstract pieces of knotwork, such as band tattoos. For instance, her *Saint Matthew Band* derives from the borders of the seventh-century illuminated gospel book known as the Book of Durrow (Fig. 8). Interestingly, she suggests a much earlier date for the medieval source, perhaps inadvertently placing it before Ireland's conversion to Christianity. She writes, "This intricate pattern is the border around the evangelist's portrait page of St. Matthew's Gospel, from the fourth-century Celtic illuminated manuscript the Book of Durrow."[36]

In addition to designs that replicate or revise ancient and medieval

objects, Fish also creates original tattoos, many of which are inspired by medieval sources and reference alternative spiritualities. For example, her *Medieval Warrior* contains explicit references to Wicca, a neo-pagan faith developed in the mid twentieth century. The tattoo includes the athame knife, a ceremonial object central to many Wiccan rituals, enclosed within a pentagram that is inscribed in a circle. The form of the knife is believed to derive from medieval books of magic and the pentagram and circle motif is a fundamental Wiccan identifying sign. Fish describes her design as follows: "A dagger pierces the pentacle of intricate knotwork to form the symbol of the athame knife joined with the forces of mystic knowledge."[37]

These examples of Fish's tattoo designs illustrate her ability to depict Celticness as simultaneously ancient, medieval, and postmodern. Each tattoo integrates a curvilinear, spiraling aesthetic with explicitly religious symbols like the Christian cross or neo-pagan athame knife. And Fish's analyses of the imagery put forth an inclusive reading that treats Celtic culture as eternal and transcendent, with little that can be academically tied to the historical Celts.

Conclusion

In her personal essay, "Acts of Will," Fish writes:

> Tattoos insist on a lifetime of agreement. Incising the colors of a totem into the skin demands a reckless defiance, one that takes no advance heed of possible future regret. Placing visual metaphors onto the skin of pirates and rebels inclines them to complete the self-identification of outcast and rogue. Once that irrevocable mark has taken its place on the body many possibilities for previously forbidden behavior present themselves for revaluation. The burden of self-governance is more than balanced by the pleasures to be explored.[38]

Here, Fish captures all the semiotic ambiguity and cultural multivalence of her Celtic tattoos. In one sense, she emphasizes independence, individual agency, and bounded selfhood by using terms like "self-identification" and "self-governance". On the other hand, she suggests that the choice to be inked offers membership in a collective; her magical metaphors operate like tickets, redeemable for access to the outsiders' club. Her use of the word "totem" also links that alternative group to non-Western social structures, and calls to mind notions of tribalism and the primitive.

Among tattoo artists working in the Celtic style, Fish and Ryan generate remarkably different but equally multifaceted images. For Fish,

the intricacy and abstraction of medieval interlace embody a timeless Celticness that serves as a venue for her unique artistic abilities while simultaneously providing her clients with visual markers of their ethnic and cultural identities. Ryan, on the other hand, works in a figural idiom, depicting ancient gods, heroes, and warriors whose legends are frequently set in the Celtic Bronze Age or pre-Christian era, but are only known to modern audiences by way of medieval books. For Ryan and his clientele, the characters in these tales represent pure symbols of an unbroken cultural legacy. The Celtic tattoos designed by Fish and Ryan serve as visual emblems of a cultural identity that slips through time and space. Indeed, they constitute a true visualization of what J. J. Cohen has described as the "intimacy of the medieval within the modern and the modern within the medieval."[39] The images, whether figural or abstract, evoke the medieval, the ancient, and the contemporary all at once. They serve as physical, visible manifestations of the wearers' identities, literally delineating and adorning (post)modern Celtic bodies.

NOTES

1. Pat Fish, <http://www.luckyfish.com/pages/aboutpf.htm>, last accessed 8 May 2010.
2. For an excellent history of the Celtic Revival in the visual arts, see Jeanne Sheehy, *The Rediscovery of Ireland's Past: The Celtic Revival, 1830–1930* (London: Thames and Hudson, 1980).
3. The scholarly literature on tattooing continues to grow. Some formative works include: *Modern Primitives: An Investigation of Contemporary Adornment & Ritual*, ed. V. Vale and A. Juno (San Francisco: Re/Search Publications, 1989); Michelle Delio, *Tattoo: The Exotic Art of Skin Decoration* (New York: St. Martin's Press, 1994); *Written on the Body: The Tattoo in European and American History*, ed. Jane Caplan (Princeton, NJ: Princeton University Press, 2000); Margo DeMello, *Bodies of Inscription: A Cultural History of the Modern Tattoo Community* (Durham, NC: Duke University Press, 2000); Michael Atkinson, *Tattooed: The Sociogenesis of a Body Art* (Toronto: University of Toronto Press, 2003); Chris Wróblewski, *Skin Shows: The Tattoo Bible* (Zürich: Edition Skylight, 2004); and *Customizing the Body: The Art and Culture of Tattooing*, ed. Clinton Sanders and D. Angus Vail (Philadelphia: Temple University Press, 2008).
4. On the history of insular tattooing, see Charles W. MacQuarrie, "Insular Celtic Tattooing: History, Myth and Metaphor," in *Written on the Body*, 32–45.
5. *The Gallic War*, ed. and trans. H. J. Edwards (New York: Putnam, 1930), Book V:14.
6. *Isidori Hispalensis Episcopi Etymologiarum Sive Originum. Scriptorum Classicorum Bibliotheca Oxoniensis*, XX, ed. W. M. Lindsay (Oxford: Oxford University Press, 1911), sect. xix, 23, 7 and sect. ix, 2, 103.

7. R. A. S. Macalister, *Lebor Gabála Érenn: The Book of the Taking of Ireland*, parts 1–5 (Dublin: Irish Texts Society, 1938–41, 1956), part 1, 164–5.

8. See C. P. Jones, "Stigma and Tattoo," and Mark Gustafson, "The Tattoo in the Later Roman Empire and Beyond," in *Written on the Body*, 1–16, and 17–31.

9. Arnold Rubin, "The Tattoo Renaissance," in *Marks of Civilization*, ed. Arnold Rubin (Los Angeles, CA: Museum of Cultural History, 1988), 233–62.

10. Author's interview with Fish, June 2009.

11. Don Ed Hardy, "Current Events," in *Tattoo History: A Source Book*, ed. Steve Gilbert (New York: Juno Books, 2000), 197–207 (199). For an anthropological perspective on the conventions, see DeMello, *Bodies of Inscription*, 79–81.

12. *Tattootime*, Issue 1, 1982.

13. Hardy, "Current Events," 200.

14. *The Táin: Translated from the Irish Epic Táin Bó Cúlainge*, ed. and trans. Thomas Kinsella (Oxford: Oxford University Press, 1970), ix.

15. *The Táin*, 77.

16. Fish, <http://www.luckyfish.com/pages/aboutpf.htm>, last accessed 8 May 2010.

17. Interview, 2009.

18. Fish, <http://www.luckyfish.com/pages/aboutpf.htm>, last accessed 8 May 2010.

19. Fish, <http://www.luckyfish.com/pages/aboutpf.htm>, last accessed 8 May 2010.

20. Interview, 2009.

21. Fish, <http://www.luckyfish.com/pages/aboutpf.htm>, last accessed 8 May 2010.

22. Fish, <http://www.luckyfishart.com/meetpatfish.html>, last accessed 8 May 2010. When I interviewed Fish in 2009, she explained that she generally does impressions or rubbings of the medieval sculptures, and then re-draws most of the designs. Her process is mainly low-tech, using folded paper, which she referred to as "origami," but she also mentioned that she is happy to have digital software nowadays.

23. Fish, <http://www.luckyfish.com/pages/articles/tattips.htm>, last accessed 8 May 2010.

24. Fish, <http://www.luckyfish.com/pages/articles/tattips.htm>, last accessed 8 May 2010.

25. Fish, <http://www.luckyfish.com/pages/articles/tattips.htm>, last accessed 8 May 2010.

26. The tattoo designs that appear on Fish's website are each emblazoned with a statement of copyright. During our interview, Fish explained to me that she had experienced legal issues with other tattoo artists and was also concerned about individuals downloading her work, taking the patterns to other artists, and ending up with unsuccessful tattoos. This issue of ownership and legality is an intriguing one, which I expect to treat more fully in my forthcoming book, *Icons of Irishness from the Middle Ages to the Modern World* (New York: Palgrave Macmillan Press, anticipated 2012).

27. Hilary Richardson and John Scarry, *An Introduction to Irish High Crosses* (Dublin: Mercier Press, 1990), 42.

28. Fish, <http://www.luckyfishart.com/killamerycross.html>, last accessed 8 May 2010.

29. For the most comprehensive survey of medieval Irish crosses, including their style and iconography, see Peter Harbison, *The High Crosses of Ireland: An Iconographical and Photographic Survey*, 3 vols. (Bonn: R. Habelt, 1992).

30. Fish, <http://www.luckyfishart.com/duleekknot.html>, last accessed 8 May 2010.

31. Fish, <http://www.luckyfishart.com/duleekknot.html>, last accessed 8 May 2010.

32. Dennis W. Harding, *The Archaeology of Celtic Art* (New York: Routledge, 2007), 16.

33. Fish, <http://www.luckyfishart.com/newtripspir.html>, last accessed 8 May 2010.

34. Fish, <http://www.luckyfishart.com/vikdragcros.html>, last accessed 8 May 2010.

35. For instance, see Paul Holm, "Between Apathy and Antipathy: The Vikings in Irish and Scandinavian History," *Peritia: Journal of the Medieval Academy of Ireland* 8 (1994): 151–69.

36. Fish, <http://www.luckyfishart.com/stmattband.html>, last accessed 8 May 2010.

37. Fish, <http://www.luckyfishart.com/medwar.html>, last accessed 8 May 2010.

38. Fish, <http://www.luckyfish.com/pages/articles/actsofwill.htm>, last accessed 8 May 2010.

39. J. J. Cohen, "Afterword: Intertemporality," in *Cultural Studies of the Modern Middle Ages*, ed. E. Joy, M. Seaman, K. Bell, and M. Ramsey (New York: Palgrave Macmillan, 2007), 295.

Contributors

VLADIMIR BRLJAK is a doctoral candidate and Junior Lecturer at the Department of English, University of Zagreb, Croatia. He is writing a dissertation on allegory in early modern English literature while teaching courses on pre-eighteenth-century English literature and literary theory. He has presented and published on his main research topics, but also takes an interest in medieval literature and modern medievalism.

HARRY BROWN is an Associate Professor of English at DePauw University in Greencastle, Indiana, where he specializes in American literature and culture. His first two books, *Injun Joe's Ghost* and *The Native American in Short Fiction in the "Saturday Evening Post,"* focus on popular representations of Native Americans. More recently, his scholarship has explored transmedia narratives in literature, history, films, and games. His latest book, *Videogames and Education*, focuses on intersections between games and the humanities.

KELLYANN FITZPATRICK is completing a Ph.D. in English at the University at Albany, New York, where she pursues her research and teaching interests in medievalisms, nineteenth-century British literature, and medieval literature and culture. She has published on neomedievalist gaming practices and film, and her current research project reads representations of Guinevere across changing economic conditions.

ALAN T. GAYLORD works as an Independent Scholar in the fields of medieval literature, Chaucer, and medievalism; after 40 years at Dartmouth he is Winkley Professor of English, emeritus; and enjoys research appointments at the University of Pennsylvania and Princeton University. His current projects include a monograph on the medievalism of William Morris (*A Cultural History of the Morris Chair*); a book with the Chaucer Studio on Chaucer's short poems and *Troilus and Criseyde* (with his readings of chosen passages in Middle English): *Adventures in Prosodic Criticism*; and a book on "medieval movies," drawing on film courses he taught at Dartmouth.

KARLA KNUTSON is Assistant Professor of English at Concordia College in Moorhead, Minnesota. Her scholarly work has focused on innocence and children in medieval literature and on medievalism, particularly on Chaucer's reception during the nineteenth and twentieth centuries. She

recently published an article on teaching the Middle Ages through medievalism in study-away programs. Her current project explores ideas of innocence and attitudes toward childhood during the English Middle Ages.

DAVID W. MARSHALL is Assistant Professor of English at California State University, San Bernardino, where he teaches courses in medieval literature, medievalism, and adaptation studies. His edited collection, *Mass Market Medieval*, encourages the study of medievalism as a broad phenomenon diverse in genre and media. He is completing a monograph concerning English collective identity and literature around the Rising of 1381 and has published on the John Ball letters. He has also published articles on uses of *Beowulf* in popular culture and is working on a book-length study of that topic.

MEGAN L. MORRIS is a Ph.D. candidate at the University of Rochester. Her research interests include Victorian medievalism, the role of the body in nineteenth-century literature and history, and Victorian authorship studies. Her other publications include "Victorian Medievalism: An Annotated Bibliography for Teachers," available online through *The Once and Future Classroom*, and "Recalled to Life: King Arthur's Return and the Body of the Past in Nineteenth-Century England," which will appear in the Spring 2011 issue of *Arthuriana*. She is a member of the Modern Language Association, the North American Victorian Studies Association, and the Research Society for Victorian Periodicals.

NILS HOLGER PETERSEN is Associate Professor of Church History and Centre Leader for the Centre for the Study of the Cultural Heritage of Medieval Rituals (under the Danish National Research Foundation) at the Theological Faculty, University of Copenhagen. He publishes on medieval liturgy and its reception in the modern arts. He is the leader of an international project on regional identity and saints' culture under the European Science Foundation. He is area editor concerning music for the *Encyclopedia of the Bible and its Reception* and main editor of the book series *Ritus et Artes: Traditions and Transformations*.

MARK B. SPENCER is Associate Professor of English and Humanities at Southeastern Oklahoma State University. He holds doctorates in both medieval history and comparative literature, which he brings to bear in his study of modern historical novels set during the Middle Ages and Renaissance. A revised version of his first dissertation on late medieval historical writing was published as *Thomas Basin (1412–1490): The History of Charles VII and Louis XI*. Recent articles on historical novels include studies of George Garrett's *The Death of the Fox*, Pär Lagerkvist's *The Dwarf*, Eva Figes' *The Tree of Knowledge*, and Sigrid Undset's *Kristin Lavransdatter*.

ALEXANDRA STERLING-HELLENBRAND is Professor of German and Director of Global Studies at Appalachian State University in Boone, North Carolina. In addition to her book on *Topographies of Gender in Middle High German Arthurian Romance*, she has published articles on the intersections of medieval literature and the arts, both visual and musical. She is presently working on a book manuscript, *Mixed Media and Memory: Crafting the Performance of Medieval German Literature from the "Nibelungenlied" to Wolframs Eschenbach*, which studies the interplay of medieval works and modern audiences in the creation of shared cultural memory.

MAGGIE M. WILLIAMS is Assistant Professor of Art History in the Art Department at William Paterson University, New Jersey. Her scholarly work focuses on medieval art in Ireland and its manifestations in contemporary culture. Her published articles include "Constructing the Market Cross at Tuam" in the edited volume *From Ireland Coming* and an essay in *Irish Art Historical Studies in Honour of Peter Harbison*. She is currently working on a book, *Icons of Irishness from the Middle Ages to the Modern World*.

Previously published volumes

Volume I

1. Medievalism in England
Edited by Leslie J. Workman. Spring 1979

2 Medievalism in America
Edited by Leslie J. Workman. Spring 1982

Volume II

1. Twentieth-Century Medievalism
Edited by Jane Chance. Fall 1982

2. Medievalism in France
Edited by Heather Arden. Spring 1983

3. Dante in the Modern World
Edited by Kathleen Verduin. Summer 1983

4. Modern Arthurian Literature
Edited by Veronica M. S. Kennedy and Kathleen Verduin. Fall 1983

Volume III

1. Medievalism in France 1500–1750
Edited by Heather Arden. Fall 1987

2. Architecture and Design
Edited by John R. Zukowsky. Fall 1990

3. Inklings and Others
Edited by Jane Chance. Winter 1991

4. German Medievalism
Edited by Francis G. Gentry. Spring 1991
Note: Volume III, Numbers 3 and 4, are bound together

IV. Medievalism in England
Edited by Leslie Workman. 1992

V. Medievalism in Europe
Edited by Leslie Workman. 1993

VI. Medievalism in North America
Edited by Kathleen Verduin. 1994